FEMME DIGITALE

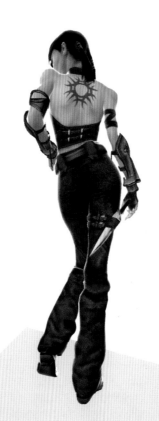

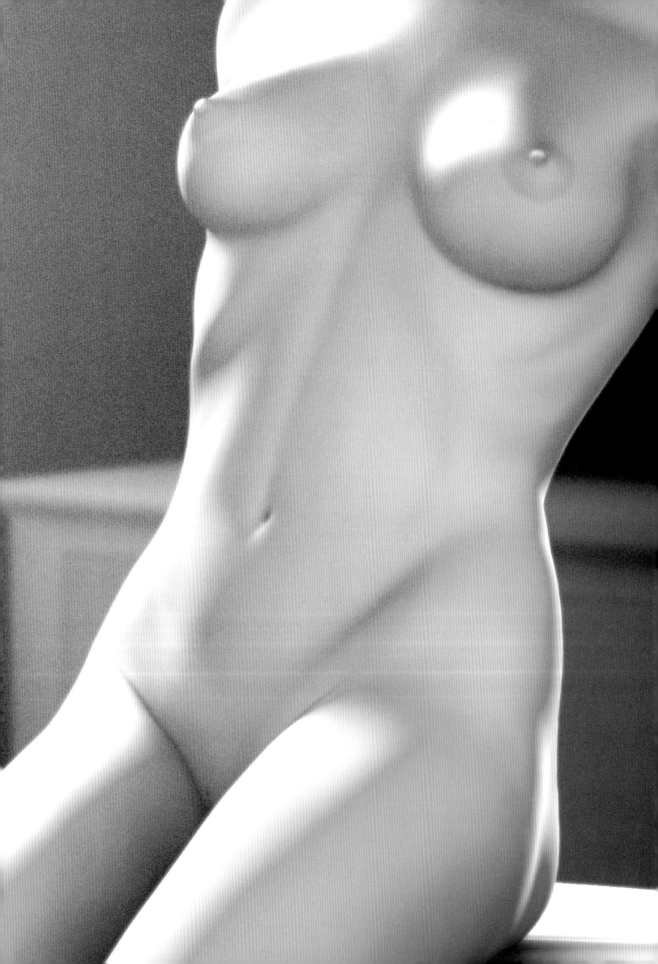

FEMME DIGITALE

Crafting the female form on your computer

ILEX

First published in the United Kingdom in 2003 by
ILEX
The Old Candlemakers
West Street
Lewes
East Sussex BN7 2NZ
www.ilex-press.com.

Copyright © 2003 by The Ilex Press Limited

This book was conceived by
ILEX
Cambridge
England

Publisher: Alastair Campbell
Executive Publisher: Sophie Collins
Creative Director: Peter Bridgewater
Editorial Director: Steve Luck
Design Manager: Tony Seddon
Editor: Stuart Andrews
Designer: Alistair Plumb
Development Art Director: Graham Davis

British Library Cataloguing-in-Publication Data
A catalogue record for this book is available from the British Library

ISBN 1-904705-02-2

Printed and bound in China

For more information on this title please visit:

www.femme-digitale.com

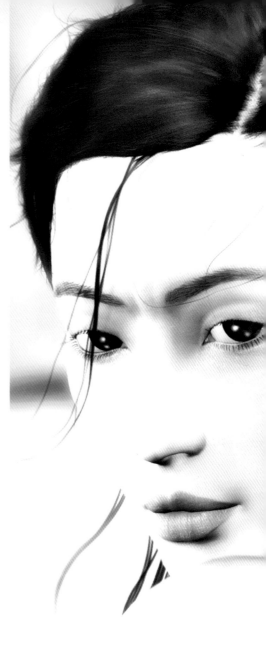

CONTENTS

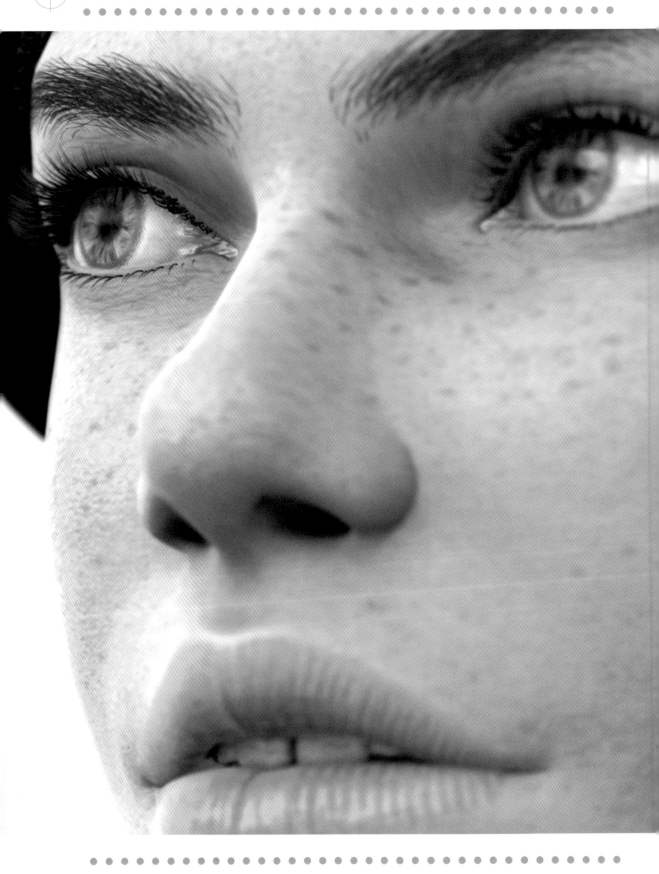

INTRODUCTION

THROUGHOUT THE AGES, ARTISTS HAVE STRIVEN TO CAPTURE THE BEAUTY OF THE FEMALE FORM. FROM BOTTICELLI'S VENUS, THROUGH MANET'S OLYMPIA, TO THE PHOTOGRAPHY OF HELMUT NEWTON AND HERB RITTS, ARTISTS HAVE CREATED IMAGES OF WOMEN IN EVERY STYLE IMAGINABLE, FROM THE PURELY AESTHETIC TO THE POTENTLY EROTIC. NOW THIS QUEST HAS BEEN EXPANDED BY THE BIRTH OF NEW DIGITAL METHODS AND MEDIA. THESE ENABLE THE SKILLED ARTIST TO EXPLORE A WORLD OF FANTASY, WHERE ANY VISION CAN BE RECREATED IN STUNNING, PHOTO-REALISTIC STYLE. THIS BOOK EXPLORES THE SUBJECT OF COMPUTER-GENERATED WOMEN, WITH HELP FROM THE ARTISTS WHO PRODUCE THEM. IT COVERS THE SOFTWARE AND TECHNIQUES USED, AND PROVIDES YOU WITH A GLIMPSE, AND A GUIDE, INTO THE WORLD OF THE 'FEMME DIGITALE'.

ARTIST
ALCEU BAPTISTÃO
TITLE
KAYA

INSPIRATION AND CONCEPTS

MANY OF THE ARTISTS IN THIS BOOK owe a lot to the airbrush art of the 1970s and 1980s record and book covers and the 'cheesecake' style of earlier years. Names like Antonio Vargas, Boris Vallejo, Jim Burns, Frank Frazetta, Chris Achilleos and, in more recent times, Brom, are all mentioned as influences. Others are inspired by the cinema, by fiction or – of course – by the great artists of earlier centuries. In recent times the characters in computer games have become art and influences in themselves. As the Internet brings people closer together, the work of established digital artists exhibited through online galleries also provides a reference for countless others and so the cycle continues.

In this book we'll be exploring the technology used to create the 'femme digitale'. It's not merely a book about how to draw the sexiest females or a similar exercise in erotica, but a guide to the use of software and techniques to produce artistic, and sometimes highly realistic, renditions of the female form. We'll be looking at what people are using in the fields of 2D image editing and illustration, how artists are using powerful 3D software and what tips you can pick up from them. First, though, as a backdrop to the rest of the book, we're going to take a look at how women are being portrayed in the digital world of today.

DIGITAL WOMAN

In recent years there has been an explosion of realistic-looking computer-generated characters in print, on screen, online and in games. Computer processor power and programming skills have increased to such a degree that we can make

people think that the picture of a woman is a photograph, not a clever artificial construction of objects, lighting and textures. In a similar fashion, the work of some computer illustrators is often mistaken for oil or watercolour paintings, because of the rich natural textures in the image.

Adobe Photoshop and Corel Painter are the digital successors to the darkroom and paintbrush. Their power has inspired thousands of traditional artists and creatives to turn to the computer, and many of the 2D images you'll see in this book are the result of that process. As for the 3D side, many of the early practitioners of modelling and animation software came from the architectural or Computer Aided Design (CAD) industry. However, instead of teapots and towers, many are now designing characters.

One of the best places to look for female digital characters is in the world of computer games design. Consumers are looking for more movie-like experiences with realistic characters and the games industry has been quick to comply. The detail and realism that some of the female stars of these games exhibit is breathtaking, and with every new release the standard is raised. Instead of the individual 3D modeler, large teams of artists and animators create and breathe life into these characters.

In addition to the in-game model of 'Jen', the lead character in the game *Primal*, Sony Computer Entertainment Europe (SCEE) created a high-resolution version of her for promotional purposes. This is an example of one of the glossy, polished renders. Dramatic lighting and a shallow depth of field help to give this image a striking, high-fashion feel.

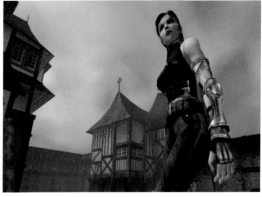

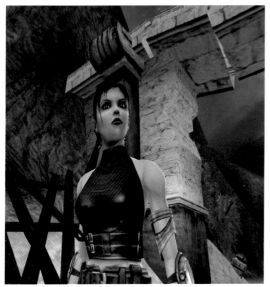

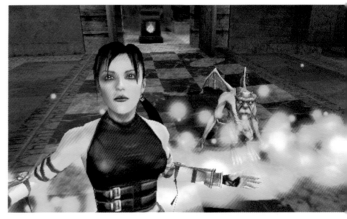

'Jen' is the computer-generated heroine of *Primal*, a game designed by the Cambridge Studio of SCEE. Taking advantage of the graphics power of the Sony Playstation 2 console, Jen is a perfect example of the advanced games characters possible today. As well as technical expertise, much thought goes into the creation of a character like Jen. Find out more about her concept and design in the Special Projects section later in the book.

FROM CONCEPT TO FINAL CHARACTER

Most of the heroines of today's games actually start with the simplest of technologies – a pencil and a sheet of paper. Developed initially as a series of sketches, the art teams discuss mannerisms, physical characteristics and the general personality of the character before doing anything. Once the concept has been finalized, sometimes using far more detailed illustrations, they're then given over to the modelling team who use software like Discreet 3ds Max or Alias|Wavefront Maya, plus a number of in-house tools to create the 3D model. Animation and texturing of the model then take place, probably the two most intensive parts of the process. Only then is the character ready to be used in the game.

As the hardware systems that run the games become more powerful, companies will have to create much more lifelike and realistic characters in games. Lara Croft, star of the mammoth hit game *Tomb Raider*, for example, has gone from an angular, relatively ill-defined collection of coloured blocks to a slinky 5,000-polygon model. Since 1996 the character has become more complex with each iteration of the game: flowing hair and rounded features were added at one stage, a seamless skin at another, and only some time later was she finally given the luxury of ears. Now Core Design, the game designers, have taken advantage of the graphics power of Sony's Playstation 2 and created a far more organic and stylized Lara than before, ten times as detailed as previous incarnations. Throughout her relatively short life, the Lara Croft character has been responsible for inspiring countless other artists, modellers and games designers to create their own digital heroines, and the trend doesn't look like slowing.

VIRTUAL CHARACTERS IN THE MOVIES

Another place to look for inspiration is at the movies. Films such as *The Matrix, Blade Runner, Alien* and *The Fifth Element* feature tough futuristic females who have made a huge impression on digital artists, especially those dealing with more fantastic subjects for their artwork. With films and games becoming more and more alike, however, it was only a matter of time before the two crossed over.

Several years ago the notion was put forward that one day human roles in films would be played by computer-generated (CG) synthetic actors. The likes of Marilyn Monroe would grace our screens again in new virtual form. Pundits in the popular press were convinced that we would see an end to the use of highly paid actors and actresses, with all their related baggage of on-set tantrums, drug problems and general unreliability. They would all be supplanted by their pristine and perfect CG counterparts. The pioneers of the technology, the US-based Kleiser-Walczak studio, even coined a term for the new digital stars of the silver screen – the synthespians had arrived.

Unfortunately, the cost of producing these perfect beings soon proved to be prohibitive. The technology simply wasn't up to scratch for more than a few minutes of on-screen time. Now all that has changed with the release of *Final Fantasy: The Spirits Within*. This

TMmy, the virtual singing teenager from Glasgow, is a creation of the cutting-edge animation company Digital Animations Group. As well as a musical career, TMmy has appeared as a host on interactive TV channels in the UK. Although their models are capable of highly realistic animation, in cases like TMmy it's not always beneficial to go for photo-realism. DA Group deliberately aims for a more stylized character when the object is to convey a mood or message. The look of the character becomes a part of the impression being conveyed.

film was touted as the state of the art in feature-length animation and featured completely 'virtual' actors, including the heroine of the movie, Dr Aki Ross. The film was based on a highly successful game series by the Japanese company Square, and turned into a film by its production arm Square Pictures.

Creating the photo-realistic humans was of course the major task facing the producers of *Final Fantasy*. The technology brought to bear to meet the challenge was staggering. On the hardware side alone, Square used no less than 167 Silicon Graphics Octane workstations, four SGI 2000 series high-performance servers, four Onyx2 visualization systems and various other SGI systems.

Square's 150 programmers and artists used Pixar's Renderman software and customized Alias Wavefront's Maya, creating approximately 100 plug-ins for, among other things, cloth effects, human movement, realistic flowing hair and follicles. Aki Ross, whose hair had to look the most realistic, reportedly caused Square no end of trouble. It cost $9 million for the most expensive hairdo in history.

FURTHER DEVELOPMENT
OF CHARACTER ANIMATION

In the wake of *Final Fantasy*, character animation continues to develop, and the tools that are available continue to be refined. Away from the huge budgets commanded by the movie world, virtual women are becoming more commonplace, first on the Internet and now on television, and especially in the hybrid of the two, interactive TV. Germany has been the focus for many experiments in virtual presenters with companies such as NoDNA populating the networks with glamorous female models. They are used to host television chat shows, promote products and, in one case, even promote their own brand of perfume.

In France, a company called Attitude Studios created 'Eve Solal', who first materialized on the Web (at www.evesolal.com) with just a picture on a French identity card, and a couple of 'teaser' images of startling realism. Attitude then created the virtual Eve using a motion-capture system and a combination of Maya and Attitude's proprietary Emotion Mapper software. Attitude also created for Eve a semblance of social life and a personality, renting an apartment for her in Paris and even buying her a mobile phone.

The Scottish company Digital Animations Group (DA Group) has also made a name for itself in the world of virtual characters. First came 'Annanova', the 'cyber' newscaster. She was created to be the online 'face' of the news agency PA News, and has been followed by more responsive and realistic creations for online communication. Driven by real-time animation technology, DA Group's virtual characters have the potential to talk to viewers and act as personal assistants helping to navigate users

After TMmy, DA Group went on to create Seonaid, an online news presenter for the Scottish Executive. DA Group's proprietary technologies coordinate their character's lip synchronization with natural face and body movement and idiosyncratic personality traits.

around different channels. DA Group also developed 'TMmy' – a virtual pop star who, like Eve Solal, has a corresponding virtual presence, biography, and what's more, has released a record. However, TMmy (pronounced 'Timmy') is not the only singing femme digitale. In Japan, where the concept of virtual characters has had longer to develop, there are several software-based songstresses, including Kyoko Date, NaNa and others.

However good these 'actresses' are, the world is yet to be convinced. While near-perfect in still-image form, both Aki Ross and Eve Solal have been criticized for a sense of 'lifelessness' when animated, with the unreal look and behaviour of the eyes being the main culprit and the plasticity of the face a close second. Facial recognition is one of the human brain's top computational areas and it will take a lot more work to fool it into believing that what we are seeing is a real human being. The animators know this of course – no one outside a marketing department has yet claimed that their digital creation looks 'totally real'.

Not every one has the time and resources to create such masterpieces, and it's a credit to some of the artists in this book that most of the work shown in the following pages is a solo effort, using nothing more than off-the-shelf software and a large amount of talent. We've attempted here to look at some inspirations and influences for digital artists, what technology is capable of, and how far the depiction of humans – in particular women – has come since the days of clay and cave painting. It's now time to look at how you too can create your own femme digitale and be inspired by the genius of others.

Along with TMmy and Seonaid, the Digital Animations Group were also behind Maddy, a sophisticated virtual character with an impressive artificial intelligence chat engine. On one occasion, Maddy joined live presenters to cohost the BBC's popular UK science programme *Tomorrow's World*.

THINKING DIGITAL

TO CREATE DIGITAL ART, you have to think digitally. Obviously talent, practice and artistic training will stand you in good stead, but if you have no experience or understanding of software, computers and their peripherals, you'll soon find yourself mired in a confusing mess of jargon, unfamiliar terms and time-wasting activities. Here we aim to give you a grounding in the technology and terms used by the artists in this book. We'll explore common techniques and terminology used in creating artwork using high-end 3D applications and professional graphics software.

The chances are that you already own a computer, a monitor and the other equipment of a digital artist. If, however, you want to find some suggestions about what equipment you should be using, you can refer to the basic setup and concepts outlined in the hardware section towards the back of the book.

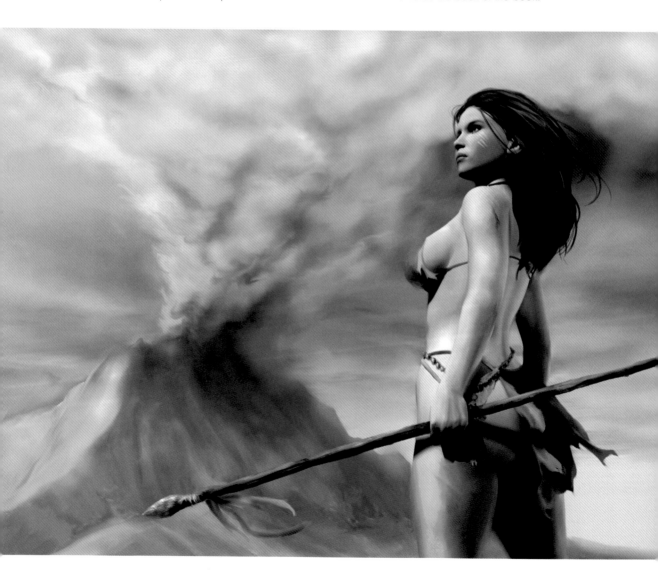

Artists like Will Kramer are rightly renowned by their peers for their digital artwork. Using applications such as Curious Labs Poser and Adobe Photoshop, they are able to create artwork with the same skill — and many of the same techniques — used by traditional chatacter artists.

Photoshop is one of the most popular software applications around and is unrivalled in its dominance of the 2D image-editing market. Highly versatile, it can be used for photo-manipulation or as a complete digital image creation studio, as shown here in this work-in-progress screenshot by Christine Clavell.

We'll take a closer look at the individual attributes and techniques of applications in the software section, but for now we're going to travel to another dimension.

THINKING IN 3D

At first glance, 3D applications may look daunting, and indeed they are, but all share the same building blocks – that is, something to move pixels around and something to render a final output. Also once you learn the basic concepts of 3D work, you can transfer that knowledge to bigger and better software packages. Like anything else, it's a question of practice, application and a modicum of talent.

IMAGE CREATION

Many of the software packages in this book have their roots in something completely different from what they are used for today. For example, most of the 3D software used to create monsters, spaceships and alluring computer-generated sirens came from the dry worlds of CAD and architectural design. Today, of course, the use of these packages is very different, but there are a few concepts that have persisted and are still relevant to digital artists.

First, though, we're going to consider 2D image editing and illustration, and look at some of the ways of manipulating pixels to create artwork. Most 2D packages share the same basic toolset that mirrors the artist's paintbox. Brushes of varying size and material, pencils, erasers and airbrushes – all are present in digital form in packages like Adobe Photoshop, Corel Painter and others. In addition, we have tools for selecting portions of pictures, cropping images, applying photographic techniques such as 'dodging' and 'burning', applying blurs and sharpening parts of the image, using techniques that replicate natural media like crayon, watercolour and oils – the list is almost endless. Anything an artist can do in the real world, he or she can do even more using a computer. What's more, the work can be saved, stored and further manipulated long after the original was begun.

Software applications like Bryce from Corel fulfill specialized tasks, but can be used for much more. Bryce is primarily a powerful 3D landscape and animation tool, but as demonstrated here by Christine Clavel, it can also be used to composite elements and objects from different 3D applications, and then render them out as a complex, high-quality scene.

850 objets
2081068 polygones

To use 3D software you must first start to think in three dimensions. This is as hard as it sounds, particularly for artists used to 2D computer applications, but before you give up remember that this is the way that we view the world – not in flat surfaces but with depth. Similarly, the way a computer describes 3D space is by adding depth to the equation. Thus, instead of x and y coordinates, 3D space is defined by the axes x, y and z, viewed at right angles to each other. 3D software applications, in a format borrowed from their architectural roots, commonly present space in a series of views – front, back, left, right, top and bottom elevations, known collectively as orthogonal views – as well as a 3D view showing objects in a perspective setting.

Points in 3D space are defined by their x, y and z coordinates, and a line drawn between two points is called an edge. Adding a third point and joining up the three creates a polygon, the building block of 3D modelling. Polygons can be any shape made up of these line segments. The edges enclose the faces of the polygon, which stitched together form the surface of the object.

MODELLING

Modelling can be seen as the creation, arrangement and interaction of geometric models and planes, which together make up the skeleton or frame of a scene. Modelling types or drawing modes vary, with the most basic being point editing – essentially, changing the shape of polygon objects by moving each point individually. Models can also be formed from preset primitive objects, such as spheres, cubes and cylinders, which are manipulated and combined together to create more complex shapes.

If you were a traditional sculptor you would be used to the concept of adding material and moulding it or knocking it away to produce your model. Well, the same can be said for 3D modelling. It's really just a case of thinking digitally. 3D applications provide polygon tools that manipulate simple shapes into ones that are multifaceted using such techniques as extrusion – literally pulling the shape out from its base points. Other polygon modelling methods you'll see used in this book are lathing – creating a 3D object by rotating a shape around an axis, and lofting, which basically forms a skin between two or more polygonal profiles. The coordinate points or vertices of the lines define and control the facets of the polygonal shapes.

Curves are also used, but in 3D modelling are known as 'splines'. Like polygons, these are defined by the position of start and end points, but also by 'phantom' points along the curve. Unlike polygons, however, the shape of the curve is calculated by a mathematical equation. Polygons and splines can be mixed to form more organic shapes. An example of this is patch modelling, used by many games designers to create realistic characters.

More advanced than simple curves are NURBS (non-rational uniform B-spline) curves, which are defined by the position of control vertices (CVs) that pull the curve into a more fluid organic shape. These CVs do not lie on the curve itself, but 'float' above the surface. The primitive objects mentioned before can be created from either polygonal or NURBS geometry, and different tools are used to manipulate objects created by each method.

When modelling objects using polygons, vertices in the polygonal 'mesh' are directly pulled and manipulated. In NURBS modelling, the CVs create a cage around the object. Pulling on the CVs allows smooth deformation of the object. More processing power is needed when manipulating NURBS objects than those made up of polygons, due to the greater amount of mathematical calculation required.

Some higher-end packages also offer the facility to create objects with subdivision surfaces, which are built up from a refined polygonal mesh. Both NURBS and polygonal objects can be converted to subdivision surfaces when greater detail is required. Subdivision surfaces are another technique heavily used in games character creation.

Another method is patch modelling, which uses NURBS sufaces to create a model with a continuous mesh. Although this technique requires a lot of planning and practice to achieve decent results, it has the advantages of even parameterization for texturing the surface, as well as a lighter geometry than other methods. There are more types of geometry than just those mentioned here, but we'll encounter them as we explore the different techniques used by the artists featured in *Femme Digitale*. Remember, though, that the greater the amount of modelling options offered to the 3D artist, the more complex (and usually more expensive) the software package involved. It is therefore wise to start with the most rudimentary 3D application you can find to learn the basics before you even think about moving into the high end.

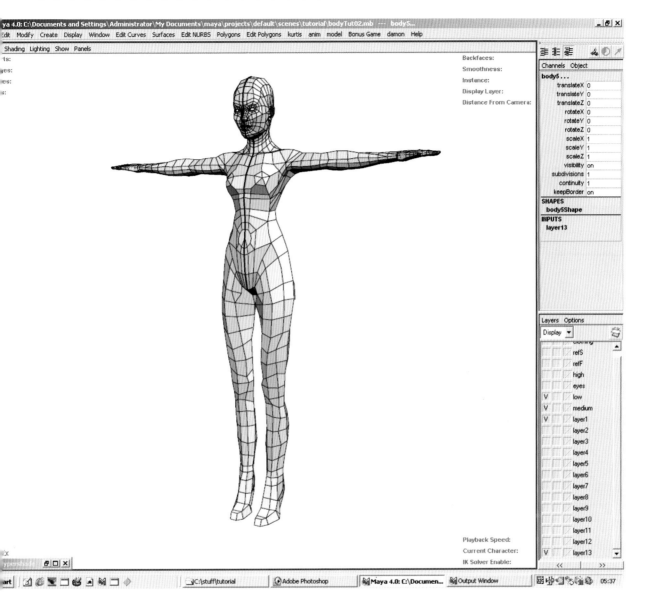

RENDERING

Thinking in three dimensions also means being aware that the canvas you are using is based on the world around you. Objects on it need to be lit, shadowed, coloured and defined just as they are in the real world. In creating a real-world scene from a simple collection of individual objects, it is necessary to apply textures and lighting, and this process is known as rendering.

The rendering process collects all the data in the 3D scene – the location and nature of every light source, the location and shape of all the geometry, the materials, the colours and reflective properties of

High-end 3D software, such as Maya from Alias|Wavefront, gives the artist the ability to create lifelike human forms by manipulating and joining geometric shapes. Here one of Damon Godley's games characters is in the later stages of the modelling process.

the textures used, and the location and orientation of the camera through which the scene is viewed – to create a 2D image. We'll look at the creation of textures and lighting, how they affect objects and how they all come together in a scene in Chapters 2–5. In Chapter 1 we are going to consider some of the 2D and 3D graphics applications available, concentrating on the software most commonly used by artists who create the femme digitale.

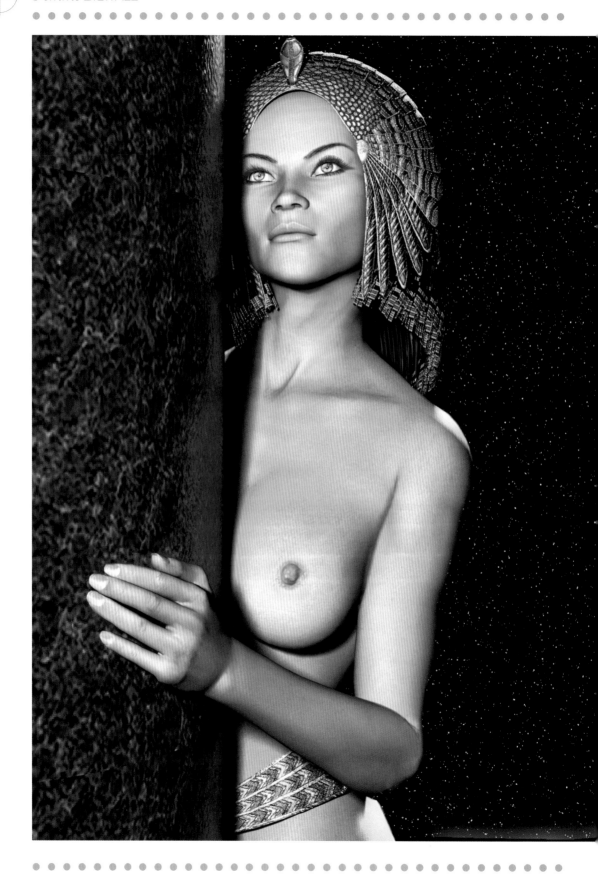

SOFTWARE

WHEN SETTING UP ANY DIGITAL STUDIO, YOU WILL BE INVESTING A LOT OF TIME AND EFFORT INTO CHOOSING THE RIGHT SOFTWARE FOR THE JOB. THERE MAY BE CERTAIN PACKAGES YOU ARE ALREADY COMPETENT OR EVEN EXPERT IN, WHILE THERE MAY BE OTHERS YOU HAVE SCARCELY COME ACROSS. THIS SECTION OF THE BOOK IS INTENDED TO GIVE A BRIEF OVERVIEW OF THE DIFFERENT CATEGORIES OF SOFTWARE AVAILABLE, AS WELL AS DESCRIPTIONS AND EXAMPLES OF SOME MAJOR APPLICATIONS. WHILE THE LIST OF SOFTWARE THAT IS DISCUSSED IS BY NO MEANS EXHAUSTIVE, IT WILL GIVE YOU A GOOD GROUNDING IN FINDING THE RIGHT TOOLS FOR THE JOB.

ARTIST
DANIEL SCOTT GABRIEL MURRAY
TITLE
WAITING FOR RA

ADOBE PHOTOSHOP

MOST, IF NOT ALL, of the artists in this book use Photoshop for some part of their workflow or image creation. It is without a doubt the most popular bitmap image-editing software available today. Built around a digital mix of a photographer's darkroom and a graphic artist's toolset, the user has access to brushes, filters, selection tools, effects and a customizable range of colours and patterns. Pressure settings for the brushes and other paint tools can be controlled by the use of a digital pen and a pressure-sensitive tablet, or colour can be built up in one place by holding down the mouse button without dragging.

A major factor in the success of Photoshop is its use of layers, which allow you to work on one element of an image without disturbing the others. You can change the composition of an image by changing the order and attributes of layers. In addition, special features such as *Adjustment Layers*, *Fill Layers*, *Layer Blends* and *Layer Styles* let you create sophisticated effects.

Updated to Version 7.0 at the time of writing, Photoshop includes some clever new tools such as the *Healing Brush*, *Patch* tool and a graphic *File Browser*. It also features a new painting engine, as well as powerful plug-ins and commands. Photoshop's new paint engine adds dry and wet brush effects, including fine art media such as pastels and charcoal, as well as the ability to add special effects such as grass and leaves. There is also a live preview for viewing different brush attributes and behaviour, which can be then be saved as custom brush presets.

Using the *Healing Brush* allows artists to clean up photographs to be used as reference images by removing artifacts such as dust, scratches, blemishes and problems caused by overcompression. It will automatically preserve shading, lighting, texture and other attributes when cloning from one layer or one image to another.

The *Patch* tool works with selections and provides a more precise way to clone. With it Photoshop users can meld sampled pixels from 'clean' areas onto problem parts of an image. Users can also patch selections from the new *Pattern* pop-up palette in the options bar. This *Pattern Maker* plug-in allows the creation of realistic or abstract patterns by selecting a section of an image and generating a pattern that can be saved and used with several tools. Another plug-in in Version 7.0 is the enhanced *Liquify* tool, which now provides greater control over image warping, with ability to save meshes, as well as pan, zoom and multiple undo. A new *Turbulence* brush adds to the effect by mixing up the pixels in the image.

The *File Browser* allows the user to search, organize and retrieve images from all connected drives, viewing them as a series of thumbnails. The *File Browser* also displays images in a preview pane, as part of a *Tree* view and as metadata information, so speeding up the artistic workflow.

Phillip James used many Photoshop tricks to create his image *Beautiful Mind*, including working with text, layer effects, hue and saturation, patterns and textures.

ARTIST
PHILLIP JAMES
TITLE
BEAUTIFUL MIND

SOFTWARE USED
ADOBE **PHOTOSHOP**

The holographic light emitting from the head was made by using *Perspective* and *Free Distortion* on a circular pattern that had been created and exported as a tiff from Macromedia Freehand. Applying *Motion Blur* gives it an appearance of glowing light and movement.

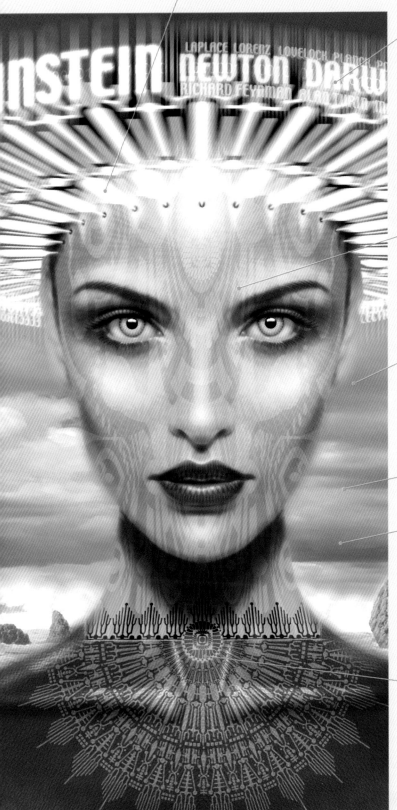

One way to create this 3D effect directly within Photoshop 7 is by using the *Warp Text* tools. Type a line of text and from the *Layer* drop-down menu look for *Type, Warp Text*. Here you will get options for distorting the text. Choose *Arch* and then manipulate *Bend* until the desired effect is achieved. The text stays editable after distorting, and a reduction in point size so that it becomes smaller towards both ends creates an impression of receding text.

Some of the patterns on the face were made with *Polar Coordinates*. To do this, create a new document roughly one-quarter the size of the image you need to cover, and fill it with black horizontal lines and circles of varying thickness and size. Apply one of the two presets in *Polar Coordinates*, duplicate the layer, double the size of your canvas and flip your new duplicated layer horizontally or vertically. Line it up with the base layer and when it's symmetrical, flatten the image. Repeat this duplication and canvas-sizing process until the pattern covers the designated image.

The chest, neck and some facial patterns were made in Macromedia FreeHand and then placed on the image using *Overlay* or *Multiply* with reduced *Opacity*.

Try working in greyscale and adding colour later with *Hue & Saturation*. First, convert your greyscale image to RGB Colour, and then in *Hue/Saturation* choose *Colorize*. After selecting the desired *Hue*, knock back the *Saturation* to about −80 or −90, depending on the effect you are trying to achieve. You can apply this method of colouring to different parts of your image with the aid of masks.

Here's another way to apply a dreamlike duotone effect to an image. First colour your main image with *Hue/Saturation*, then create a new layer set to the *Screen* blend mode at about 30% *Opacity* and fill this with a bright colour. (Supposing your main image is a desaturated blue, try red, orange or turquoise – the key is to experiment.)

Using your own digital pictures can save you a lot of time, effort and money trying to source an image. It also helps avoid copyright problems. With digital photography, you can take a shot, download it to your computer and have it placed in your image within minutes. Another good source of images and textures can be found on CDs of royalty-free images, which is where Phillip James found this sky background. The sky was stretched and faded to give it a more dramatic look. The rocks and sea were added separately from images taken with a digital camera.

If you have only a small area of texture to use over a much larger area try the *Rubber Stamp* tool. With this tool selected, Option+click (or Alt+click) the area of the texture you want to clone, then paint into the areas where you want to expand the texture. This creates a seamless texture as long as you keep choosing random areas of the original.

THE PHOTOSHOP STUDIO

PHOTOSHOP IS A MULTIFUNCTIONAL studio for the digital artist. Many use it in conjunction with other software, bringing elements into the Photoshop workspace, and then adjusting, resizing, distorting and compositing them to create a new scene from many disparate sources.

For this, the Photoshop artist's palette consists of a variety of specialized tools. The selection tools, also known as *Marquee* tools, allow rectangular, elliptical, single row and single column selections of the image, which can then be moved, cut or cropped. In addition, the *Lasso* tools make freehand or polygonal (straight-edged) selections, while the *Magic Wand* tool selects areas with similar pixel values.

Selections can be flipped, resized and distorted using the *Transform* tool, accessed from the *Edit* menu. This also allows the selection to be scaled, skewed or have perspective applied to it. Each transformation can only affect the selection at one time, but the *Free Transform* command allows them all to be applied simultaneously and in a freeform fashion.

You can smooth the hard edges of a selection by anti-aliasing and by feathering, both accessible from the options bar when using the selection tools. Anti-aliasing is useful when cutting, copying and pasting selections to create composite images as it smooths the 'jaggies' at the edges of a selection. It does this by softening the colour transition between edge pixels and background pixels. Feathering blurs edges by building a transition boundary between the selection and its surrounding pixels. This blurring can cause some loss of detail at the edge of the selection, but the amount of feathering can be set by the user down to the smallest pixel width. You can add feathering to an existing selection or define it when using the *Marquee*, *Lasso*, *Polygonal Lasso* or *Magnetic Lasso* tools.

There are also *Paint Bucket* and *Gradient Fill* tools for applying colour to large areas, as well as *Blur*, *Sharpen*, *Smudge*, *Burn* and *Dodge* tools. Built-in effects, such as the ability to manipulate colour, brightness and contrast, can all be accessed from the tool palette and are bolstered by

Landscape details and corrections to the clouds were made using Photoshop brushes as well as the *Blur* and *Add Noise* filters.

The position of the sun was indicated using the *Lens Flare* filter in Photoshop. Later it was merged and moderated to fit the composition. It forms a focal point for the image, to which the eye is ultimately drawn.

ARTIST
RICHARD MURRIN
TITLE
THE ARRIVAL OF SUMMER

SOFTWARE USED
ADOBE **PHOTOSHOP**

a multitude of plug-in filters. Among other things, these offer artistic, texture, distortion and lighting effects that include glows, spotlights and the highly popular *Lens Flare* effect.

Third-party filters are available as plug-ins from vendors that include Alien Skin Software and Flaming Pear. The latter creates plug-ins such as BladePro and SuperBladePro, which add textures, bevels and mirrorlike reflections to objects, while another, called Flood, can fill your selection with water.

Most of Richard Murrin's paintings are in oil or acrylic on canvas or board, although some recent work has been created digitally. In *The Arrival of Summer*, Murrin creates a stunningly realistic scene using a combination of a handpainted digital figure and a background created using Terragen from Planetside Software. The work was composited in Photoshop where extensive post-production then took place.

The landscape and sea were made using Terragen on a wide-angle setting to produce dramatic sky effects. This landscape had to conform to the illumination on the figure, whose position was crucial for the composition to work, just as would be the case with traditional media.

The figure itself was painted from scratch in Photoshop. Created at first on a large-scale canvas, it was then reduced in size. *Blur* and *Noise* were added and the *Smudge* tool was used until an acceptable finish was achieved. This stage of the process took about ten hours, which is still considerably less time than would be required for a similar image using traditional media.

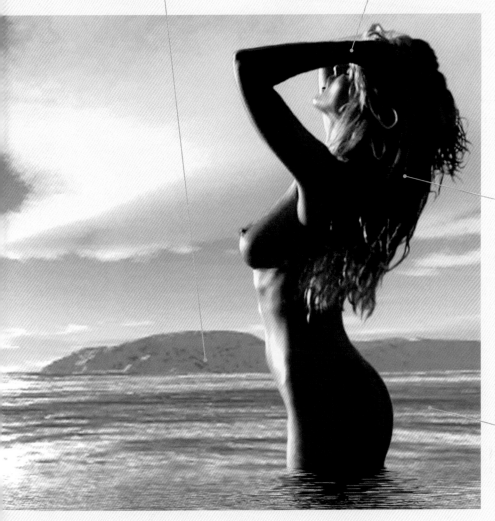

The figure was first painted on a separate layer, then moved onto the seascape background. Once in position, the layers were merged. The edges of the figure were softened by giving a three-pixel feather to an inverted selection of the figure layer and hitting Delete. Any loose parts were retouched using the brushes and *Smudge* tool.

The original Terragen water was altered using the Flaming Pear Flood Filter in Photoshop. The appearance of water was then corrected using the Photoshop brushes as well as the *Smudge* tool.

USING PHOTOSHOP

PHOTOSHOP'S BLENDING MODES ARE A VERY POWERFUL addition to any digital artist's toolbox. Blending functions can be accessed from the *Mode* pop-up menu in the tool options bar. They set the way that a tool such as the *Airbrush* affects the pixels in the image and include *Dissolve, Darken, Lighten, Multiply, Screen, Color Dodge* and *Overlay* modes among several others. Phillip James ably illustrates the *Overlay* mode in the following workthrough project shown here, where he demonstrates its use in building up the figure in *Automorphic*. When using *Overlay*, patterns or colours overlay the existing pixels while preserving the highlights and shadows of the base colour. The base colour is not replaced but is mixed with the blend colour to reflect the lightness or darkness of the original colour. The *Screen* mode used in the final step of the workthrough has a similar effect to projecting multiple photographic slides on top of each other.

ARTIST
PHILLIP JAMES
TITLE
AUTOMORPHIC

SOFTWARE USED
ADOBE **PHOTOSHOP**

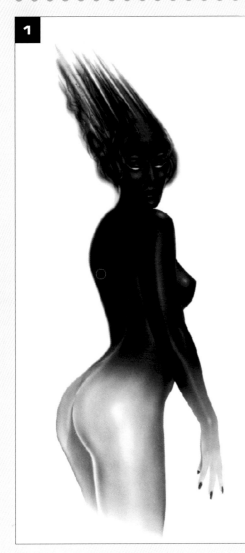

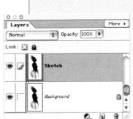

In Photoshop, open a sketch or a figure created in Poser and reduce its *Opacity* to about 50%. On a new layer using the *Airbrush* tool at about 25% *Opacity*, begin roughly sketching in your figure, keeping it loose at first. For this illustration try working in greyscale. You can add colour later with *Hue/Saturation*. Try using a large brush and concentrating on getting your tonal values right. Reduce the brush size and add more detail as you progress. A pressure-sensitive graphics tablet gives you more control of the *Airbrush* tool.

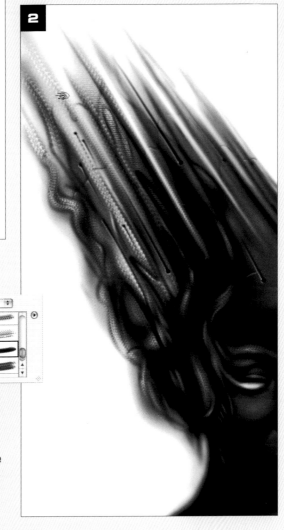

A tip for drawing straight fading lines in Photoshop using a pressure-sensitive pen is to select a brush, click once on the area you want the line to start from, and with slightly less pressure, Shift+click where you want the line to go. This technique was used on the head area. For the patterned lines on the head, use one or two of the pattern brush presets on a new layer set to *Overlay*.

On a new layer set to *Overlay* and *Opacity* set at 55% draw the body circuit lines. Try and follow the general shape of the figure. Through the use of *Overlay* on this layer, the white lines appear to pick out the highlights and recede into the shadows. For the straight lines use the *Brush* tool and the 'Shift+click' technique described on the previous page. If you use the mouse instead of a pressure-sensitive pen, your lines will remain the same thickness on the second click. For the circles on the hips, mark out your centre point with guides. Selecting a *Circular Marquee* tool, Alt+drag a circle from the centre point to varying distances from the centre and apply different stroke thicknesses. Remove areas you don't need with the *Eraser* tool.

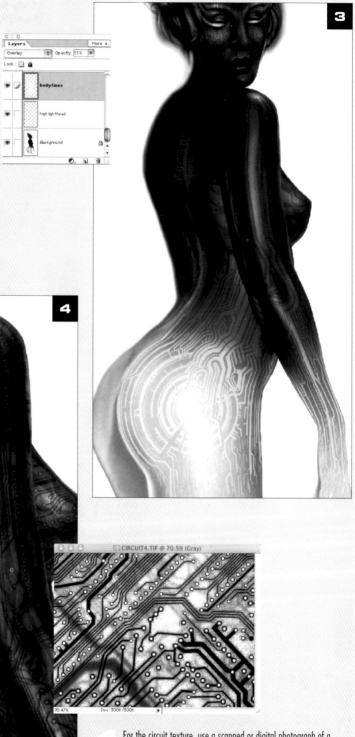

For the circuit texture, use a scanned or digital photograph of a circuit board or find some stock image on the Web. Convert to greyscale and in *Adjustments*, choose *Equalize* to give more contrast to your texture. If the image is small, duplicate it a few times and rotate it to follow the general shape of the figure. Merge all the circuit layers and set this layer to *Overlay* and reduce *Opacity* to 80%.

5

6

In a new document with the same width as your original but squared, choose the *Gradient* tool set to radial, with foreground set to dark grey and background set to white. Drag a radial gradient from the centre to the edge of the document. On a new layer set to *Overlay*, place a marble or rough stone texture at 60% *Opacity*.

7

Still in the new document, on a third layer place a circular pattern created in Macromedia Freehand or Adobe Illustrator and give this a slight *Gaussian Blur* to reduce edge sharpness. Flatten the layers and in *Image >Adjustments*, choose *Invert*. Drag this doctored image into your main document and place it behind the head of the figure.

For the background texture, take a digital photograph of a roughly plastered wall or paint a canvas with large strokes and thick-layered paint and then scan the most interesting areas. Flatten the image and adjust levels until you are satisfied with the results.

To add an unusual duotone effect, convert the greyscale image to RGB. You can then add colour using *Hue/Saturation*. Choose the *Colorize* option and slide the *Hue* around until a blue *Hue* is chosen, and reduce the *Saturation* until almost all the colour has gone, leaving a subtle blue/grey colour to the image. Make a new layer set to *Screen* at about *30% Opacity* and fill with a colour close to a rust red.

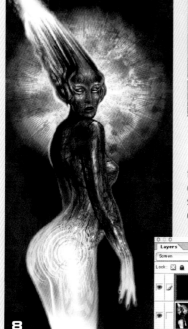

8

2D PAINTING

PHOTOSHOP IS NOT THE ONLY ILLUSTRATION SOFTWARE used in female character painting. There are countless others at a wide variety of prices and complexity. Many ship as part of a software bundle with scanners and pressure-sensitive tablets, while others come free with the operating system. Whatever the level, the traditional ways of laying down brush strokes and blending colours still hold true for the digital domain. However, the benefit of the new technology is that if you make a mistake there is no need to rip up the canvas and start again. In the age of the *Undo* command, we all have the opportunity to practice.

PAINTER

Like Photoshop, Painter is much more than just a single-purpose tool. This multifaceted application from Corel's Procreate division has championed the use of 'natural' media tools – such as digital representations of oil or watercolour paints, chalks, crayons and charcoal. It also allows the use of more exotic media such as liquid metal or fire. There are extensive brush controls and the *Image Hose*, a type of brush that loads images instead of paint. In this way you can load images of leaves, grass or anything else and apply them to a canvas in a stream, adjusting the angle and size of the component images by pressing harder with the stylus of a pressure-sensitive tablet.

With Painter, artists can use gradients, layers and fills, apply patterns, take advantage of the different properties of paper textures and replicate a host of painting effects.

Recent enhancements to the application mean that the unique diffusive properties of watercolour paints on paper can be closely emulated. Other new features include the ability to dynamically change the direction in which the watercolour paint 'dries' and the use of thick viscous ink as a medium.

PAINT SHOP PRO

A highly popular pixel-pushing application from JASC, Paint Shop Pro combines photo-editing with vector illustration. The software's *Picture Tubes* feature is similar to Painter's *Image Hose*. There is also an integrated image browser for all 50 supported image file formats. Layers, special effects, gradients, textures and patterns are all included in this alternative to Photoshop on the Windows platform.

COREL PHOTO-PAINT

Photo-Paint focuses on the manipulation, blending and merging of objects, but also offers facets of the layer-based system used by Photoshop and other applications. It offers customizable tools and advanced masking features. Other effects available are *Smart Blur*, which creates images with sharp edges and blurred contents, an interactive drop-shadow effect, a colour channel mixer and an image-sprayer tool similar to Painter's *Image Hose*. You can also use a 'lens' to apply a special effect to part of an image, repeat a special effect to intensify its result or fade an effect to diminish its intensity.

EXPRESSION

Like Painter, Expression is a natural-media creation tool. It has the added bonus, however, of also being a vector-drawing application that paints in natural media strokes. These can be edited in many ways. The software features list also includes paper textures, soft-edged and embossed fills, transparency control, object warping, clipping masks and blending modes, as well as support for Photoshop filters and Photoshop file export, complete with layers and alpha channels.

ARTIST
GREG BALDWIN
TITLE
ROBO CHICK

SOFTWARE USED
ADOBE **PHOTOSHOP**
COREL **PAINTER**

Painter's brush strokes can emulate natural oils much more closely than other software packages.

Painter's engine can now imitate the unique properties of watercolour paints on paper, allowing the artist to bleed colours together.

In order for the figure to appear 'alive', Baldwin here contrasts muscular tension with more relaxed areas. In the shoulder, the bottom of the deltoid is heavily defined because the tricep is in tension. This gives the illusion that the figure is holding up her own weight. In contrast, her stomach and legs are relatively relaxed, so little muscular tension is shown.

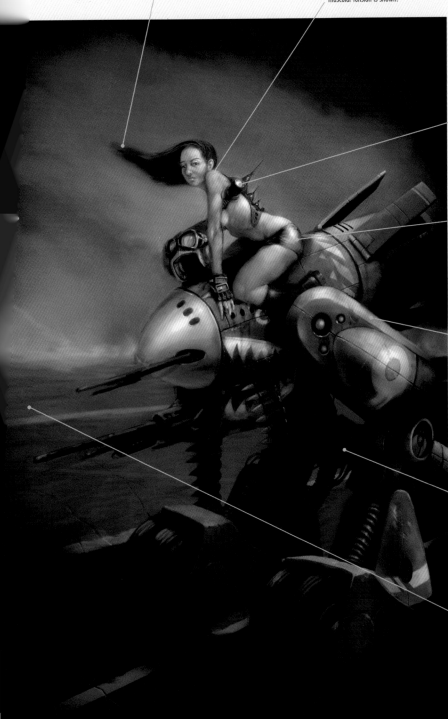

Here the brightest element in the image is established. Baldwin always creates the lightest and darkest elements in the piece very early on so that he can use them to gauge how bright or dark other elements should be. This helps him avoid mistakes such as making the highlight on some dark piece of metal brighter than it should be.

A combination of different brush sizes and forms in Painter can be used to get the effect you desire. For example, a fine brush can be used to add highlights and blend some of the background colours.

Where a surface, such as metal, is relatively smooth and plain, try to create as much imperfection as possible to give a greater sense of reality. This removes from digital painting much of the sterility that is all too easy to achieve. Painter's watercolour brushes are excellent for getting very painterly marks, which translate well as imperfections.

Here Baldwin has used a black silhouette on the robot's leg, allowing him to show a lot of detail without putting in a busy mess that may distract from the overall piece. Clear silhouettes play a very important part in keeping an image clear.

Baldwin uses lines quite frequently to break up vast planes of space, such as the ground plane represented here in the form of a runway. The lines on the ground provide both a realistic perspective and a graphic element he can use to control his composition.

CURIOUS LABS POSER

POSER SHOULD REALLY NEED NO INTRODUCTION to many readers of *Femme Digitale*, as the 3D character solution from Curious Labs is very widely used in this genre of digital art. Here we give an overview of the application in order to introduce some of the terms and conventions used in later sections of the book

The main reason for Poser's success is that it provides artists with ready-to-use human figures, capable of being posed in any position, then exported as a rendered 3D image, set up for animation purposes or used as part of an artistic composition in other software. Poser figures, which in the earliest versions were really little more than updated digital representations of the wooden models traditional artists use for figure studies, are now complex 3D characters made up of a polygon-rich mesh.

Models are loaded from the *Library* palette into the *Pose* room, which is the main working area of Poser. Figures consist of groups of body parts that can be individually selected and posed. Each body part is named and is referenced and controlled from the *Properties* and *Parameters* palettes, or you can directly pose the articulated parts using the Editing Tools palette. Poser uses a 'room-based' metaphor for the different stages of creating a figure – currently these include *Setup*, *Hair*, *Cloth*, *Material* and *Face* rooms. Lighting and camera controls are present in every room to allow the artist to adjust lighting properties and select and move the angle of the camera with which the figure is viewed in 3D space.

RANGE OF MODELS

Over 70 fully poseable and textured models now ship with the standard software. There are also add-ons from Curious Labs and third-party vendors that increase the number of models available to the digital-character artist. Poser itself ships with libraries comprising hundreds of poses, expressions, clothes, scene props, light sets and camera sets in order to build a scene around the models. These models can be given a personality and are highly customizable, using a variety of tools and geometric parameters.

Deformers such as magnets, force fields and waves all affect the body from the outside, distorting the body parts in different ways. All figures also contain internal deformers called morph targets – custom parameters that are assigned to each part of the body in order to give an artist control over their shape and form. Morph targets are represented as dials in the *Parameters* palette to give the artist precise control over their effect. Poser 5 adds the *Morph Putty* tool which allows artists to sculpt directly and control morph targets interactively, seeing the results in real time as they work.

APPLYING ATTRIBUTES

Lifelike skin and other material attributes can be applied to the figures using texture, bump, reflection and transparency maps. Texture maps can be those that ship with Poser's figures, created using an image editor like Photoshop or purchased from third-party vendors. The *Material* room in Poser 5 allows the use of shaders to create materials, adding a new dimension of node-based control for the colour, pattern and texture of objects in the scene.

Poser now also includes the *Face* room, where artists can create customized faces for their models and personalize figures with facial photo mapping. The *Hair* room is also new, allowing artists to add lifelike, dynamically-growing hair to the models. Similarly, the *Cloth* room can be used to create realistic dynamic cloth and make it flow and drape around any object in the scene.

ARTIST
DANIEL SCOTT GABRIEL MURRAY
TITLE
DEADLY CHINA DOLL

SOFTWARE USED
CURIOUS LABS **POSER**

The eyes can be posed using either the *Editing* tools or by accessing the *Current Actor* pop-up menu and positioning them using the parameter dials. Here, shadows and bright white reflections were added in Photoshop and the irises were adjusted with *Dodge* and *Burn* to add depth.

Human figures in Poser have fully articulated faces, allowing artists to select and position facial muscles such as the mouth or cheeks to create a certain expression. Either parameter dials or the new *Morph Putty* tool can be used for this purpose.

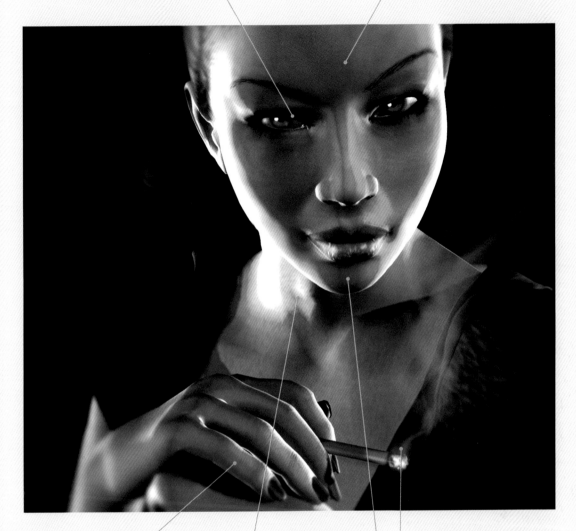

Many Poser figures have fully articulated hands. Hand poses can be applied from the Library palette or posed using the *Editing* tools just like any other body part.

The model was set in Poser using only three lights. Two bright white lights were placed behind the head and a 35% white was positioned in front of the face.

Some Poser models contain ethnicity morphs to apply a more ethnic feel to characters. The morph target loads automatically when the character is loaded into the *Studio* and contains an *Ethnicity* parameter dial.

Post-production of this image in Photoshop included colour removal to achieve a 'film noir' look. The image was rather flat, so contrast had to be adjusted to advance the highlights and drop back the shadows. A cigarette and airbrushed smoke were added to build atmosphere and a soft focus blur was applied to the entire image.

RENDERING IN POSER

Rendering has never been Poser's strong point but the new FireFly rendering engine may change that. This hybrid micro-polygon and ray tracing render engine offers subdivision surface rendering of polygons and supports procedural shaders. With this in addition to the Poser 4 rendering engine, Curious Labs claims that artists can achieve breathtaking results.

Daniel Scott Gabriel Murray is a prolific artist who uses Poser extensively in conjunction with other software such as Painter, Bryce and Photoshop. He usually sets and poses his figures in the main application, then exports the rendered scene for post-production work. In the case of *Deadly China Doll*, he turned to Photoshop in order to add atmosphere.

MID-RANGE 3D

POSER IS NOT THE ONLY APPLICATION you can use to get 3D figures into your artwork. There is a wealth of software out there to provide you with opportunities to build realistic female characters and props out of nothing more than polygons and texture maps.

AMAPI 3D

This modeller from Eovia offers a wide selection of tools to create and sculpt in 3D. A polygonal and NURBS object-based modeller, it incorporates technologies such as subdivision surfaces and Dynamic Geometry and supports formats such as OBJ, DXF and VRML. It has a powerful renderer and a large selection of advanced modelling tools such as polyhedral constructions, multiple extrusions and sweepings, smoothing tools, chamfers and Boolean operations. Although heavily used in product design, it can also be used extensively in creating props and character models.

CARARRA STUDIO

Eovia's Cararra Studio is an affordable high-quality 3D environment with high-end features such as photon maps and global illumination rendering, Bones and subdivision modelling. Carrara features five rendering engines, seven different modellers (and multiple animation tools), an advanced shader editor, special effects, sky environments and over a thousand 3D models and textures. The package splits the modelling process into rooms, presenting the user with an open, customizable workspace. Workspace elements, tools and controls are task-sensitive. The multiwindow working box and pull-out storage drawers will be familiar to users of other high-end 3D applications and Poser.

The *Assemble Room* is the main workspace to build the elements for a project. Object primitives, spline objects, vertex objects, lights, text, environmental primitives, volumetric clouds and metaballs – all can be added by dragging into the scene. The *Assemble Room* also offers the ability to add physical forces and properties to objects.

The other rooms offer the facilities one would expect from high-end 3D – a *Shader* tree in the *Texture* room; spline, vertex, metaball, subdivision and text modellers in the *Model* room.

Carrara is able to compute the global illumination of a whole 3D scene, as well as render features such as photon maps, phong shading, reflection, refraction, radiosity, caustics, area light emitters, sky dome illumination and environment illumination. The results are very impressive indeed.

CINEMA 4D

Cinema 4D by Maxon is renowned for its rendering and lighting, especially its fast ray tracing. It supports subdivision surface modelling and it features BodyPaint, a 3D painting component that allows paint to be applied to an object's mesh in real time, including in *Raytrace* mode. Cinema 4D also features a comprehensive set of polygonal modelling tools to manipulate the points, edges and polygons by extruding, bevelling, cutting or other similar operations. The interactive tools can be used by dragging the selection in the workspace or by adjusting parameter values, while different shaded, wireframe or X-ray views of geometry can be used throughout the modelling process.

LIGHTWAVE 3D

Lightwave 3D by NewTek is one of the most popular mid-range 3D applications around. It's a modelling, rendering and animation tool featuring subdivision surface modelling and advanced rendering facilities but is priced within reach of the professional digital artist. Lightwave is, in reality, two separate

ARTIST
CHRISTINE CLAVEL
TITLE
NEREIDS, NYMPHS OF THE SEA (DETAIL)

SOFTWARE USED
ADOBE **PHOTOSHOP**
CURIOUS LABS **POSER**
COREL **BRYCE**
COREL **PAINTER**

applications. Layout is mainly used in animation, but both it and Modeller are used in the process of creating artwork. Lightwave has long been praised for its excellent lighting system and rendering engine and the modelling tools are fast and comprehensive enough for most tasks.

Highlights includes radiosity, ray tracing and caustics, HyperVoxel volumetric rendering, basic hair and fur rendering, a powerful spreadsheet for tracking object parameters, a sky rendering system called Skytracer and Digital Confusion – an image filter that adds realistic depth-of-field rendering effects.

ZBRUSH

ZBrush by Pixologic features a collection of 2D and 3D painting, texturing and modelling tools. Powered by a real-time rendering engine based on proprietary Pixol rendering technology, ZBrush enables artists to paint an image by applying both 2D and 3D effects in an integrated real-time workspace. Artists can paint with colour, material, texture and depth; push and pull the canvas; and sculpt and texture 3D models. Recent enhancements include a 3D modelling tool called the ZSphere, new painting and sculpting tools, enriched texturing features, enhanced lighting and rendering options such as *SoftShadows* and a customizable streamlined interface. Users are also able to create both high- and low-polygon meshes with UV coordinates automatically assigned. The mesh can be textured and incorporated into a ZBrush composition using the integrated TextureMaster tool. The low-polygon meshes can also be exported to other modelling programs, or used in real-time applications such as game development.

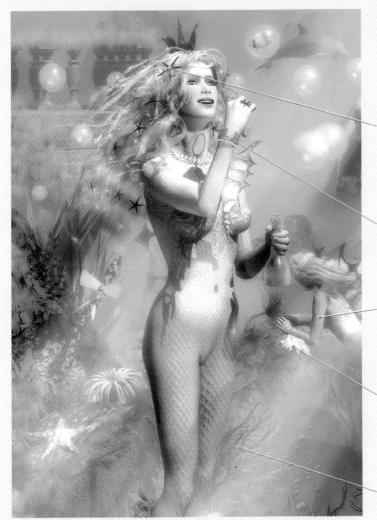

In this detail of the *Nereids* painting by Christine Clavel, several different software packages were used to create the submarine inhabitants and their underwater world, including Amapi 3D, Photoshop, Bryce, Painter and Poser.

The starfishes in the Nereid's hair were created with Amapi 3D from Eovia and Amorphium from Electric Image, as was the coral.

The bracelet was modelled with Amapi and Bryce and formed the basis for other jewellery accessories.

The figures were created in Poser and the whole image was set up and rendered in Bryce.

Some of the undersea scenes, props and figures come from the online stores of Dan Cortopassi and Mitch Janssen. (See Sources section for details.)

The plants here were made with Amapi 3D and Amorphium, another 3D modelling tool that can handle subdivision surfaces for accurate sculpting.

HIGH-END 3D SOFTWARE

FOR 3D MODELLING AT THE LEVEL demanded by the film, game and television markets, you need a high-end solution. Artists working in this field have a variety of powerful applications to choose from, but those involved in creating female characters seem to prefer 3ds max from Discreet and Maya from Alias|Wavefront over other competing packages.

3DS MAX

3ds max features a fast and powerful toolset for a variety of modelling, animation and rendering solutions. It allows artists to model splines, polygons, polygonal mesh, Beziér patch or relational NURBS surfaces in direct or procedural mode, and offers hierarchical subdivision surfaces modelling and a variety of surfacing, texturing and mapping tools. The software also features advanced splines-based patch modelling, enabling the creation of complex characters. Max ships with a *Material Editor*, a number of pre-defined shaders and over 30 procedural 2D and 3D maps and has the power to combine an unlimited number of textures. It also offers an unlimited number of objects, cameras, lights, materials, maps, modelling history and rendering effects and has no limits on geometry or scene size.

The interface has the four-window setup common to many other 3D applications. These are known in 3ds max as viewports and normally correspond to the traditional drafting views of top, front and left with the fourth being a perspective view, although each can be customized to show any view. In addition, users can set up any of the viewports to provide the view from lights and cameras and objects can be viewed in several different shading and surface mapping modes. An interactive and photo-realistic ActiveShade render engine allows users to run quick rendering previews in the viewports, updating the scene whenever lighting or material changes occur.

3ds max supports plug-ins for advanced add-on effects and the creation of components such as atmospheric features and hair. The application can also accept and add in scene components and effects from other applications, such as Photoshop, making it a very versatile tool and a good way of moving up from 2D image editing.

MAYA

A favourite of the film and games development industries, Maya is a highly versatile piece of 3D modelling, painting, animation and rendering software. It features polygon, NURBS and subdivision surface modelling, as well as surface deformers. It has an accurate system for simulating digital clothing and fabric and another for styling and rendering short hair. Maya also features Artisan and 3D Paint for digital sculpting and painting textures and attributes onto NURBS and polygons, as well as Paint Effects for creating 3D scenes or 2D canvases with a high degree of realism and complexity. Paint Effects features an array of advanced brush types, such as *Natural Media* (for example chalk, oil and pastels) and *Effects*, which include whole trees, hair, eyebrows and even beards. There are also special-effects brushes which create lightning, clouds, rain, star fields, fireworks, fire and sparks.

With a highly customizable interface, Maya's workspace can be divided into multiple panels and floating menus. It features a node-based system architecture, where node attributes control and determine the shape, position, shading and construction history of all objects. A shader editor, HyperShade, allows the user to create complex shader networks such as skin, dust and rusty surfaces, while the Visual Outliner component offers a selection of libraries of textures and image swatches. Maya uses selective ray tracing for rendering and features

ARTIST
ALCEU BAPTISTÃO
TITLE
KAYA

SOFTWARE USED
ALIAS|WAVEFRONT **MAYA**

Interactive Photo-realistic Rendering (IPR) to provide instantaneous editing of colour, texture, lights and other effects.

For illumination, there are point, spot and area lights as well as realistic glows, fogs, lens flares and atmospheric effects. In addition, the application features 3D motion blurs and depth of field for photographic realism. As well as a custom scripting language, it can import and export many common and specialized file types and geometry. Maya has one other key advantage for Mac users: out of all of the very high-end 3D packages, it is the only one that is available for the Mac platform as well as Linux, IRIX and Windows.

KAYA'S FACE BUILT IN MAYA

Alceu Baptistão, partner and director of the Brazilian visual effects company Vetor Zero, created Kaya almost entirely in Maya. Apart from the teeth, all the modelling, shaders and lighting were created using only the basic software with no plug-ins or proprietary software. Although still a work in progress (Baptistão intends Kaya to be a fully animated character), incredibly realistic detail can already be seen. Baptistão created the face with polygon modelling and used polysmooth to create lifelike surfaces. Textures were spherically projected and hand-painted in Photoshop and a simple layered shader was used to create the skin. For lighting, Baptistão used ray tracing and a simplified version of the SkyDome light set, with some additional directional lights. You can see the animated work in progress at http://www.vetorzero.com/kaya

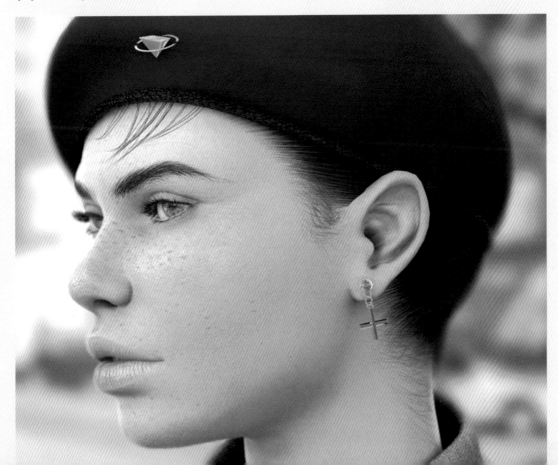

SCENE SETTERS 1

ONCE YOU HAVE YOUR MODELS AND FIGURES CREATED, posed and textured, it's time to place them in your scene. Although you could just paint or import a background in Photoshop, there are a number of applications that can create whole 3D worlds for your characters to inhabit. Most of these applications ship with CDs full of scene elements and accept files imported from packages such as Lightwave and 3ds max. All you need to do is start creating your world.

MOJOWORLD GENERATOR

Pandromeda's software models and renders entire fractal-based planets. Worlds can be created at unlimited resolution thanks to the mathematical nature of the software, with amazing atmospheric effects. As well as landscape features such as river networks and lakes, MojoWorld can generate multiple moons with 3D relief as well as cloud and sky textures.

All standard primitives and 3D operations are supported while the application can export 8- and 16-bit height fields with textures to many file formats.

NATURAL SCENE DESIGNER

This is an easy-to-use application from Natural Graphics that allows you to design, render and animate natural outdoor scenes. It features advanced algorithms for creating realistic natural outdoor scenes with trees, clouds, rocks, bushes, lakes, atmospheric effects, imported 3D objects and snow. 3D terrain models can be imported or created randomly from fractal mathematics and the settings for the sky, clouds, water and lighting added. The software ships with nearly a thousand high-resolution 3D terrain models and can also import files from the US Geological Survey to create scenes.

TERRAGEN

Terragen is a highly acclaimed scenery generator that, at time of writing, is a 'work-in-progress' and can be downloaded free for non-commercial use. It features an intuitive user interface and an extensive terrain-sculpting toolset. Sunsets and sunbeams, three-dimensional clouds, realistic water effects, mist and fog, night scenes and moonlight are all possible, while the powerful rendering engine allows foreground texturing in high detail, Terragen can export terrains in VistaPro-compatible format and as Lightwave 3D object (LWO) files. You can also create greyscale images in a normal paint program and import them into Terragen as landscapes.

VUE D'ESPRIT

Eon Software's Vue d'Esprit is a 3D scenery, animation and rendering tool using a layer-based system to organize objects in the scene. It features the four–window view familiar to users of high-end 3D packages and supports ray tracing and other rendering techniques. For scene creation tools, Vue is up there with the best of them, containing technology such as SolidGrowth2, a realistic tree and plant creation and rendering technology, which makes every plant unique. Similarly, the *Terrain Editor* uses Solid 3D to give you real-time previews of your landscape as your model it.

Vue also concentrates heavily on the volumetric properties of scene components (that is, the whole volume of the object not just the surface). Thus you can create realistic fog, smoke, dust, spray, fire and so on without the need for a particle system. Vue's atmosphere system also uses the volumetric approach to create highly realistic skies. Throw in the high-quality lighting system (including ray tracing) and the ability to animate scene elements and you've got a very powerful package indeed.

Shannon Howell created *Wasteland Warrior* mainly using Vue d'Esprit 4.0. Howell says that as well as the realistic atmospheres and vegetation provided by the software, the ability to import Poser 4 files alone makes this software invaluable for creating realistic 3D scenes

The atmosphere in the scene was created using Vue d'Esprit 4's built-in volumetric atmospheres. They give a highly realistic effect when creating a scene. They are also customizable so that you can create your own unique atmosphere.

The vegetation in the scene, including the plants and trees, was created using the built-in vegetation editor, SolidGrowth2. The editor has a preset list of plant life you can use, each item of which is very realistic.

One of Vue d'Esprit's most powerful features is the Poser 4 PZ3 file import. With it you can import models that were posed in Poser 4 and use them in your scenes with textures already on the model, which really speeds up your workflow.

The terrain in the scene was created automatically using Vue d'Esprit 4's built in *Terrain Editor*. The terrain is also directly customizable for times when you wish to tweak parts of the scene to fit the mood of your image.

The rocks were created using Vue d'Esprit's random Editor for Rocks. Each of the very realistic rocks created in this fashion changes in shape and form as new rocks are created, so allowing for many different styles.

The lighting effects were created in Vue d'Esprit using point lights. You can apply volumetric effects to these to create a more realistic scene by changing the light colour, intensity of the light, and more.

SCENE SETTERS 2

ANIMATEK WORLD BUILDER

This application by Digital Element is a traditional four-window 3D package for landscape generation, which has many interface similarities with 3ds max. It has strong integration with Discreet's software via a plug-in and also supports Poser figure import. Extrapolating mountains and hills from simple lines drawn on the landscape creates terrain. Water, vegetation and 3D objects can all be added to the terrain, which is highly editable at all times.

Digital Element has also developed a Photoshop plug-in called Aurora that allows artists to create natural environments, such as volumetric skies, clouds, oceans, lakes, rivers and stars, without leaving the image-editing application.

WORLD CONSTRUCTION SET

World Construction Set is a photo-realistic terrain visualization application from 3D Nature. It features a modular architecture to create images with unlimited terrain, detailed ecosystem combinations, naturally accurate skies, precise landscaping of trees and foliage, 3D objects, moving water, randomized star fields, volumetric atmospheres and multiple cloud models. It features OpenGL interactivity and previews as well as several rendering options that include High Dynamic Range output. Simple one-click positioning can put a sun or moon in the sky exactly where required and multiple celestial objects can be added at one time. Terrain and object data can be imported easily and the application supports many 3D file formats, including Terragen, Bryce, Lightwave, Poser and 3ds max files.

BRYCE

Bryce from Corel is primarily a landscape creation tool with excellent environmental effects, but it is so heavily used by digital artists that it deserves more than a brief mention. Bryce has an intuitive interface consisting mainly of a screen-filling working window where the objects in a scene are planned and positioned. Tool palettes and menus update dynamically for each task, while various view and camera controls mean you can navigate easily

through the 3D space. There is also a preview window for viewing small rendered versions of the scene in progress.

Bryce features controls for creating skies, where the user can set the number, shape and direction of clouds, sky colour, light direction and atmospheric effects. A *Terrain Editor* can be used to create custom terrains and natural elements such as rocks and water can easily be added to create landscapes. The *Materials Lab* is a powerful tool to add realism to a scene, allowing the user to apply combinations of textures and channel values to simulate materials. A recent release has added more authentic and controllable lighting features, enhanced rendering and a *Tree Lab* that enables users to create realistic tree objects in a scene.

Bryce uses ray tracing algorithms to generate high-quality 2D images and is also widely used as a renderer for scenes built up in other packages such as Poser. It uses multiple-pass rendering to generate an image from a 3D view and, depending on the complexity of the scene and the power of your computer, this can take quite some time. The first pass renders the image in large pixel blocks, then successively refines them with each pass. The final pass, usually the most time-consuming, is used to apply anti-aliasing to the image.

The software offers several rendering modes to create different effects. For instance, the *Object Mask* rendering mode renders selected objects as white anti-aliased shapes on a black background. The resulting mask can be exported to 2D painting applications as an alpha channel.

Apart from its ability to create 3D landscapes quickly and easily, Bryce now contains some object-modelling capabilities. Its users can now also model using Metaballs – sphere-based objects – to create organic shapes, in addition to its more traditional method of manipulating primitives. The software ships with a host of preset values and objects with which it is easy to create an advanced scene. However, every aspect of Bryce is capable of being customized, allowing artists to create the most alien of worlds or the most realistic of environments.

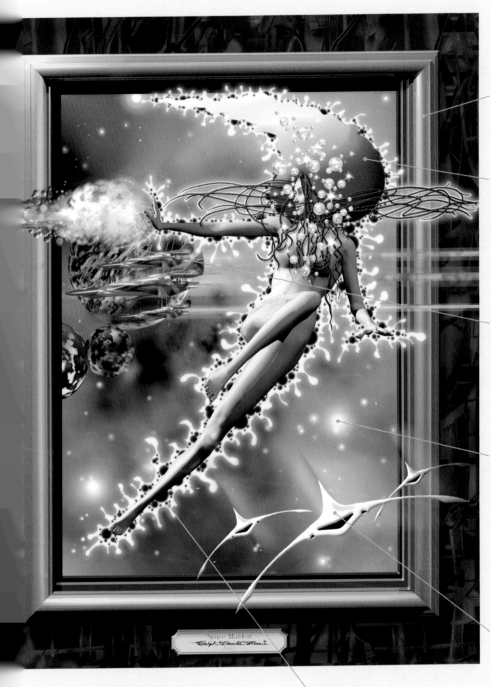

This gold frame was created with Bryce, utilizing a symmetrical lattice and the *Terrain Editor*, with a slice of the frame created in Photoshop and imported through the pictures tab.

The special effects in this painting were created in Photoshop using many layers, as well as the *Paintbrush, Blur and Lasso* tools.

Spaceships are complicated to build, but planets can be modelled and textured easily with Bryce.

In Bryce, the space background was created inside a transparent reflective sphere with a cloud material and multiple radial lights bouncing off the inner wall of the sphere.

The 3D spaceships were created in Bryce but rendered in Photoshop using alpha channels as well as *Gaussian Blur* and *Lighting Effects* filters.

For *Space Maiden*, Ralph Manis created the body of the stellar traveller with Poser, but the starfield, background, frame and spaceships were all created and rendered in Bryce 3D. Special effects were added with Photoshop. This is a digital version of a painting Manis created in the 1970s.

Using Bryce, artists can create some wild special effects with the *Deep Texture Editor* and by using the *Volume* materials.

PEOPLE, PLUG-INS AND PROPS

SOMETIMES CREATING YOUR DIGITAL WOMAN can be only the start of the artistic process. What if you wanted to go further than the models that ship with Poser, or create realistic hair in a high-end 3D application like 3ds max? The answers to your creative dreams can all be found in the commercial market in the form of add-ons and plug-ins for the various popular applications.

PEOPLE

Many of the Poser artists in this book are firm devotees of DAZ Productions. This company specializes in providing high-quality 3D models that have been created using digitized and photographic references from live models. The figures, for Poser and other 3D software applications such as Lightwave, are sold through the DAZ online store, which also hosts third-party textures and objects.

DAZ offered more than the usual Poser figure models when it introduced its Millennium range of character models. Its Victoria figure is made up of over 28,000 polygons, with over 90 morph targets (parameters to reshape objects) in the head to allow facial changes to account for mood, ethnicity and character. Victoria 2.0 came along next, offering more versatility with over 100 new morph targets to change face shape and expressions. Victoria 2.0 also provided several options for tweaking physique, age, weight, height and ethnicity.

Following this model came Stephanie, a figure loaded with 169 head morphs, 45 full body morphs and 71 partial body morphs. Although compatible with Victoria's clothing and accessories, Stephanie is able to take advantage of strategic mesh resolution, which allows for extra versatility, such as independent muscle morphs. The latest girl on the block is Victoria 3.0, a model comprising 74,510 polygons. The third incarnation of Victoria features more strategic resolution, smoother joint rotation and morph deformation, as well as new pose technology called morph injection poses.

Photo-realistic texture maps are available for all the figures, as are clothing and equipment sets.

DAZ is not, however, the only character creator. Others, such as Zygote Media and Dacort, also provide quality Poser models to take the figure design tool that one stage further.

PLUG-INS

Plug-in modules are software programs in their own right that take the form of filters or add-ons to major applications. They can be used to add atmosphere, a finishing touch or a completely outlandish feel to an image.

There are many thousands of plug-ins available for all sorts of applications, ranging from distortion filters for Adobe Photoshop to hair effects for 3ds max. Once installed, plug-in modules usually appear in the *Filter* submenu and other parts of the main application interface.

KPT Effects, the latest addition to the Kai's Power Tools family, is developed by Corel for its procreate brand. It features effects such as an image 'liquidizer', fractal effects, texture and pattern tools. Also from procreate is KnockOut, a tool for quick and highly accurate masking. With it you can 'knock out' fine detail like hair more easily than you can with the ordinary tools found in image-editing packages. It can define multiple alpha channels, so users can create masks for shadows, for example, while avoiding other background elements.

Cinematte from Digital Dominion is another plug-in for Photoshop that allows blue and green-screen compositing of objects or people into stock photographs, 3D rendered backgrounds and more. Defocus Dei by Blackfeet is a plug-in compatible with 3ds max and Lightwave that gives the impression of putting things out of focus, thus giving the scene a greater sense of photographic reality.

PROPS

Props can be attached to 3D models in a parent and child hierarchy, with the result that when the model is moved, the hair, clothing or other prop moves with it. Zygote Media has a large amount of props ranging from animals to weapons, all

available in either 3ds max or Poser-compatible OBJ formats. Shag-Fur and Shag-Hair by Leapfrog are 3ds max plug-ins that create the behaviour of fur, hair and other follicle shapes, while Druid by Sisyphus Software is a tree and grass creation plug-in for 3ds max that delivers fantastically realistic results. Many other props can be found as 3D objects from companies such as DAZ Productions or from vendors selling their own props on websites, such as Renderosity or 3D Café.

Props like this pistol from DAZ Productions can be added to the figure by selecting from the Libraries palette. They then are tied to the main figure through a hierarchy.

Victoria 2.0 from DAZ Productions is a high-polygon figure for use in Poser. To create her realistic texture maps, she was mapped from digital photographs taken of a live female model.

The catsuit is matched to the body of the main figure by selecting the *Conform To* command from the *Figure* menu. In this way clothing can be posed in the same position as the figure.

The Parameter dials for the head of the Victoria 2.0 model show a large variety of morph targets for ethnicity and facial expression.

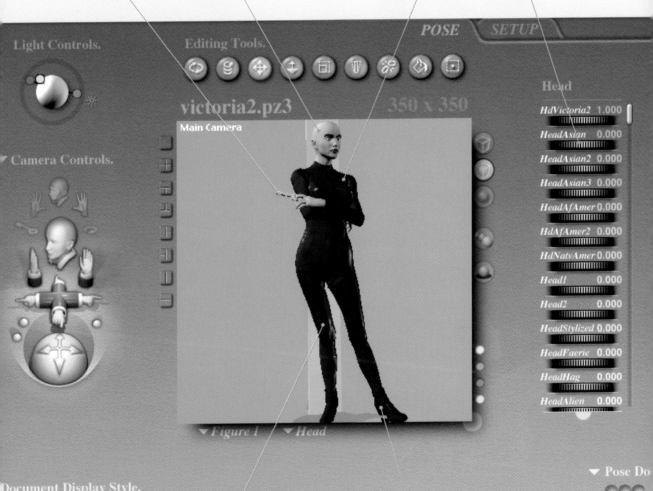

Poser includes a whole library of clothing to dress your figures. However, third-party characters such as Victoria 2.0 often have their own wardrobes specially made, as in the case of this catsuit.

Sometimes the clothes do not quite fit. In the case of the boots here, the underlying skin on the foot, which was shining through, was made invisible by accessing the elements properties in the *Object* menu.

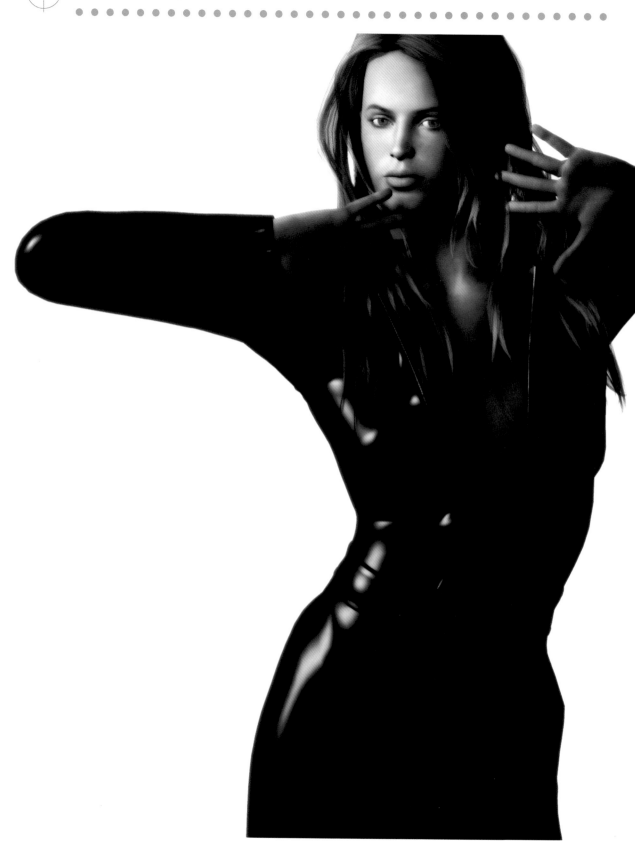

BUILDING THE BODY

HAVING THE RIGHT SOFTWARE IS ONLY THE BEGINNING. YOU NOW NEED TO LEARN HOW TO USE IT. THE FOLLOWING PROJECTS ARE INTENDED TO THROW YOU RIGHT IN AT THE DEEP END OF 2D FIGURE PAINTING AND 3D CHARACTER MODELLING. SOME KNOWLEDGE OF 3D TERMS AND PRACTICES IS REQUIRED IN SOME PLACES, BUT OTHER PROJECTS CAN BE ATTEMPTED BY ANYONE WITH A FAIRLY BASIC KNOWLEDGE OF ADOBE PHOTOSHOP. THIS SECOND SECTION FOCUSES ON BUILDING THE FEMALE CHARACTER. WE START IN A 2D PAINTING SETUP AND THEN MOVE ON TO CREATING DIFFERENT ASPECTS OF THE FEMALE BODY IN 3D, INCLUDING BUILDING A COMPLETE CHARACTER. MOST OF THE SOFTWARE USED CAN BE PURCHASED OR DOWNLOADED AS A DEMO FROM THE COMPANIES LISTED IN THE SOURCES SECTION AT THE END OF THE BOOK.

ARTIST
ELLIE MORIN
TITLE
PHOTO SHOOT

BUILDING THE BODY IN 2D

FIGURE PAINTING IN 2D can be achieved in many different ways but an effective technique used by Michael Yazijian is to emulate the traditional method of building up thin layers of paint. Yazijian's personal preference is to limit the use of layers to keep the painting as fun and traditional as possible, and also for the reason that he finds using too many layers can get a little distracting. Here he describes how you can use this technique to produce finished artwork that more resembles an oil painting than a digital image, as in *Vampire*.

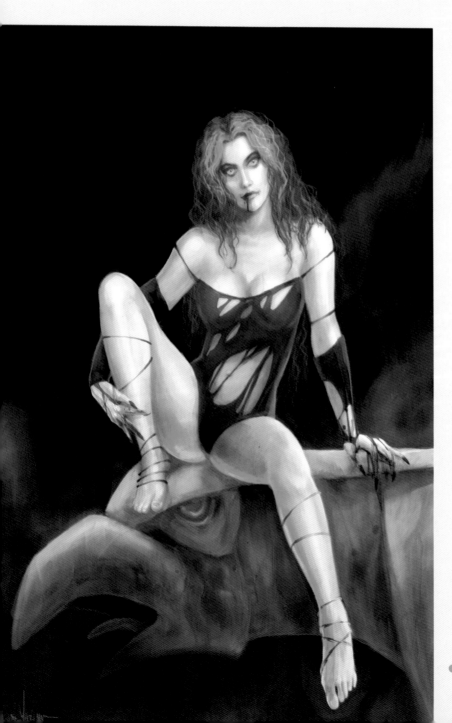

ARTIST
MICHAEL YAZIJIAN
TITLE
VAMPIRE

SOFTWARE USED
ADOBE **PHOTOSHOP 7**

ADDITIONAL HARDWARE
WACOM
PRESSURE-SENSITIVE TABLET

1 Prepare a sketch or drawing either by hand or using a Wacom tablet. Once you are satisfied with your line artwork, scan it at 300 dpi as a greyscale TIFF, then import into Photoshop and convert it to an RBG Colour and adjust the *Brightness* and *Contrast* settings. *Colorize* the image to a warmer shade of grey.

2 Create a new layer, *Fill* it with a tan or light sienna colour, and use it as *Multiply* on top of the line art layer. Then *Flatten* the image. This technique will give you similar results to traditional tinted drawing paper. Next, start establishing your highlights and shadows by using *Dodge* and *Burn*. These tools work really well when used in moderation. But be careful not to overdo it since you might end up losing your mid-tones.

3 Start blocking in the background in order to concentrate on the main figure. Use the *Brush* tool set on *Multiply* (20-40%) to darken some of the areas like the hair and the clothing. Use the *Brush* tool set on *Screen* to pick up some highlights. Establish your darkest and lightest values. Pick an area of the painting and spend some time refining it. Then bring the rest of the painting up to the same level of detail.

One of the great features of Photoshop 7 is the scalable *Brush* tool. Experiment with different brush types and settings. Pick a brush you enjoy working with, set it on a 70 to 80% pressure, and lay down some skin tones. Lay down a medium hue of colour for the skin tone (for example R: 206, G: 151, B: 112) then use the lighter and darker values for your highlights and shadows. Avoid going too thick with your paint so as not to lose the line work underneath. Use the highlights and shadows you established earlier on to guide you when using thicker layers of paint.

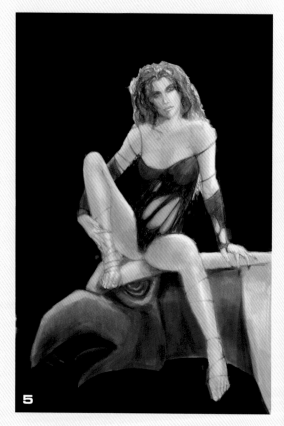

Finish blocking in the background. At this point you may want to select the main figure, and copy and paste it into another layer to work on it separately from the background. Alternatively, simply keep everything onto a single layer.

Tip: Always keep a recently numbered save of your work (vampire1, vampire2, etc.) in case you don't like the direction you are going with your painting and decide to go back a version or two.

Build up the intensity of the colours by increasing your brush pressure. This way you can slowly get thicker layers of paint. Add colour to the background, in this case a hellish red to complement the mood of the painting.

Tip: With the *Brush* tool selected, use the "[" or "]" keys on your keyboard to quickly choose a smaller or larger brush.

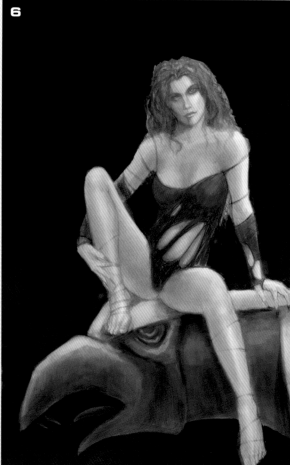

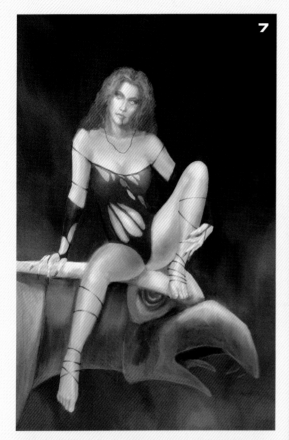

7 Flip the painting horizontally and sometimes even vertically, to detect flaws in your work. Make the necessary corrections. Do this as frequently as you wish in order to make sure all the elements look right. As you get closer to completing your painting, get rid of any traces of your line work.

Work all over the painting, alternating between the background and foreground. Add more red to the background. Use yellow ochre and desaturated green as a cooler colour. Add another layer to add more detail to the hair.

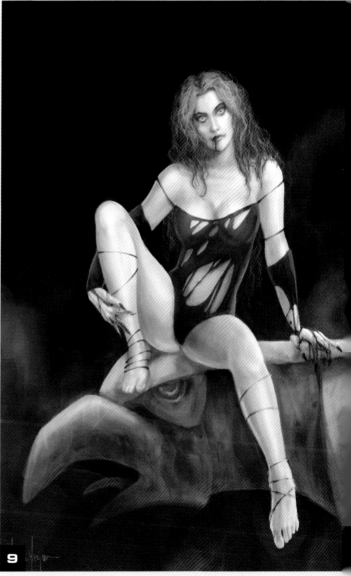

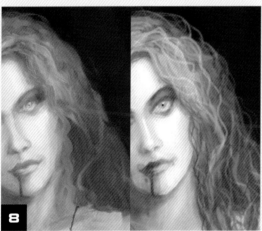

8 To create realistic hair, use a hard brush, (about 80% pressure) and lay down some uneven strokes. Use dark colours such as brown, then work up to lighter oranges and reds for the mid-tones and highlights. Occasionally use the *Blur* tool to soften some of the finer strands of hair. Darken the existing layer of hair, then add more hair on top of that. Repeat this a few times until you're satisfied with the results.

9 Now add texture detail to the gargoyle. Make a small brush and draw fine cracks and dirt spots to simulate a stone texture. *Flatten* some or even all of the layers (depending on how comfortable you feel painting on a single layer) and unify the colours by adjusting the *Brightness* and *Contrast* settings and adding touches of highlights on the brightest areas of the figure.

CREATING A HEAD IN 3DS MAX

ANATOLIY MEYMUHIN LIKES TO DEVELOP a sense of atmosphere in his artwork and, as is evident from the characters in *Amazon*, fantasy is his favourite subject. Unlike many of the artists in this book, he uses spline modelling in 3ds max, but like others he draws on the classic techniques of painting and photography. Always building the models from scratch in 3ds max or reusing his previous creations, Meymuhin limits any postwork in Photoshop to minor blur and depth of field effects, mainly due to the fact that he renders his 3D scenes from ten different angles. Here he explains how he created *Amazon*.

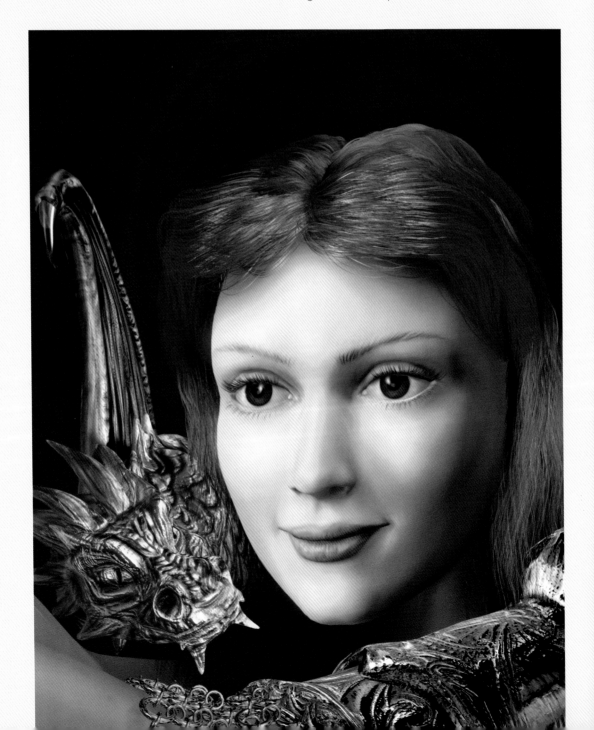

1

I began by scanning a reference image (front and side view) into 3ds max and loaded it in the right and front viewports. You can place any bitmap (JPEG, TIFF, BMP, or other) object in 3ds max by one of two ways — as the background of any viewport or as a texture applied to the *Plane* object (the *Plane* object must have the same *Width* and *Height* parameters as the reference image). The latter method was used here.

I next selected the *Line* tool from the *Create* panel and in the right viewport traced the contour of the head with a low number of connected points (or vertices). You don't have to be too accurate when you do this, as you can correct and add new points later with the *Modify* panel and *Vertex Selection*.

2

3

Changing to the front viewport, I followed the shape of the face with another line of connected points (a spline). I did the same for the shape of the eye, then again to build the nose and mouth splines. All the splines were grouped together using the *Attach* function, and the new spline was renamed 'Amazon head spline'.

I rotated the model in the front viewport, so that I could see all the splines clearly. In the *Selection* rollout of the *Modify* panel, I selected *Spline* and highlighted the eye shape. I then minimized the front viewport using the toggle in the lower right corner of the 3ds max window.

In the right viewport, I moved the eye spline along the Y-axis to the correct position. The same was then done for the nose and the lips: I selected them in the viewport, moved them to the correct position along the Y-axis, and adjusted any vertices to fit.

In the front viewport I selected the mouth shape by *Spline* selection and then in the *Geometry* rollout selected the *Detach* option.

ARTIST
ANATOLIY MEYMUHIN
TITLE
AMAZON

SOFTWARE USED
DISCREET **3DS MAX**
RIGHT HEMISPHERE
DEEP UV
RIGHT HEMISPHERE
DEEP PAINT 3D
DIMENSION DESIGN
ANIMATION GROUP
SHAG: HAIR

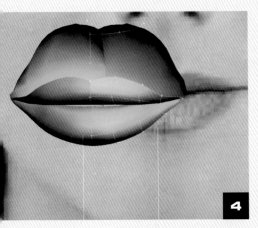

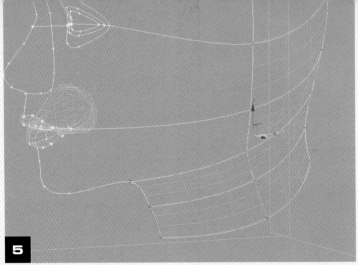

4

The detached spline was increased by 115% using *Select and Uniform Scale* while holding down the Shift key. I selected Shape01 and in the Submodification level selected *Spline*. This spline's proportions were decreased by a factor of 3 using the *Select and Uniform Scale*, again while holding down the Shift key. I then moved the spline to the right. All the mouth splines were grouped together using *Attach*. A *CrossSection* modifier was applied to connect the spline cross sections and the spline was attached to the Amazon head spline. After holding down the Shift key and left-clicking the Amazon head spline, in the *Clone Options* dialog I selected *Reference* in the *Object* area. I removed the 'spline 01' prefix in the *Name* field and selected OK. I then applied a *Surface* modifier to create a patch surface.

5

After selecting the Amazon head and using the *Mirror* tool from the *Edit* menu, in the dialog box I chose *Clone Selection: Instance* and selected OK. That was another part of the head added. I then turned on *Vertex Selection*, selected the *Refine* option and added two vertices to the nose. With *Create Line* selected and *Toggle Snap* turned on, I drew lines from the nose to the back of the head through the vertices, from the corner of the mouth to the back of the head and around the neck. I then added two new vertical splines and on the *Geometry* rollout clicked on *Connect*. I then selected the *Refine* option to increase the number of CVs on the spline.

6

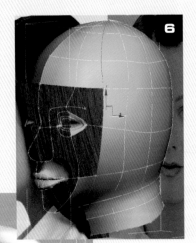

Horizontal splines were added to the top of the head (refining the vertices that were needed and removing those that were not). I added another vertical spline and created the spline for around the eye. I added another new spline from the centre of the eye and corrected some of the vertices. Next the jaw spline was added, the vertices adjusted and a spline added for defining the mouth. The nose splines were created in the same fashion.

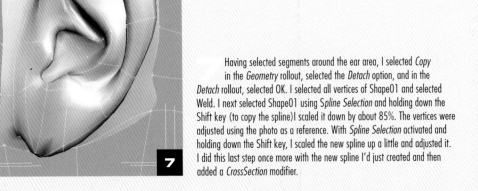

7

Having selected segments around the ear area, I selected *Copy* in the *Geometry* rollout, selected the *Detach* option, and in the *Detach* rollout, selected OK. I selected all vertices of Shape01 and selected Weld. I next selected Shape01 using *Spline Selection* and holding down the Shift key (to copy the spline)I scaled it down by about 85%. The vertices were adjusted using the photo as a reference. With *Spline Selection* activated and holding down the Shift key, I scaled the new spline up a little and adjusted it. I did this last step once more with the new spline I'd just created and then added a *CrossSection* modifier.

8

The ear was attached to the Amazon head spline. In the front viewport I then created a sphere with *Radius* = 14, *Segments* = 32, *Hemisphere* = 0.5, and adjusted the vertices around the eye. Sphere01 was renamed as 'Eye left'. I selected and mirrored the eye as an instance (a completely interchangeable clone of the original) and changed the name from 'Eye left01' to 'Eye Right'. I moved it along the X-axis to the correct position.

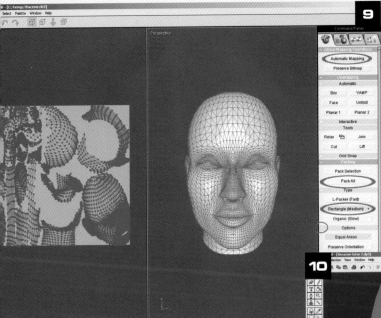

9

To add mapping coordinates to the head, I used the DeepUV program from Right Hemisphere. First, however, I selected the Amazon head object and *Assign Material*. Leaving the material at the default value, I changed its name to 'Amazon head'. It was now necessary to run the DeepUV application.

I did this by going to the *Utilities* panel and selecting the *More* option, *Right Hemisphere* and the *Map Selection* option. Next I selected the *Automatic Mapping* option and set *Packing Type* to *Rectangle (Medium)*. Left-clicking on *Options* opened the dialog box, enabling me to set *Spacing* to 0% and select the *Pack All* option. To send the new UV coordinates to 3ds max, I selected *File>Export>Send UV update*.

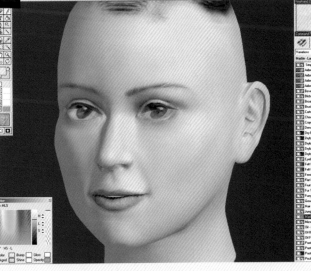

10

In the *Right Hemisphere* rollout, I selected *Paint Selection* for sending the image to Deep Paint 3D. Wanting to run Deep Paint 3D, I selected *OK* when given the option in the *Material Import* dialog box. I then used the F7 key to open the *Elements* tab. I left-clicked on the blank white rectangle under the letter C and, in the *Add New Channel* dialog, clicked *Nothing*. I set the material size for both X and Y to 2048 and maximized the window showing the head model. I then turned on *Toggle Projections* mode and *Paint Hide Pixels* also.

To paint human skin, try using the *Marble – Large* and *Skin Pores* brushes from the *Variations* category. For better painting, use a graphics tablet and apply paint with very little opacity and with different colour variations. Send the resulting texture to 3ds max.

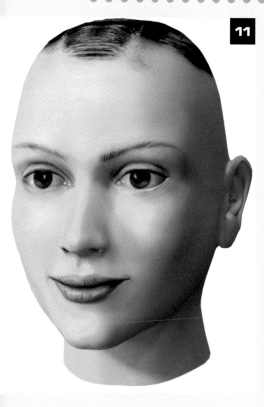

11 In the top viewport, I created a camera, changed the FOV to 16.0 and changed *User* view to *Camera* view with *Show safe.* I changed the colour of *Global Ambient* by selecting the *Environment* dialog from the *Rendering* menu and setting the ambient colour as follows: Red=15, Green=7, Blue=0. Then I set up the lights, adjusted the position of the face and adjusted the textures to give them a more realistic look.

To add eyelashes I used the Shag: Hair plug-in. To do this first create a spline for the eyelash and add a *Model Hair* modifier to it. Make the base for the eyelashes. Select the *Environment* dialog from the *Rendering* menu and in the *Atmosphere* rollout, select the *Add* option and add *Shag: Hair*. Select the *Add* option again and add *Shag: Render*. In the *Object* rollout select the *Pick* option under *Emitter* and select *Eyelash* base. Now select the *Pick* option under *Model Hair* and select *Eyelash*. Adjust the parameters to suit your own preferences.

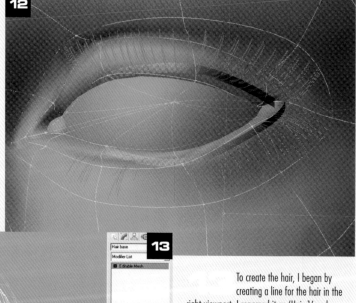

13 To create the hair, I began by creating a line for the hair in the right viewport. I renamed it as 'Hair 1' and assigned a *Model Hair* modifier. In the top viewport I created a sphere with default parameters, but changed the *Hemisphere* value from 0.0 to 0.5. Using *Uniform scale*, I made the sphere the same shape as the head. Then I renamed the sphere as 'Shag base', rotated it and moved it into the correct position.

I next went to the *Environment* dialog from the *Rendering* menu. I added a new *Shag:Hair* effect and renamed it as 'Shag:Hair 1'. For *Emitter*, I picked *Hair base* and for *Model Hair*, I picked 'Hair 1'. I adjusted the parameters and assigned the *Hair* material to the *Shag* object. I then selected *Mirror* for the *Shag* object. By the same method, I added other *Shag* objects until I had the effect I wanted.

The hand was built using splines and the *CrossSection* and *Surface* modifiers. To make the armor, Torus objects were added and 'instanced'.

The dragon was built using splines and the *CrossSection* and *Surface* modifiers. When all the modelling was finished, new materials were assigned. DeepUV was used for mapping and Deep Paint 3D for painting textures as before.

For rendering the scene, I used the default *Scanline* renderer. I changed the *Anti-Aliasing* filter to *Blend* and adjusted the parameters for it according to the size of the render.

NATURAL HAND TEXTURES

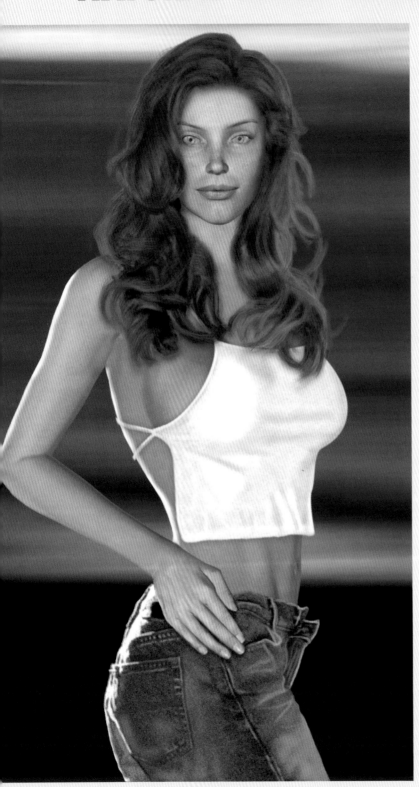

ONE OF THE KEYS to working with textures from nature is to get them to fit together seamlessly. If you've ever tried to tile a natural texture, you know how difficult – if not impossible – that can be. Byron Taylor says that it can take him up to two weeks to create a perfect hand, and that time doesn't include making it fit the wrist.

Taylor uses a Wacom Intuit graphics tablet and two main Photoshop Tools for creating real-world textures – the *Eraser* tool and the *Clone* or *Rubber Stamp* tool. He finds that other tools, like the *Airbrush* or the *Paintbrush*, tend to obscure the texture. Unless otherwise noted in the text, the *Clone* tool in Photoshop is set at 100%, the *Aligned* box is checked, and the *Stylus* set for opacity with a feathered brush. The *Eraser* tool is set at 50%, with the *Stylus* set for pressure, again with a feathered brush.

1

2

Look at your own hand and notice the differences in texture. The palm has the ridges or finger/palm prints. The back of the hand has extremely flexible skin with a larger texture, especially the knuckles. The edges of the fingers have a very smooth texture. Now look at your photos and see where all of these features are.

Fit the hands to the template with *Free Transform* as closely as possible. It's generally a good idea to go by the middle finger for position and start with the back of the hand. Select the little finger, including the back knuckle. Using *Free Transform*, rotate and size the image to fit the template. Take a look now at the Poser template for this finger: notice the indications for the knuckles and fingernail.

In Poser select a hand texture template. These templates come with the application or you can make new ones with UV Mapper. In Photoshop, create a new layered file with the Poser hand template as one of the layers. Take or scan in images of the hand you want to use as a reference onto another layer and remove anything that isn't part of the hand.

You're going to run into a lot of seams later on, so you'll want to do quick renders periodically to see how the features are fitting. How often you do this is up to you.

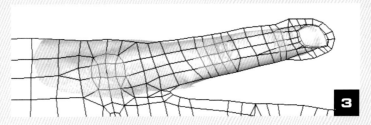

3

Now look at your own finger again and see where the flexible skin blends into the smooth skin at the sides. Remember that this part of the template wraps halfway around the finger, so some of that smooth skin is going to need to be at the edges. If the hand were mapped to the model at this point, the knuckle would wrap halfway around the finger! Scale the finger so that the knuckles and flexible skin area fit into the template as shown.

4

Using the *Clone* tool very carefully, clone the smoother skin outward to the template and a little beyond. Note the word 'carefully', because it's very easy to create unwanted patterns with the *Clone* tool. While you're at it, clean up around the fingernail as well. Be sure to obscure the shadows at the edges.

ARTIST
BYRON TAYLOR
TITLE
SHELLEY

SOFTWARE USED
ADOBE **PHOTOSHOP**
CURIOUS LABS **POSER**
STEVEN L COX
UV MAPPER

ADDITIONAL HARDWARE
WACOM **INTUOS**
PRESSURE-SENSITIVE
GRAPHICS TABLET

Now show the layer below and use the *Eraser* tool to blend this finger into the hand. Don't *Merge* yet (**a**). Repeat this procedure for the ring finger. Keep each finger on its own separate layer until everything is blended with everything else (**b**). On the middle finger in this example, the middle knuckle doesn't fit when the finger is sized to the template. In this case, select the knuckle and make a new *Layer via Copy* (**c**). Move the knuckle to the appropriate area of the template and blend the edges with the *Eraser* tool. Don't *Merge* yet (**d**).

6

Use the *Clone* tool to duplicate the texture in the finger to cover where the knuckle used to be. Now you can merge the knuckle onto the finger. Repeat the procedures for filling the template area and blending with this finger and the index finger. Keep all of the layers separate.

Unless your model is double-jointed, you won't have had a straight-on picture of the thumb in your original hand image. So open up the shots you did of the thumb. You know the drill here – *Duplicate* to the *Texture* file and *Erase* everything that isn't thumb. Size and rotate to fit the template. Repeat the procedures you used on the other fingers to make the thumb fit the template and blend into the hand. This may take some colour correction as well.

7

8a

8b

Continue to use these procedures for the rest of the back of the hand. Notice the skin on the sides of the hand and their wrinkle patterns (a). Now double-check your blending on all of the fingers and the thumb. Use the *Eraser* tool and the *Clone* tool as necessary (b).

Let's move to the other side of the hand — the palm. Your shots here should ideally be clear, because it's always nice to be able to see the ridges and whorls in the fingertips and palm in a high-resolution render. Doing the palm is exactly the same procedure as for the back of the hand, except that you don't need to work around the fingernails. Select, duplicate, size, clone, blend finger by finger and add the thumb from the separate shot.

9

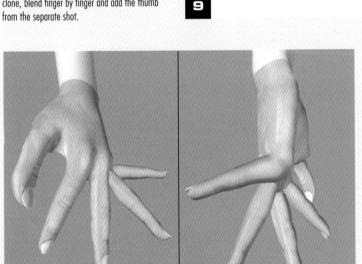

10a

10b

This is the part where the hand can take several days to perfect. But it's time well spent. A vendor will reject a texture based on seams and they check here too — all around the hand, between the fingers — everywhere (a). Once again, there is no easy way to fix these seams. Refer to your seam guide, use the *Clone* tool and do a lot of renders until the front and the back of the hand match (b).

CHARACTER DESIGN IN MAYA

HERE DAMON GODLEY, AN ARTIST AT GAMES company Core Design, describes how he uses Alias|Wavefront Maya 4.0 to create a character – in this case, 'Isobel'. However, the project can be followed just as easily in any other version of Maya or in most other modern 3D applications.

The main technique Godley uses to build his characters is called fake subdivision of surfaces. This basically involves using a 'low-polygon cage' to control a high-resolution smoothed surface and is a more accessible method than using true subdivision surfaces.

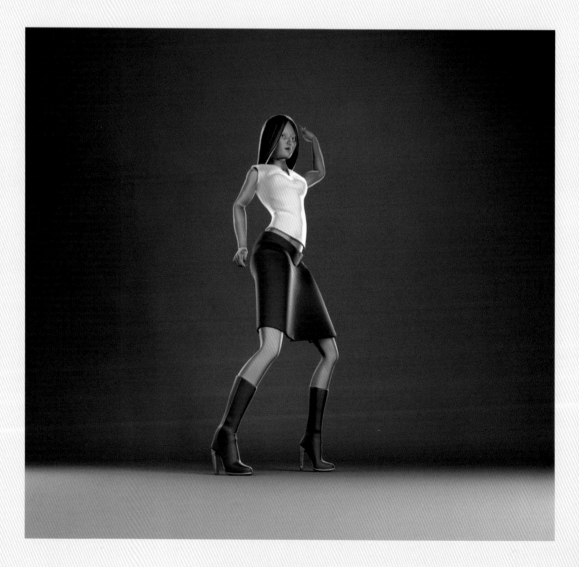

ARTIST
DAMON GODLEY
TITLE
ISOBEL

SOFTWARE USED
ALIAS|WAVEFRONT **MAYA 4**

1

The initial stage of character design includes gathering reference material and compiling it to make it usable inside Maya. A good starting place is a front and side sketch or image, placed in your 3D view.

Alter the scale of the reference plane to suit the image size. Continue to add reference planes wherever and whenever the need arises — looking down on a hand, for example.

2

Continue by shaping a cube to roughly contour the reference material you positioned earlier.

It's sometimes difficult to know where to begin, but I usually start with the hips. First create a cube then rotate it 45 degrees and offset it from the centre axis to create the top of the thigh. Continue by subdividing the height, then splitting the top innermost vertex to form the lower abdomen.

3

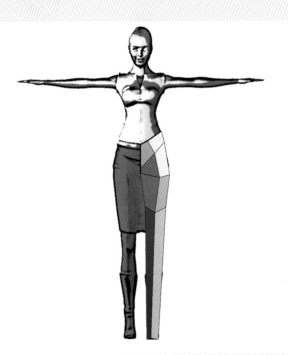

4

The next stage is to refine your model so it more clearly represents the reference. Work in one orthographic view at a time — don't get too caught up in details at this point or worry if another view doesn't quite work. The only tools you really need at this stage are *Split Edge* and *Extrude*. Using *Extrude Face* to rough out the legs, select the lowest face of the thigh and extrude your selection to the base of the reference image.

Edit the result by splitting each polygon about halfway to define the knee area. Do this another three times to create the foot, calf and thigh shapes.

It's a good idea at this point to *Duplicate* or *Instance* with a scale value of 1 to get a mirror image in order to check that things are going well.

 5

Completing the torso is equally simple and follows the same procedure, apart from the junction where the arms and neck meet the rest of the geometry.

Note: At this point you need to consider the 'flow' of your polygons. Using the *Flow* function is good practice. It also creates nicer-looking models for animation as it helps to convey the more subtle curves of the body and it also makes the mess of polygons more palatable when detail creeps in. The polygon flow effectively corresponds to the underlying muscle of the body. For instance, muscle from a woman's breast flows around her chest and into the arm, while the muscle in the neck reaches down to the collarbone. You can take advantage of this awareness of flow when using the *Split* tool later to create subtle detail.

6

Using a similar technique to the one you employed to create the leg, extrude from the top of the abdomen to form the base of the neck. Ignoring the arm at this point, split the torso across the stomach, chest and collar. To create the base of the arm, which will be kept four-sided, split from under the arm to the top of the shoulder.

Extrude and build the arm, again adding only enough detail to make the basic form. You should now have something resembling your character in the perspective view. At this stage you can easily adjust proportions due to the simplicity of the model.

7

You could now try a subdivision test. One likely result of the test is that the model will appear thinner. However, don't be overly concerned as this will partly be resolved through the next process, which is refining the model. The refinement of the model is helped by setting the *Poly Split* tool to have three snap points and 75% snap. Taking each limb, one at a time, refine to one level of detail over the entire model.

8

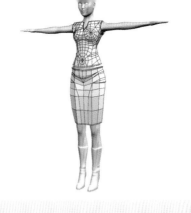

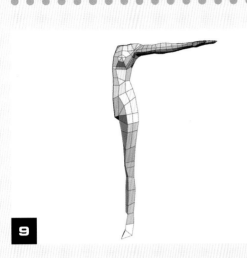

9

Now you should have a good figure to which you can really start to add features. At this stage, looking at your model in smoothed mode becomes essential: an important feature to consider is muscle tone. There are lots of websites and references for this, so get surfing. Body-building books also offer a clear if exaggerated view. However, the best way to see muscle tone in action is to look at your own body.

11

There are many ways to create clothing in 3D. One example is to build patterns and weld or sew the panels together in a similar fashion to real tailoring. This is the method used by Maya for its advanced cloth-simulation technique.

12

10

Refinement of the face again relies on knowing at least a little about muscle and proportion. A common mistake is to add details where there is only colour. Lips, for instance, do not start and stop on the colour border between skin and lip; they continue much further into the face due to the muscles that control them. In effect, you need to model areas of muscle that you can't actually see.

A tip for making your surface look cleaner is to apply two smooth passes. The first pass blends the low polygon cage and really alters the look of your character, while the second takes care of any harshness in the geometry without altering the shape. This is superior to applying one smooth pass with two subdivisions.

One simple method for building garments is to extrude the area of the body you want to dress. This can be quite effective for well-fitted items. The skirt is simply connected in the middle and then small creases are added. At this stage you can refine corners and other surfaces to sharpen up the elements of the clothing.

13

HEAD AND FACE MODELLING AND PAINTING

I N THIS PROJECT, BASED ON HIS *ANGIE* PORTRAIT, Ralph Manis covers modelling in Poser, creating a UV Map and using photographs and painting in Photoshop. You will need a fair understanding of these applications, plus UV Mapper Professional, an application by Stephen Cox, which you can download free from his website at http://www.uvmapper.com

Note that keyboard shortcuts are used throughout this project. It's good practice to use them whenever you can because when they become second nature they will really speed up your workflow.

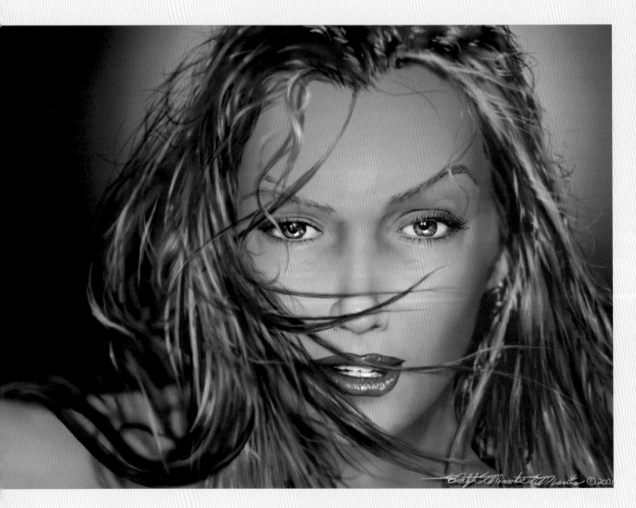

ARTIST
RALPH MANIS
TITLE
ANGIE

SOFTWARE USED
ADOBE **PHOTOSHOP**
CURIOUS LABS **POSER**
COREL **BRYCE 3D**
STEPHEN L COX
UV MAPPER

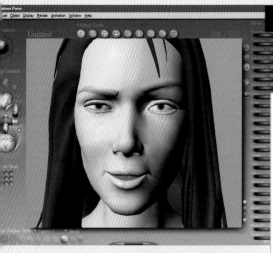

1

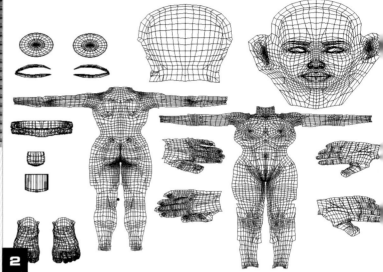

2

Open Poser and choose a new female figure. Select *Face Camera* from the *Camera Controls* drop-down menu or click on the small grey head. Adjust the facial features and head shape with *Parameter Dials*. Once you have your desired characteristics, select *Export as Wavefront Object* (obj) from the *File* menu. In the *Export Range* pop-up menu, select *Single Frame*. In the *Hierarchy Selection* pop-up menu, uncheck the *Ground* and *Hair* boxes then click *OK*. Name the file Head.obj, save the file and close Poser.

Tip: When using *Parameter Dials*, make your adjustments in small increments.

To create and edit the UV Map, first open UV Mapper and *Load Model*. Find and select Head.obj. If you saved your 'Head' model without hair, then select *Color* from the *Edit* menu and then *Black and White*. Choose *Save Texture Map* from the *File* menu, then name it UVMap.bmp. Save it and close UV Mapper.

You may want to separate your body parts into groups, making it easier to select the individual parts in Photoshop with *Select Color Range*. To do this, go to the *Edit* menu and select *By Group* from *Color*. Then select *Save Texture Map* from *File* and name the file UVMap.bmp. Again, save and close UV Mapper.

Tip: Pay no attention to the fact that the UV Map does not look like it has the facial expressions (morphs) that you applied to your model in Poser.

There are two basic ways to create textures for your 3D models. One is to paint them and the other is to use high-resolution scans of photographs. Both of these techniques are described here, but if you do not possess a high-resolution digital camera or a scanner just paint everything.

To use photographs, either from a digital camera or from scans, always have the resolution set at 300 ppi to capture the highest possible amount of digital information.

Open the UV Map in Photoshop. Adjust the image size: *Width* = 2000, *Height* = 2000 at 72 pixels/inch. Press Command+0 (Ctrl+0) to fit the image on the screen. Select the *RGB Color* mode from the *Image* menu. Since you are only concerned with the head, neck and shoulders, you can delete all the body parts that will not be seen by using any of the selection tools, such as *Lasso*. With the background colour set to white, select the body parts that are not needed and either delete or press Command+Backspace (Ctrl+Backspace) to fill with white. Leave all the parts of the body that will show up in your scene, such as the neck and chest, teeth and eyelashes.

Tip: Never move any of the body parts on the UV Map. If you do, your images will not line up correctly when applied to your model.

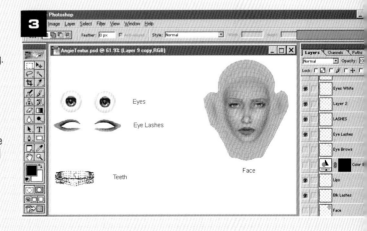

3

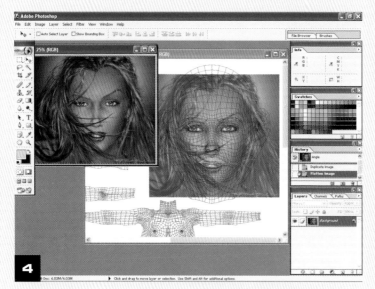

Open the scanned image or photograph in Photoshop. Use the *Lasso* tool to select the face, then copy and paste or drag with the *Move* tool over to the UV Map file. Set the *Opacity* of the image layer to around 78%. Select the face image in the layers palette. From *Select*, choose *Transform Selection* and hold the Shift key to constrain proportions as you drag one of the *Resize Corners* until the eyes are as close as possible to the ones on the UV Map. Reset the *Opacity* of the image layer to 100% before saving.

Try to line up the corners of the eyes and mouth of your image with the corresponding corners of the UV Map. You may need to make separate copies of the lips and eyebrows to be able to position them precisely. If so, use the *Lasso* tool to select and copy. Click the *New Layer* button on the bottom of the layers palette then paste. Double-click the layer to select it and line up each part with the *Move* tool

Click the *New Layer* button and, with the background colour set to white, fill the layer. Drag the Face layer above this new white background layer in the *Layers Palette* so that the face is on top of the white layer. Hide any visible layers by clicking the *Hide/Show Layer* eye so all you see is the face on a white background. Save the file as Face.psd (save in .psd or .tif file format).

Repeat this process with the eyes (keep left and right eyes together), eyelashes, lips and teeth if they are visible in your image. The neck, chest and collar can be painted together or a photo can be used instead. Save each part in its own named file (at *Width* = 2000 and *Height* = 2000 at 72 pixels per inch).

Tip: Create your eyes, eyelashes, teeth and chest on separate layers. When you are ready to save a body part just hide the layers that you don't want to be visible by clicking the *Hide/Show Layer* eye then Command+S (or Shift+Ctrl).

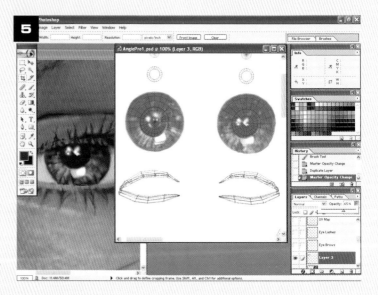

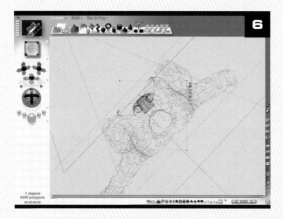

Now move to Bryce 3D to import the models and add some photo-realistic textures. From the Bryce *File* menu, choose *Document Setup* and select the *Standard* button: 1:3.00 and 1920 x 1440 or higher. Check the boxes for the *Constrain Proportions, Anti Aliasing* and *Superfine* settings. Import your Head.obj file via the *File* menu. Select and delete the ground plane. Click the *View* arrow and select *From Top*. Click the head to select it and place the cursor/pointer over the Y-axis. When you press and hold Command (or Ctrl), the *Rotate* icon will appear. Rotate the head -45 degrees so that it is facing the camera. Alternatively, click the 'A' and in the *Object Attributes* pop-up menu, type -45 in the *Rotate Y-axis* (under the *General* tab). Click and drag the head right up till it is in front of the camera. Click the *View* arrow and select *Camera View*. Hold down Option (or Alt), then click and drag to the right until the head is in the frame. Hold Command (or Ctrl) and click on the head object. In the pop-up window select Head_3.

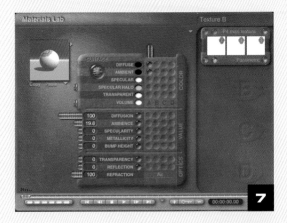

Open the *Materials Lab* by clicking Command+M (or Ctrl+M). Select *Diffuse* and *Ambient* in the 'A' column. Click the *Image Texture* button (the one with the 'P' on it) and 'Leo' will appear in the display window. Click the pink *Texture Source Editor* button.

To begin importing the texture images in *Picture Editor*, go to the first large window and click *Load* . In the pop-up menu find and select your Face.psd. Still in the first large window, click *Copy*. In the second large window click *Paste* and in the pop-up menu select *Delete*. Leave the third window as it is and click *Finish*. Exit the *Materials Lab*.

It's now time to add the eyelashes, eyes, lips and other texture maps. Hold down Command+Shift (or Ctrl+Shift) and click on the right eye. Select *Deselect All*. Still holding down both keys, click the eye again and select (Right_Eye_1), (Right_Eye_2) and (Right_Eye_3). Then holding down Ctrl+Shift, click on the left eye and select (Left_Eye_1, 2 and 3) one at a time. These are the pupils, irises and the whites of the eyes, so just keep holding down Command +Shift (or Ctrl+Shift) and clicking until you have selected them all.

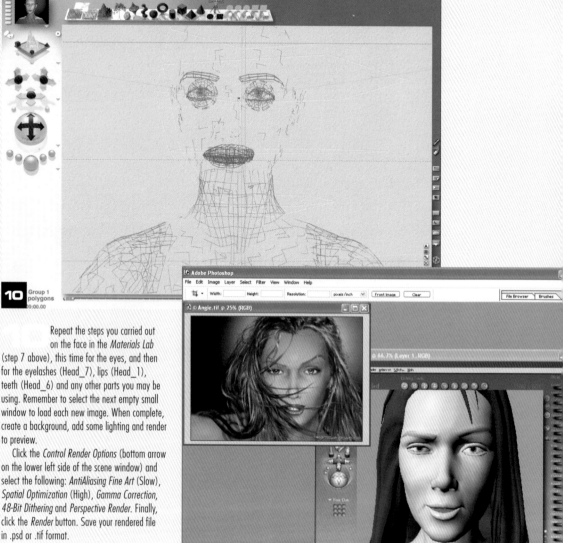

10 Group 1 polygons 00:00.00

11

Repeat the steps you carried out on the face in the *Materials Lab* (step 7 above), this time for the eyes, and then for the eyelashes (Head_7), lips (Head_1), teeth (Head_6) and any other parts you may be using. Remember to select the next empty small window to load each new image. When complete, create a background, add some lighting and render to preview.

Click the *Control Render Options* (bottom arrow on the lower left side of the scene window) and select the following: *AntiAliasing Fine Art* (Slow), *Spatial Optimization* (High), *Gamma Correction*, *48-Bit Dithering* and *Perspective Render*. Finally, click the *Render* button. Save your rendered file in .psd or .tif format.

Now go back to Photoshop and open your rendered file for some hair painting and touch-up work.

Add a new layer and select *Layer Properties*. In the pop-up window type 'Hair', then press Command+0 (or Ctrl+0) to view full screen. Select the *Lasso* tool (L) and roughly outline the main structure of your hair. Click the background colour and in the *Color Picker* pop-up menu, select a dark brown (almost black) colour. Now, press Command+Backspace (or Ctrl+Backspace) to fill the hair outline selection. Select a smooth, medium-sized *Brush* and set it to *Airbrush* mode in the options bar. Set the *Pressure* to about 63%. Starting with a dark brown colour, roughly paint

the darker areas, then build up with a lighter brown. Choose a reddish dark brown and build up some more. Select a light yellow and apply where necessary. Repeat this process a few times with a few colours but don't get too carried away.

Select a smaller *Smooth Brush* from the brushes palette and repeat the steps above. Then select an even smaller brush and turn the *Pressure* up to around 86 before repeating the colouring steps again. Repeat this process a few times, selecting a new lighter shade each time. Referring to your sample photos, roughly add your very darkest areas and your lightest highlights without using black or white. Try to build up your hair in groups of strands, getting smaller as you go.

12

Enlarge your image and select a dark brown (almost black) colour. To add highlights and details, select the one-pixel *Smooth Brush* to apply some very fine line details where necessary and add some occasional short strokes and fine dots. Select a lighter reddish brown and add fine line details where necessary with some occasional short strokes and fine dots. Repeat with a light yellow colour.

Use the same techniques that you used to create the hair to paint the eyes and lips and add fine details to finish your work. Carefully build up your details as you did with the hair, using dark to lighter shades of colour. Add stray hairs, as they will give any hairdo more realism than anything else.

Since there is no such thing as pure white or black in nature, try not to use them unless you need to. For the lips, only use black in the corners of the mouth and around the teeth. Adding white for the reflective highlights simulates the effect of being under bright light. For the eyes, add a touch of pure white to the pupil to create realism.

13

FULL BODY MODELLING

THE TECHNIQUES USED TO BUILD A FANTASY FEMALE figure are discussed here in some detail by Les Garner, with reference to his image entitled *Lupina*. Starting with initial concept sketches, he describes what's involved in NURBS and Polygonal modelling, creating hair and fur with Maya Paint Effects, texturing with image maps and procedural materials and, finally, posing the figure using Bones.

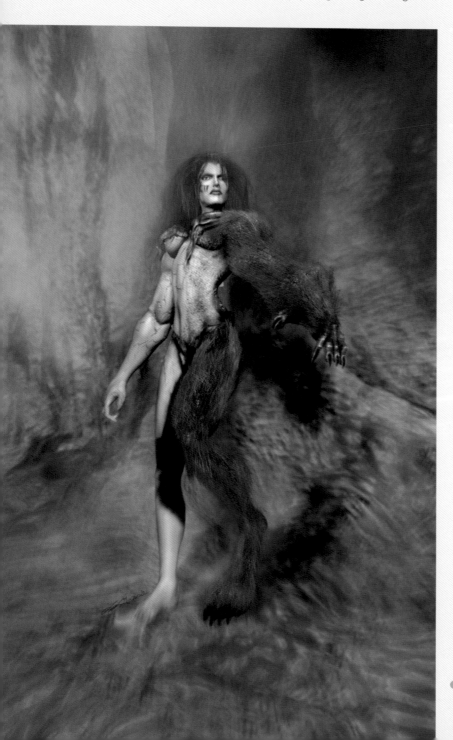

ARTIST
LES GARNER
TITLE
LUPINA

SOFTWARE USED
ALIAS|WAVEFRONT **MAYA**

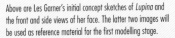

Above are Les Garner's initial concept sketches of *Lupina* and the front and side views of her face. The latter two images will be used as reference material for the first modelling stage.

1

First you have to load your template images. In perspective view, create two NURBS planes and situate them at right angles to each other. Create a new material for each of these and load the guide drawings into their colour channels. Press 6 on your keyboard to turn on *Hardware Texturing*, then right-click each object and select *Actions>Template*. This will enable you to view your references without worrying about accidentally selecting them.

Remember that we will be working on only half of the figure at one time, then mirroring that half and combining the results to complete the entire model. Throughout this process, it is sometimes beneficial to temporarily mirror the current figure to assess progress. Feel free to do this as often as you like, although it is advisable to delete your mirrored figure when you have finished checking in order to free up valuable system resources.

2

Commence modelling the head by creating a polygonal plane in side view and scaling this to a relatively small area just before the ear. Begin the process of selecting edges, extruding and then moving them to follow the basic contour of the design template. While doing this, try to alternate between front and side views, making sure to check how accurately the polygons being created are following the contours from both directions. A good way to approach the head is to model from the area in front of the ear to the lower-most point of the chin.

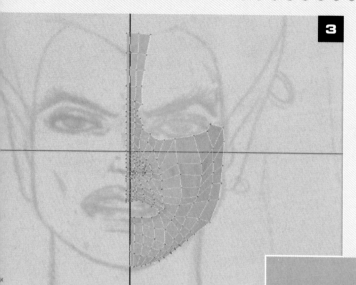

3 If the topology is matching the drawings closely, begin extruding edges from the newly created jaw line, pulling them upwards and shaping them accordingly, occasionally merging vertices where necessary. Once the mesh leading up to the bottom of the eye socket has been created, continue the process of edge extrusion along the cheekbone area, manipulating the new edges to complete the upper frontal quarter of the head. Next concentrate on the creation of the frontal profile of the neck using the same edge extrusion techniques described above. For the remainder of the head, continue extruding and manipulating edges, guiding their creation to correspond with the template images.

4 It's wise to leave the small details of the ears and eyelids for the final touch, as these can be easily created by selecting and extruding the groups of edges forming the holes where they will eventually be. For the eye area, it is sometimes useful to place a sphere in the appropriate area to ensure that the shape of the eyelid conforms closely to the shape of the eye. For the ears, use a similar method of extruding the edges of the hole left there until enough mesh has been created in the area to allow for some moderate shaping. Then convert the innermost edge selection to a vertex selection and merge these vertices, effectively closing the hole.

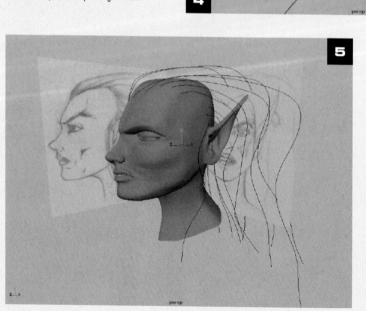

5 In *Face* mode, select groups of faces from this area and move them in front view to begin shaping them to the ear in the drawing. Back in perspective view, extrude the faces from the top of the newly created ear area and pull them to form the pointed shape shown in the drawing that is visible in the side view. At this stage it's worth thinking ahead to the issue of the character's hair. This will be accomplished later on using Maya Paint Effects, and it's a good idea at this point to draw NURBS curves as guides for the shape and flow of the hair. As you'll see, these will eventually be used as *Control Curves*.

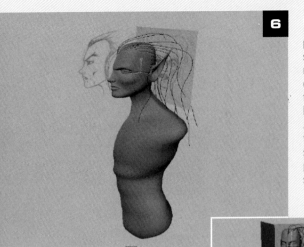

6

For building the body of the figure, begin by drawing a basic CV (control-vertices) curve in the shape of the front half of the torso's profile in side view. Next, use a *Lathe* command to revolve a 180-degree surface that will comprise the basis of the torso. Then, in side view, further manipulate the shape by moving CV s where needed. While shaping the torso, don't worry about forming breasts, but rather concentrate on the form of the bones and musculature that support the breasts, leaving the rounded breast shape to be extruded later. With this shape complete, select *Modify>Convert>Nurbs* to *Polygons*, making sure that you check the option to create the polygon mesh based on the CV cage and not the underlying surfaces. Any conversion based on these surfaces will usually create a prohibitively dense mesh, whereas what is needed at this point is a simpler shape that you can work with easily.

7

Creation of the leg begins with selecting *Create>Nurbs>Cylinder*, then rotating, scaling and placing the object accordingly. Then, alternating between side, front and perspective views, move CVs to create the desired leg shape. Once this shape has been created, convert the NURBS object to polygons in the same manner as for the torso.

The next step is connecting the leg to the torso. With both objects now in polygon form, simply delete a selection of faces from the lower hip area of the torso, then select both torso and leg objects and choose *Polygon>Combine* to make them into one object. With that object selected, proceed into vertex mode and complete the attachment by selecting small groups of vertices from each shell, locating where they should fit together and merging them. Repeat this process until the leg is seamlessly joined to the torso.

Creation of the arm is a near-identical process to building the leg. The basic musculature of the arm is almost identical to the leg, with the deltoid area being analogous to the gluteus, the bicep analogous to the biceps femoris (large muscles at the back of the leg), the elbow to the knee and so on.

To complete the torso/arm/leg object, repeat the same methods of attachment used for the leg with the arm object. Once this has been attached, select faces on the chest area and extrude them once or twice, creating enough mesh detail there to make the subsequent shaping easier. This is completed through a combination of vertex and edge editing. Keep in mind that the breasts should appear to have weight and form and that the muscles providing support for them are the pectorals, which connect to the collarbone and extend beneath the frontal area of the deltoids. Remember, we want breasts here, not balloons!

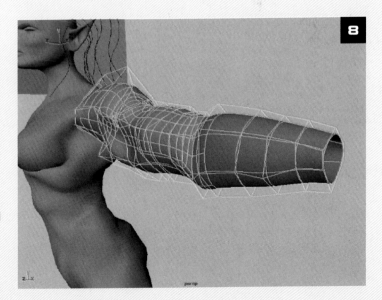

8

Beginning with a simple polygonal cube, pick one face from the side view and extrude this three times along the X-axis. Next, from the front view, select the face you will see in the centre, go back to top or perspective view, and extrude this a short distance along the Z-axis to create a small nub from which you will eventually extrude the rest of the thumb. Now back in the side or perspective view, slice the face that is furthest along the X-axis into four new faces with the *Slice Polygon* tool. Next, go to *Polygon>Tool Options* and make sure that the *Keep New Faces Together* option is turned off.

Back in the perspective view, select the four newly created faces and extrude them three times. These extrusions correspond to the three joints of the fingers and will have their appropriate details added in later. Now select the outermost face of the nub where the thumb will be made and extrude that three times as well, forming the basis of the thumb.

Looking in perspective view at the underside of the hand mesh, it is a good idea to prepare for adding details to the palm by using the *Slice Polygon* tool there to cut new faces. This will allow future smoothing of the mesh.

Switching back and forth between top and perspective views, select the faces of the fingers and thumb that will become the fingernails. Extrude these once, apply a small inward bevel to this extrusion, and move the newly created face slightly into the interior of the corresponding fingers. This helps to create the small ridge or folding shape where the fingernails meet the flesh of the fingers. Select each of these faces and extrude them, then move that extrusion slightly away from the finger to create the rest of the fingernail.

The method for creating the feet is almost identical to the one used for the hands, except that here you create slices resulting in five faces in the front from which to extrude the toes. There's also no side nub that, on the hand, would become the thumb.

Now it's time to connect the body half to the hand and foot. Select the body object, then the hand and foot. Combine them and merge their respective groups of vertices using the same method described for combining the arm and leg.

With all these objects now connected, you need to create and connect the other half of the body. To do so, simply select *Polygon>Mirror* and be sure to have *Merge With Original* checked. Once the body has been mirrored, select the vertices of the left arm and, from the *Animation* mode, select *Deform>Lattice*. Then use the lattice to shape the arm as needed for the character and follow this by going to *Edit>Delete>History*. Next, use the *Artisan* tools to sculpt/paint the figure's smaller details. These steps are then repeated to create the changes for the corresponding leg.

Now that you are ready to add hair and fur to the figure, you need to create the NURBS surfaces that will hold the Paint Effects strokes. For the arm and leg, create two NURBS cylinders and reshape them to follow the basic shape of their respective limbs. Also create a NURBS sphere from which the hair on the head will emanate. Edit these objects through manipulation of their CVs to ensure that they exist just beneath the surface of the polygon model.

Switching to the *Render* menu (F5 on the keyboard), select these NURBS surfaces and go to *Paint Effects>Make Paintable*. Now change to a full perspective view and hit '8' on the keyboard to jump into *Paint Effects* mode.

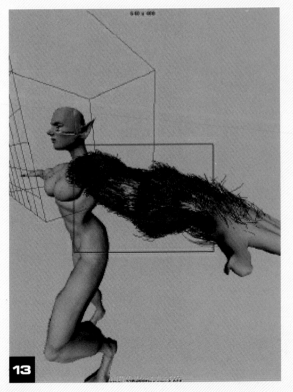

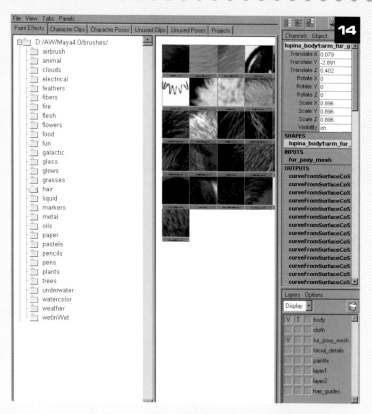

14

From here, click on *Paint Effects>Get Brush* to bring up the *Visor* window with your brush presets in view. Select an appropriate brush preset, then begin painting a few short strokes on the model. Select one of these strokes and select *Paint Effects> Template Brush Settings,* or type Command B(or Ctrl+B). Also make sure that the *Attribute Editor* is open. You should spend some time experimenting with the settings of the *Template Brush* and *Attribute Editor* for your newly created brush strokes, until you reach a desirable result. Try using IPR rendering regularly at this stage so that you can properly gauge the changes you have made to your brush stokes.

Once you have achieved satisfactory settings for one or two strokes, go to *Paint Effects>Save Brush Preset.* Name your new brush preset accordingly, then select from the two radio buttons present either *To Shelf* or *To Visor.* If you choose to save to the *Visor,* you will also have to enter a *Visor Directory* name in the.corresponding field. Using your newly created brush, continue to paint the fur throughout the scene. Once you have painted the hair on the head, select the curves created on the NURBS sphere and the guide curves created to control the flow of the hair, then go to *Paint Effects>Curve Utilities>Set Stroke Control Curves.*

The creation of accurate mapping coordinates can be an exceedingly tedious process if not thought out properly in advance. For example, with *Lupina,* the primary areas that required accuracy in the painted mapping were the torso, right arm and head. Because the left arm and left leg would ultimately be covered in fur, the need for painstaking coordinates was reduced. To assist in creating a more varied and natural look for the character, as well as a look that further exploits the powerful material capabilities of Maya, it's a good idea to use a layered material, thereby allowing the combination of both the painted mapping and procedural texturing. In the example of the left arm and leg, the coordinates for the painted texture do not need a high degree of accuracy. The primary reason for mapping over these sections is to allow the painting of transparency areas, which will enable the procedural texture you will be using there to show through.

15

16

You can create coordinates for polygon-based figures using three steps, which can be repeated for various sections of the mesh. First, from a side view, enter *Face* mode and use the *Lasso* tool to select roughly half of the figure. It is often beneficial at this point to zoom in and add or subtract polygons to your selection, working in this manner until a relatively smooth section of mesh has been selected. Next, switch to the front view and, with History on, apply planar coordinates by selecting *Edit Polygons>Texture>Planar Mapping*. In the flyout for *Planar Mapping*, be sure to turn on the check boxes for *Automatically Fit the Projection Manipulator* and *Insert Before Deformers*. Choose *Camera from the Mapping Direction* options also shown there.

The final step is to open the *UV Texture Editor* and, with the *Planar mapping* tool still active, move the selection off of the main mapping coordinate grid. Also at this stage you might choose to scale the selected coordinates to a manageable size as the *Planar Mapping* tool makes this very easy to accomplish. The reason for moving the selection out of the way is to prevent any overlap of other coordinates, as the steps outlined above should now be repeated for each subsequent section in need of coordinates.

17

Though Maya can automatically 'pack' the UVs for you once you have mapped all of the figure, you may prefer to separate them all manually as they are created and 'pack' them yourself once they have been mapped. This ensures that the areas that gain the greatest space in 2D mapping are of your choice and not the product of the program's system of 'packing'. You may also want to avoid using the *Automatic Mapping* feature. This tool can be beneficial if your polygonal figure is going to use *Maya Fur* (*Maya Fur* will often not work or will behave erratically if the surface it is applied to has any overlapping UV coordinates). However, in general it seems to break up most models into tiny pieces which are extremely difficult to deal with when used as a template for painting.

Roughly one half of the *Lupina* figure was textured using painted image maps for colour and bump. To enable accurate texture mapping, you must create an image file template of the figure's 2D coordinate system. This is easily done by selecting all the faces for the mesh for which a template is needed and then, in the *UV Texture Editor*, selecting *Polygons> UV Snapshot*. Choose to open the flyout for this command in order to set the path where it will output your template image and other options. Once your path has been set and selections made for *Size X, Size Y, Keep Aspect Ratio, Color Value,* and *Image Format*, click *OK* to output your template. From here you can open the template in your image editor of choice and begin painting.

You'll find that the painting of image maps is easier and a lot more accurate, if you use 3D paint packages such as Deep Paint or, though somewhat outdated, Painter 3D.

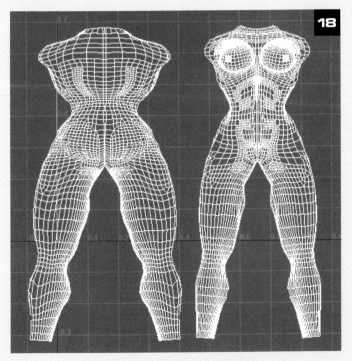

18

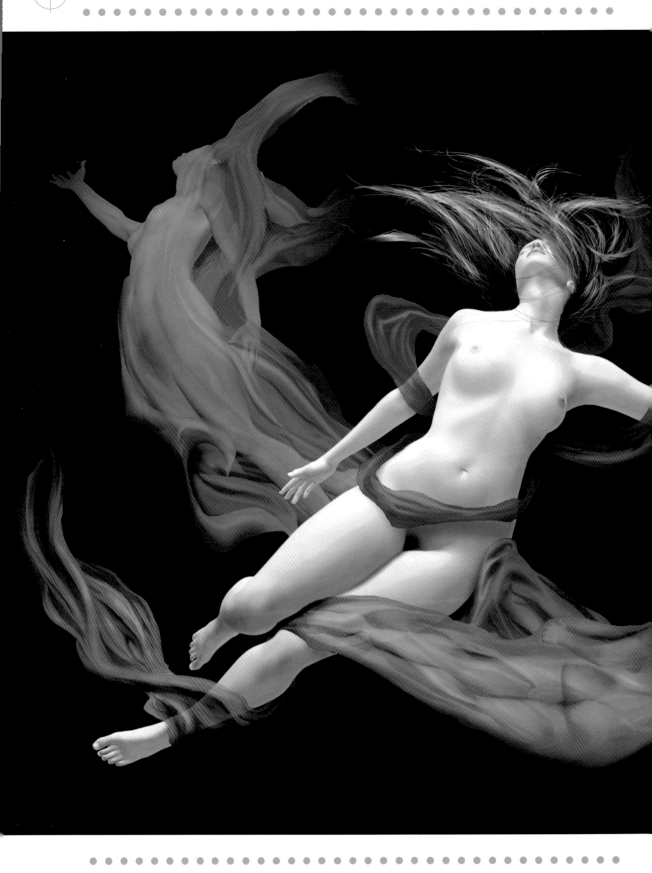

COMPONENTS & INGREDIENTS

SOMETIMES YOUR POSER MODEL NEEDS AN EXTRA SOMETHING TO ADD JUST THAT BIT MORE REALISM. IT COULD BE MORE NATURAL HAIR PERHAPS, OR A DARKER SKIN TEXTURE, OR EVEN BETTER LIGHTING IN YOUR SCENE TO LIVEN THINGS UP. THE USUAL SOFTWARE SOLUTIONS MIGHT NOT PROVIDE ALL THE ANSWERS, WHICH IS WHERE THE TIPS AND TRICKS DESCRIBED IN THE FOLLOWING PROJECTS WILL PROVE INVALUABLE. THESE PROJECTS WILL SHOW YOU HOW TO CREATE ALL SORTS OF TEXTURES FOR YOUR FIGURES, HOW TO LIGHT THEM, COMPOSE THEM IN A SCENE, SET THEM UP WITH PROPS AND EVEN DRESS THEM IN THE LATEST POST-APOCALYPTIC FASHIONS. ONCE AGAIN, BASIC KNOWLEDGE OF THE SOFTWARE IS ALL THAT IS REQUIRED TO FOLLOW THE STEPS AND BRING A PROFESSIONAL FINISH TO YOUR PAINTINGS.

ARTIST
WILL KRAMER
TITLE
LA MER DE LA NAISSANCE

TONES, TEXTURES AND LIGHTING EFFECTS

THE HUMAN BODY IS THE MOST DIFFICULT SUBJECT TO PORTRAY. Even the most inattentive observer can easily tell if proportions or anatomy are off. For this reason, and especially if the goal is to achieve a realistic look, it is best to use some form of reference (such as models and photographs) when drawing the body. Reference is especially useful during the initial phase of the process. In *Goddess*, Roberto Campus wanted to convey a sense of power and elegance. The body, muscular yet very feminine, creates a seamless curve with the hair.

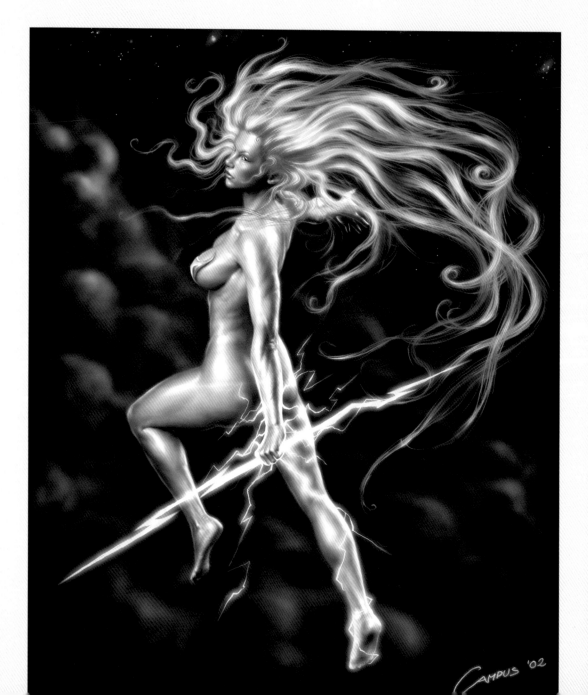

For this image, I rendered a pose of the main figure in Poser to use as a reference. Poser also helped me find the best composition and angle for the subject. As you can see in the screenshot, the Poser character model I used does not carry many details when it comes to muscles and tendons or even bone structure, but it was enough for me to use as a base upon which to build my painting. The 8 x 10, 300 dpi resolution Poser render was then imported into Photoshop, cut in a separate layer and desaturated.

1

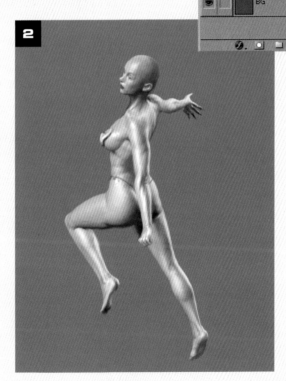

2

To paint the figure, I relied heavily on my knowledge of human anatomy. The key requirement in drawing a realistic body is a solid knowledge of its many muscles and bones and the way they work together. You can acquire this knowledge by drawing from live models and from copying photographs, although the latter method does not produce results as fast as the first.

On a separate layer, I started painting the main figure using the *Paintbrush* tool set on normal mode with a 30% *Opacity* smooth brush varying in width from 10 to 50 pixels. I referred to the Poser render for the main shapes and their position. I used only shades of grey because they allow me to concentrate on volume, chiaroscuro and shapes without the distraction of colour.

After I was satisfied with the sketch, I zoomed the image to 200% and, using the *Smudge* tool (50% *Opacity*, 0% *Hardness*, round brush), I blended together all the brush strokes to obtain a smooth and realistic look. Then, using a small brush, I zoomed in even more to add many smaller details, like the folds of the skin in the hands and feet and the eyes and nails.

ARTIST
ROBERTO CAMPUS
TITLE
GODDESS

SOFTWARE USED
ADOBE **PHOTOSHOP**
CURIOUS LABS **POSER**

ADDITIONAL HARDWARE
WACOM **9X12 TABLET**
PRESSURE-SENSITIVE
GRAPHICS TABLET

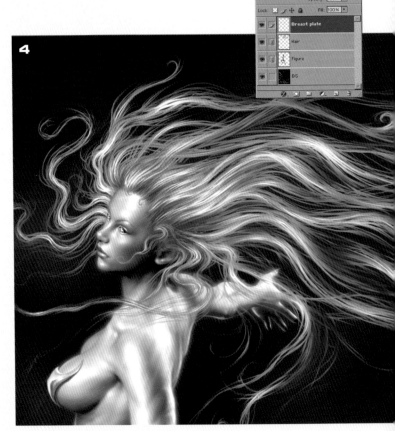

At this point, with the figure mostly finished, I added colour. Flesh tones are hard to obtain because of the translucent quality of skin and because of the different degree of tones that various body parts have. Before using the paintbrush to colourize the figure, remember to lock the transparent pixels on the layer (by pressing the forward slash key) to avoid brush strokes going over the edge of the figure and partially covering the background layer.

To colourize the figure, I selected the figure layer, then launched the *Hue/Saturation* tool, checked the *Colorize* button, set the *Hue* to 10, the *Saturation* to 35 and *Lightness* to 0. The black-and-white figure was now coloured. The colours needed further manipulation, though, because the flesh tone was still too uniform. Next I used the *Curves* tool to add colour variation. I shifted the darker range towards red and added a bit more blue to the lighter range. To add more realism to the figure, I used the *Paintbrush* tool to add even more red tones to the figure's cheek, nose, feet and hands, and some blue make-up above the eye. I also slightly shifted the colours in the bent leg and rear arm to blend them better with the background. Finally, I used the *Dodge* tool to add some highlights and to enhance the contours in some specific areas, such as the legs, back and torso.

3

Painting the hair is very labour-intensive and requires light pressure and long curved brush strokes. The key to painting hair is to use a brush that varies in size and *Opacity* depending on the pressure applied on the stylus.

I drew the hair on a separate layer, placed above the main subject layer. I began by drawing the main hair shapes with electric blue colour, using the following brush settings: brush tip size 15 pixels wide, 80% *Hardness*. Under *Shape dynamics*, I set the minimum diameter to 1% and assigned *Size* control to the pen pressure. Under *Other dynamics*, I assigned the *Opacity* control to pen pressure.

Once the main shape was set, I switched to the *Smudge* tool, set the mode to *Lighten*, *Opacity* to 90% and the brush *Hardness* to 0%. This method allowed me to add more hair strands by picking up existing pixels from the base hair shapes without affecting or smudging hair I had previously drawn. Next, I used the *Dodge* tool to add highlights where needed. I also used the *Eraser* tool to make some portions of the hair more transparent.

4

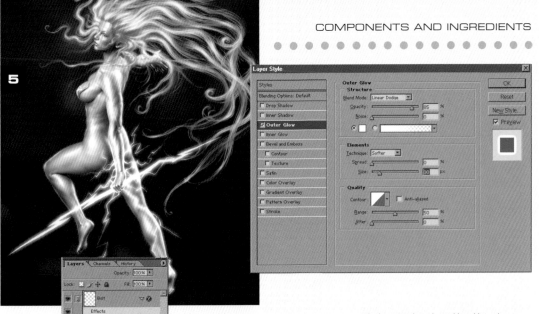

I drew the lightning bolt and electric sparks on separate layers, and then added a glow effect to give them a realistic look. The glow was achieved in the following way: in the layer blending option I enabled the *Outer Glow* effect and set its blend mode to *Linear Dodge*, *Opacity* to 85% and *Size* to 30 pixels. I used the same colour as for the lightning bolts.

The hair was also enhanced by additional manipulation. To give the hair a softness and glow effect, I duplicated the hair layer and applied a *Gaussian Blur* filter. I then set the layer blending mode to *Lighten* and *Opacity* to 85%. Additional glow to the hair was added by duplicating this last layer and setting its blending mode to *Linear Dodge* and *Opacity* to 50%. The edges of the arm holding the lightning bolt were also enhanced to give the impression of a stream of energy emanating from the lightning bolt.

I mostly painted the background with a large brush set to vary in *Size* and *Opacity* based on stylus pressure. In the *Shape Dynamics* brush settings, I set the minimum size to 30%. I used the same colours as in the foreground, arranged so that they would complement and enhance the contrast with the main subject in the foreground. On the upper portion of the background, I used warmer magenta tones to balance the area with the blue hair. The same principle was applied to the lower part of the background where blue tones were used to bring up the legs (coloured in warm tones).

I made sure not to add any sharp details to the background (besides a few stars), as that would have shifted the focus away from the main figure. Some colour balancing was applied to the background layer. In all, the illustration took about 12 hours to complete.

CREATING TEXTURES

THE SECRET TO CREATING A REALISTIC, NATURAL TEXTURE IS, in a word, *Noise*. Natural textures are rarely slick, at least not most textures you find on bodies or in clothing. So a working knowledge of *Noise* in Photoshop is essential. Byron Taylor creates and sells his textures for Poser models on www.renderosity.com, but here demonstrates how to make one of your own.

Occasionally, say in the seam areas of the hands and feet, you may find yourself in an area where you can't find the right texture to duplicate and have to make something up. That's where *Noise* could come in. It should be used very sparingly in a photo-realistic texture. It should also be used delicately. Always work with *Noise* on a new layer. The *Eraser* tool can then be used to blend it with the lower layer before applying the *Merge Layers* function.

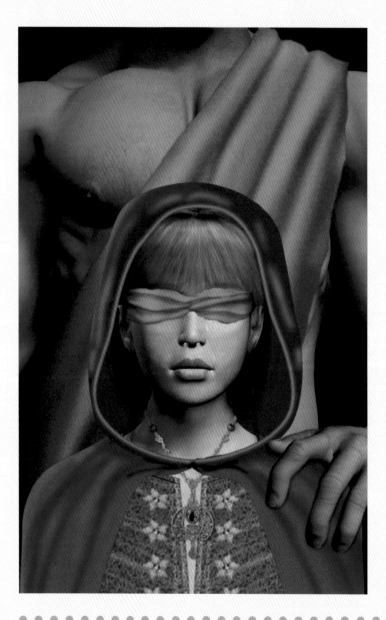

ARTIST
BYRON TAYLOR
TITLE
SEERESS

SOFTWARE USED
ADOBE **PHOTOSHOP**
CURIOUS LABS **POSER**
STEVEN L. COX
UV MAPPER

ADDITIONAL HARDWARE
WACOM **INTUOS**
PRESSURE-SENSITIVE
GRAPHICS TABLET

MANIPULATING NOISE

Experiment with the different settings of *Noise* before you use it.

In (a), you can see a sample of a high *Noise* setting on a white background. Doing a *Blur* on it twice results in (b) – a more natural effect. (c) is the result of selecting an area and doing a *Free Transform* (Command-T or Ctrl-T) on it in one direction, to stretch it.

In (a) a selected area has been *Free Transformed* in both directions, and in (b) it has been blurred further. Making a new channel of this, blurring it with *Gaussian Blur* set at 3, and adjusting the *Levels* so that a lot of the texture disappears, results in (c).

To create (a), make a new layer from a selection of this channel and then apply a *Free Transform* horizontally. Doing the same thing with colour makes (b), which could be applied as a wood grain or as a hair texture. Since the *Noise* is random, it can also be used to make star fields, foliage and so on.

APPLYING NOISE TEXTURES TO FACES

You can see here how plain colour applied to a model – in this case, Victoria 2 in Poser – makes it look very artificial. Starting with a 1000 x 1000 pixel Photoshop file (most Poser textures are created by files with a 1:1 ratio), the background has been filled with a light flesh colour. The settings for this flesh tone are R:228, G:198, B:174.

Now apply a low (6-20) *Noise* (*Filter>Noise>Add Noise*) setting (remembering to keep it monochromatic) and use *Blur* (*Filter>Blur>Add Blur*) on it a couple of times. Rendering with this applied to the face yields a somewhat more natural effect.

4

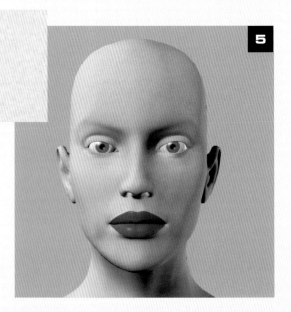

5

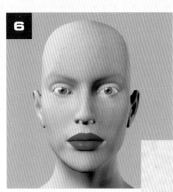

6

To achieve the effect shown here, create a new layer and repeat the process, but apply a higher *Noise* setting (40 or so) and use *Blur* several times. Shift-Select a small area (about ⅛) of this layer (to keep the proportions at 1:1) and *Free Transform* it to fill the image. Then set the layer to *Darken* at an *Opacity* of about 50%.

You can also use the original *Noise* texture as a bump map. The image shows how this would look, applied to the face, with a *Bump Strength* of 76%. This *Noise* method was used to create the basic skin on the texture shown here.

7

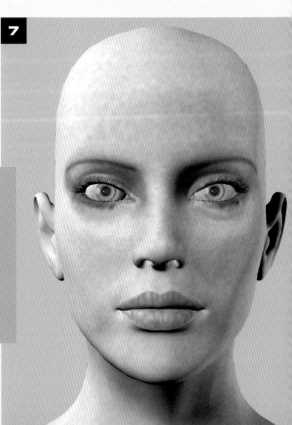

USING NOISE FOR SKIN TRANSITIONS

In Poser, start working with the hand texture — you can see the template lines in the illustration. These templates come with the application, or you can make new ones with UV Mapper. In Photoshop, place a photograph of a hand on a separate layer below the template layer and *Free Transform* it to fit as closely as possible to the template.

When working with photo-realistic textures, keep in mind that you've got most of the references you need, sitting there in your chair. Look at your own hand and see how the different skin textures work together.

What you want to do with *Noise* here is create the transitional area between the skin on the back of the hand and the skin of the palm. Make a new layer (Command or Ctrl+J) of a selection of one finger, *Free Transform* it to fit the template, and erase the area of the finger that is not flexible skin. Keep in mind where this skin texture needs to end, in relation to the template. Use the *Eraser* tool around the back knuckle to blend the finger into the hand, then the *Clone* tool to clean up around the fingernail.

After creating a new layer behind the layer that the hand picture is on, make a selection of the hand by drawing a *Lasso* line around the hand on the template. Then use the *Magic Wand* with the Alt key pressed to deselect everything outside the template area.

Use *Select>Modify>Expand* to expand the selection by three pixels, sample the colour in the finger with the *Eyedropper* tool, and fill the selection on the new layer. Using *Filter>Noise>Add Noise*, and adding about 5% monochromatic, gives a blending texture for the hand, but is not recommended for high-quality textures. Once again, use this technique sparingly, if you use it at all, with photo-realistic textures.

CREATING TEXTURES FOR DARKER SKIN

THE VICTORIA FIGURE FROM DAZ PRODUCTIONS is a very versatile model and lends itself well to customization. As always, it's convincing skin tones that complete the picture. The following steps outline the digital painting techniques Ian and Dominic Higgins employed in creating African female textures for their Shanika character, which is based on the Victoria model.

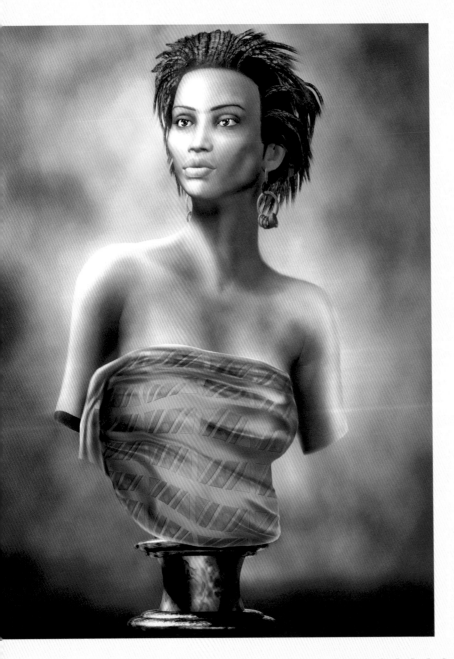

ARTIST
IAN AND DOMINIC HIGGINS
TITLE
AFRICAN PORTRAIT

SOFTWARE USED
ADOBE **PHOTOSHOP**
CURIOUS LABS **POSER**

ADDITIONAL HARDWARE
WACOM **INTUOS**
PRESSURE-SENSITIVE
GRAPHICS TABLET

In Photoshop we began by painting a solid colour within the wire frame shapes on the head texture template for Daz's Victoria figure. We chose a yellow/brown tone for Shanika's base colour. This helped to give the skin tone a golden hue.

Next, we began to build some skin tones. We chose a dark red/brown for the *Foreground Color* (at the bottom of the toolbar) and for the *Background Color* we chose a fleshy brown/pink. On a new layer we created a cloud pattern (*Render>Clouds*). This layer was set to *Hardlight* and faded to 59%.

Noise was applied (*Filters>Noise>Apply Noise*), then the layer was blurred (*Filters>Blur More*) to soften the noise. Next we added the *Crystalize* effect, (*Filters>Pixellate>Crystalize*). We only wanted to use a small setting to create the effect of skinlike cellular patterns.

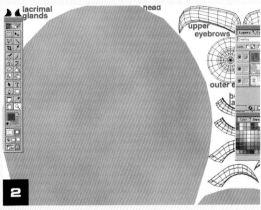

We then duplicated the base layer and, using the *Hue/Saturation* tool (*Image>Adjust>Hue/Saturation*), we set the colour to *Hue* 74, *Saturation* 17, *Lightness* −39. The *Opacity* of this layer was then set to 38%.

We added some *Noise* to the duplicate layer, with a setting of around 3%. Next we applied a little *Blur* (*Filters>Blur>Blur More*) and then the *Crystalize* filter (*Filters>Pixelate>Crystalize*) — here we set the cell size to 3. Finally, the layer was desaturated a little [Command+Shift+U (or Ctrl+Shift+U)].

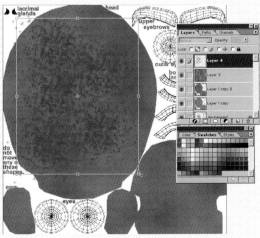

From the brush palette we selected the *Spatter Brush*. In the brush properties we set the spacing to 999. Choosing a dark purple colour and with the brush intensity set to full strength, we applied a few dabs with the *Spatter Brush* on a new layer. Using the *Transform* tool this pattern was stretched so that it covered most of the face. We set the layer mode to *Overlay*, applied the *Gaussian Blur* at about 5.2 and faded the layer to about 14%. The layers were merged and just a little *Noise* added.

As we worked on the details of the texture, we toggled the *Opacity* setting of the base colour layer so that we could clearly see features such as the cheekbones and eye area.

5

6

The two layers were then blended and the *Opacity* set to about 22%. Gradually we built up the porous texture over the face, concentrating on strengthening particular areas such as the cheeks and forehead. Because we wanted to emphasize the pores on certain areas of the face, we used the *Sharpen* tool, set to a low pressure and dabbed the brush around the cheeks and nose. The *Blur* tool was used to help take down the texture on other areas.

To create the effect of pores, we selected the *Paintbrush* tool and opened the brush selections. *Spatter Brush* was selected and once again set to the widest setting: 999. The *Opacity* of the *Brush* was set at 100%. On a new layer, we painted dark spatters, then with the *Transform* tool, expanded the selection to about 140%.

A little *Blur* was added. The layer was then duplicated and, using the *Brightness/Contrast* tool, we brightened the new layer to provide a highlight effect. The layer was then displaced (access this function from the *Distort* submenu). We didn't want to create the illusion of directional light on our texture map, so we didn't use this filter too drastically.

The next step was to start to build some 'shape' into the texture map. Using a darker shade of brown, we airbrushed in some dark areas around the nose, cheeks and eyes. The layer was then switched to *Overlay* mode and faded to 26% and the layers blended.

Using the *Burn* tool, with the exposure set to about 4%, we worked more on the mid-tones and shadows. We were careful not to make the shadows too dark. A little pink was also added around the cheek area. By now, our texture map was beginning to come alive.

7

Since we used Poser 4 to create our model, the biggest challenge we faced in creating an African texture map was to capture the natural sheen on the skin without the aid of *Specularity* maps. This would have to be accomplished instead by painting natural-looking highlights on the texture map.

From the *New Adjustment* layer options we selected *Hue/Saturation* and set the colour to *Hue* 32, *Saturation* 56, *Lightness* −34. The layer was applied in *Screen Mode* and served as the highlights. It was faded to about 25% and, using a large brush and a low setting, we carefully began to mask it away.

8

9

Bearing in mind that the lighting needs to look as neutral as possible on the face, we experimented with several adjustment layers, using different darker and lighter tones and applied them in various lighting modes to enhance cheekbone shapes, eyes sockets and overall skin tones. Then, using various small brush settings, we worked on the detail, such as eyebrows, eye bags and creases. Using a small brush we painted in the shadows and highlights caused by the lip creases, then we added the colour. The lips needed to look fleshy so we chose a pink for the base colour and concentrated on darkening the tone around the edges of the lips.

10

For the eye texture, we created a new document (about 200 pixels x 200 pixels) in Photoshop. We then described a large circle using the *Elliptical Marquee* tool and coloured the circle brown using the *Paint Bucket*. On a new layer, we created a smaller circle, filled it with black and positioned it in the middle of the larger circle to create a pupil. With the pupil layer selected, we applied a little *Radial Blur* in zoom mode (*Filter>Blur>Radial Blur*). We used a setting of 34% and set the quality to *Good*. This gave a much softer edge to the pupil.

Next, we began to work on the pattern and structure of the iris. On the toolbar, we changed our foreground colour to a much darker tone of brown and our background colour to a much lighter tone. We then duplicated the iris layer and filled this with the *Cloud* filter. We applied a little noise to break up the cloud pattern. With the iris still selected, we applied the *Radial Blur* filter in zoom mode with a setting of about 24%, after which point we had something looking like an iris.

11

12

Our next step was to work on the iris coloration. We did this with the aid of several adjustment layers. By using *Hue/Saturation* and *Brightness/Contrast* modes, we created variations of the iris colour. We then masked away parts of these adjustment layers and faded their *Opacity* so that we were left with areas of subtle variations in colour. We kept the colour darker around the edge of the iris. This stage is the most time-consuming and requires plenty of experimentation. A little spot of reflection was added to complete the effect.

When we were happy with the effect, the layers were merged. The iris/pupil layer was then dragged onto the face texture map and resized to fit the iris/pupil template. On a separate layer, beneath the iris/pupil layer, the white was coloured and details such as veins added.

On a new layer we painted a grey/yellow colour over the eyes. The layer was switched to *Overlay* mode and faded to about 15%. This helped to give our eyes the correct coloration. Finally the texture map was merged and a little more work carried out on the overall colouring.

13

COMPOSITION

I F YOU LACK THE SKILLS TO DRAW HANDS, you can leave them out of the picture. If a 3D model doesn't turn out as well as expected, you can pose it from a different angle. But if your composition skills are weak, nothing with the exception of improving them will make that weakness go away. Here Ken Gilliland describes how he worked on the composition of *Waiting*.

ARTIST
KEN GILLILAND
TITLE
WAITING

SOFTWARE USED
CURIOUS LABS **POSER 5**

For the creation of the main subject of the piece, I began as I usually do in Poser by loading a stock model. I then slowly refined the character and expression using the software's morphing dials. Once a few test renders were done and I was happy with the character, I added the hair and clothing. Lights and camera angle were then chosen. I found the profile of the model very '1920s retro' in feel and this guided the structure and mood of the final image.

For *Waiting* I created a background image using the period buildings, truck, and the diner gents without including the foreground girl. Besides the three default Poser lights, four 'spots' and two subtractive lights were used to emulate the night-time lighting in the diner. The scene was then rendered as a *Background* image. I created the background separately because of the geometry-laden aspects of the models. Resolving the background's geometry to a 2D image cut down on the render time.

2

I reloaded my original '1920s retro girl' file and set her to the period background. I took special care to ensure that the scene lighting matched with the background image. With the images in place, it was time to start thinking about the final composition. When viewing an image, people normally start on the left side and move to the right. Many compositions fail because they do not understand this simple rule – in vain they try to keep the viewer's eye to the left or dead centre.

4

This is a fairly simple composition. As the viewer, your eye is drawn into the diner by the architectural lines and the men inside (1), then moves immediately to the girl (2), wondering what she's up to, then opens the door knob (3) which invites you back in (4) to start all over again (1). The girl was placed close to the edge of the right side to slow down the viewer and encourage them to do the turn around to the café. Arranging the composition in this repetitive fashion helps to keep the viewer interested in the image.

During the Renaissance, many artists found that placing an image off-centre at a third mark on the composition made the image more pleasing to the eye. This is known as the 'Rule of Three' or 'Magic Thirds'. With this image, the café windows start on the left edge, middle third, thus indicating compositional importance. This allows the viewer's eye to be welcomed into the composition. You'll next notice that the seated man wearing the fedora is on the first third line, which is where your eye would first go. The girl's face is locked directly into the right end middle third, an important compositional area. Positioning the participants in this way suggests, compositionally at least, that the two are paired.

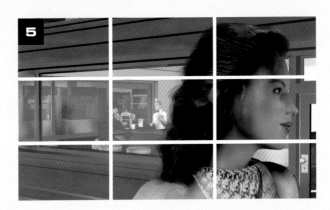

LIGHTING FIGURES IN POSER

CREATING REALISTIC LIGHTING IN POSER IS CHALLENGING. However, with the use of spotlights you can create some pretty dramatic scenes and produce some great shadows. The lighting in *Snake Charmer* consists of three main lights. This is known as the three-point process and will be referred to here as the Key, Fill and Side lights. Additional lights may be added if your scene requires them.

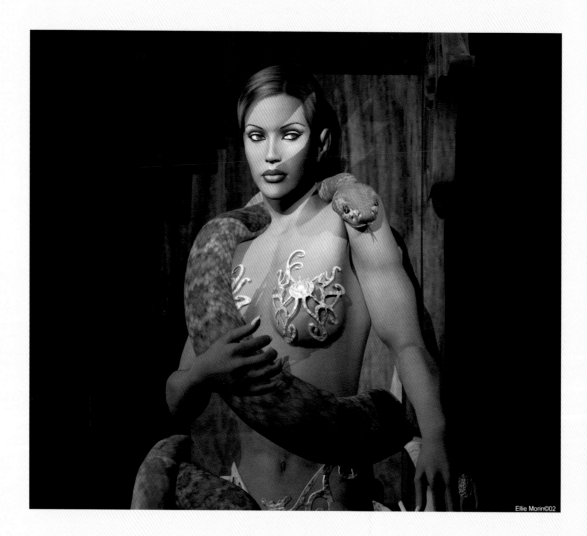

Ellie Morin©02

ARTIST
ELLIE MORIN
TITLE
SNAKE CHARMER

SOFTWARE USED
CURIOUS LABS **POSER 5**

When you first open Poser, three default lights appear, known as ambient or infinite lights. The defaults simply light up your scene and tend to make your subject look flat. Here a new scene has already been created, with all the default lights deleted as shown.

To add a new light, double click on the symbol that looks like a light next to the light controls. Then click on the symbol that looks like a spotlight. A pop-up window appears and displays the *Properties* and *Parameters* palettes for the new light. Rename the light Key. The Key light is used to illuminate your main figure and is usually the brightest of the lights and casts the darkest shadows. It is normally placed behind your main camera at an angle of 15 to 45 degrees. Now click on the *Parameters* tab. You can use the *Parameter* dials to position lights or you may choose simply to grab a light using the *Push Pull* tool, and pull it to the position in which you want to point it. Using the dials, change the parameters to the positions shown in 3 and 4 and leave all other dials in their default positions.

The next step is to create a Fill light. The Fill light softens the shadows of the Key light and simulates a secondary light source. The Fill light is usually placed to the right of the Key light and also points at the subject. Using the same steps as before, create a second light and name it Fill. Under the *Properties* tab, turn off the shadows and change your *Parameter* dial settings to reflect those shown here.

Now create the final light and name it Side. The Side light is also a supplemental light and acts to accentuate and highlight the textures of the subject. The Side light can be placed on either the right- or left-hand side of the subject. When creating this light you will want to turn off the shadows under the *Properties* tab. Change your *Parameter* dial settings to reflect those shown. Under *Object* in your tool bar, click *Point At* and in the *Hierarchy* click on the Head.

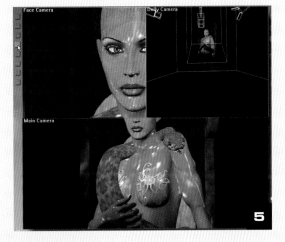

Poser gives you the ability to view your scene using various split-screen views. In the next example, the fourth tab to the left of the main window has been clicked on to show the *Face*, *Dolly* and *Main Camera* angles. Note the positioning of the Side and Fill lights, while the Key light is positioned behind and slightly above the main camera. You can manually move the positions of any of these objects by placing your cursor on either the *Camera* or *Lights* and dragging them to a new location. Remember that in doing so, your *Parameter* dials will automatically change.

For comparison, here are the before and after shots, first using the default ambient lights and then the three spotlights.

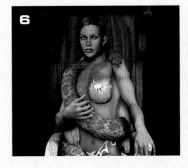

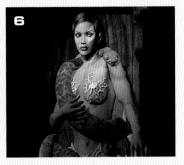

ADDING CHARACTER

WHAT DISTINGUISHES A PARTICULAR ILLUSTRATION from others? Design and technique are of course relevant, but to set an image apart you need character. Character brings a figure to life, gives it soul. You'll have seen many illustrations and renders where the figures are simply there. They are static, giving no sense of life or rhythm. Character is, however, an elusive concept. What gives one figure character and another not? Daniel Murray demonstrates how he addresses this question, focusing on how he created *Oni* (a Japanese word meaning 'ghost').

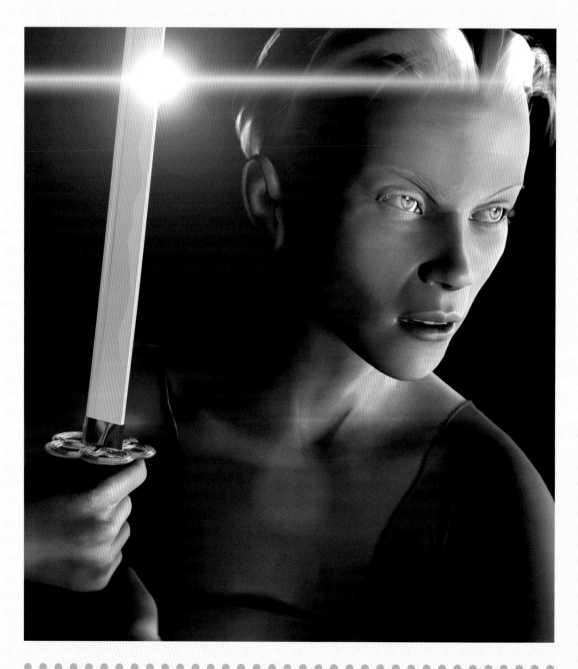

1

The image features a generic female figure rendered in Poser. I use high resolution texture maps for my work because I like a great deal of detail, especially in the face and hands of a figure. The map used for this figure is 100 dpi at a 3000 x 3000 resolution. Working at this size makes life much easier. My images are output in a .tif format at 300 dpi and at around 2500 x 4000 pixels in size. Bigger is always better, especially if you ever plan to go to print with the final render.

2

ARTIST
DANIEL SCOTT
GABRIEL MURRAY
TITLE
ONI

SOFTWARE USED
ADOBE **PHOTOSHOP**
CURIOUS LABS **POSER**

ADDITIONAL HARDWARE
WACOM **INTUOS**
PRESSURE-SENSITIVE
GRAPHICS TABLET

3

I usually have a pretty clear idea at the outset of what I want to appear in the final image. In this case, I added a katana prop sword and maneuvered the figure into the basic position I wanted. In Poser you can add props by selecting them from the *Props* category in the *Library* palette, or import third-party props in a variety of 3D formats. Props can be edited in the same way as other scene elements—by using Poser's tools and the *Parameter* dials, or by specifying values in the *Properties* palette.

I added some prop-based hair and started to change the camera angles to achieve the look and feel I wanted. I usually approach projects from a very cinematic point of view. Character for me is such things as the feel of the skin and the depth of the eyes. I tend to position the full body even though I will only use a close-up.

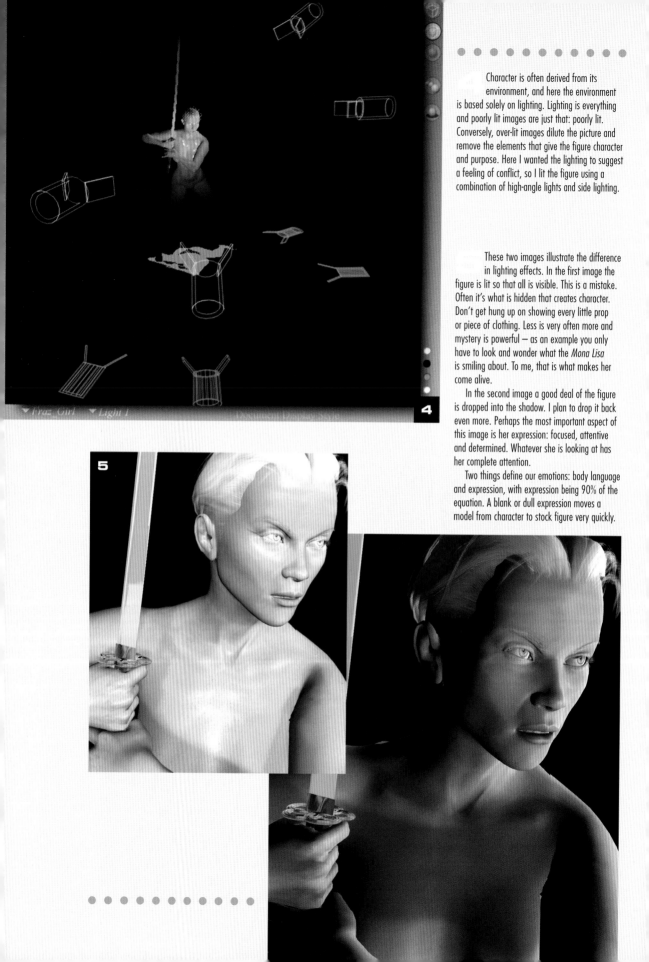

Character is often derived from its environment, and here the environment is based solely on lighting. Lighting is everything and poorly lit images are just that: poorly lit. Conversely, over-lit images dilute the picture and remove the elements that give the figure character and purpose. Here I wanted the lighting to suggest a feeling of conflict, so I lit the figure using a combination of high-angle lights and side lighting.

These two images illustrate the difference in lighting effects. In the first image the figure is lit so that all is visible. This is a mistake. Often it's what is hidden that creates character. Don't get hung up on showing every little prop or piece of clothing. Less is very often more and mystery is powerful — as an example you only have to look and wonder what the *Mona Lisa* is smiling about. To me, that is what makes her come alive.

In the second image a good deal of the figure is dropped into the shadow. I plan to drop it back even more. Perhaps the most important aspect of this image is her expression: focused, attentive and determined. Whatever she is looking at has her complete attention.

Two things define our emotions: body language and expression, with expression being 90% of the equation. A blank or dull expression moves a model from character to stock figure very quickly.

Before rendering, I alter the focal
length on my render camera. In Poser,
the default camera is set at somewhere around
38 mm. I usually set this at anywhere from
25 mm to 35 mm for the most part, with 25 mm
being toward the 'fisheye' end of the spectrum.
Once the camera angle is selected, the image
is rendered.

Here the image is presented with a dual
tone to illustrate the technique I've used to bring
out the depth of the skin tone. The right side is the
affected side, the left is the raw render. To achieve
this effect, I moved to Photoshop and created a
duplicate layer of the figure image. From the
Layers palette, I selected *Overlay* for this new
layer. Still in the *Layers* palette, I fiddled with
the *Opacity* levels to get the effect I desired.

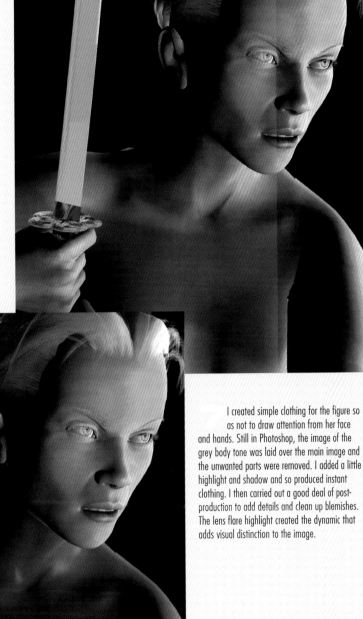

I created simple clothing for the figure so
as not to draw attention from her face
and hands. Still in Photoshop, the image of the
grey body tone was laid over the main image and
the unwanted parts were removed. I added a little
highlight and shadow and so produced instant
clothing. I then carried out a good deal of post-
production to add details and clean up blemishes.
The lens flare highlight created the dynamic that
adds visual distinction to the image.

MANIPULATING FIGURE GEOMETRY

WHEN WORKING WITH THREE-DIMENSIONAL ART, it really helps to become versed in the manipulation of geometry. Rather than start from scratch, however, you'll find a plethora of programs and companies that provide the means to do this. For example, Curious Labs' Poser gives you a virtual stage with characters that come ready for movement from head to toe. The models from DAZ Productions and others ship with an ever-growing range of morphs that allow you to do such things as add muscularity, reshape the curve of the lips or flare the nostrils with the turn of a dial. Poser comes with tools called magnets that allow you to attempt your own morphs but there has to be enough geometry to support large modulation of the mesh. The Millennium models from DAZ and Version 5 of Poser supply models with such a high geometry resolution. In this project Cris Palomino uses morphing to personalize a figure and adds some post-production to make it unique.

ARTIST
CRIS PALOMINO
TITLE
THE SEDUCTRESS

SOFTWARE USED
CURIOUS LABS **POSER**
PIXOLOGIC **ZBRUSH**
DAZ PRODUCTIONS
'STEPHANIE' MODEL

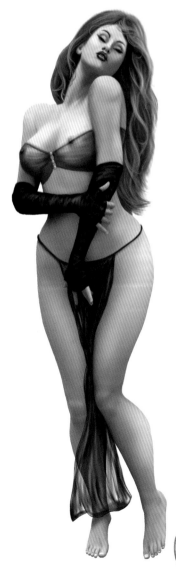

To create *The Seductress*, I used morphs that come with 'Stephanie' plus ones I created in Poser and ZBrush. Morphs can be created in other programs as well, such as Rhino from McNeel & Associates, Amapi by Eovia and Lightwave from NewTek. Each requires a different level of expertise. In this image you can see Stephanie posed, but straight out of the box with no morphs added on the left. On the right, the addition of texture maps begins to soften the model and create her human appearance.

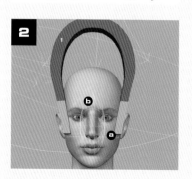

The magnets used in Poser to create morphs consist of several elements. The *Magnet*, which looks like a magnet, is the actual deformer. Scaling along an axis or moving from side to side produces a direct effect. The *Magnet Base* – a bar at the base of the *Magnet* handles (a) – is the magnet's target area, while the *Magnet Zone* – represented by a ball or ellipsoid (b) – is the spherical area of influence.

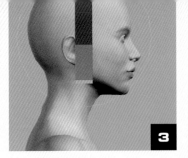

3

The easiest way to work with the magnets is to change their *Element Display Style* (click and hold on the triangle next to the default *Document Display Style*). If you change this to *Outline* the magnets won't obscure what you are working on.

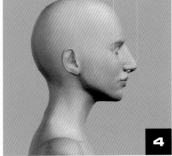

4

I usually try to see where and how the magnet affects something by applying a high percentage of change such as 150% or more. Once that is done, I can see where to move the base to pinpoint the target area. From here I can start resizing the zone of influence to see what effect that has and what still needs to be changed.

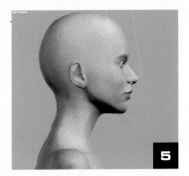

5

Sometimes, as in this case, a rotation of the magnet will provide the desired effect. The more you experiment with size, rotation and orientation of the three elements of the magnets, the more you will learn, while at the same time gaining precision and expertise.

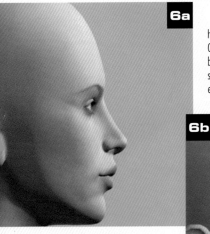

6a

6b

6c

The strongest part of the effect is at the centre of the sphere and the effect falls as it nears the outer edge of the sphere. The nose of *The Seductress* was created using three magnets: two to shape the bridge and one to contour the end of it. The three images here show the magnet's influence and the before and after stages.

Once the figure is morphed, my next consideration is hair and clothing. Many good clothing and hair models are available, but I prefer to paint them by hand. In this way I have more control over the figure and how it finally looks. I usually carry out such post-production using Adobe Photoshop and Corel Painter, but something like Jasc Paint Shop Pro could also be used. In this image I've blocked in my clothing using Photoshop's *Airbrush* and *Pencil* tools. Sometimes I paint a sheer fabric from the onset and sometimes I use modes in Photoshop to achieve the effect. Note that the top and gloves are opaquely painted.

Experimentation and trusted technique together become the cornerstone of any good working relationship with a paint program. The key is to have as many elements as you can on separate layers. This gives you control and the ability to use different modes on individual parts. Some of my more complex images have up to 30 layers, but *The Seductress* contains seven. These are: the base render (*Levels*, *Saturation* and *Hue* manipulated); airbrush coloration, correction and enhancement; hair; painted clothing to create a sheer effect; opaque clothing set to *Multiply*; shadows; and finally my signature block which was created in 3D and is coloured or set to an effect that will not detract from the image.

7

8

MANIPULATING 3D FIGURES

THE VICTORIA MODEL FROM DAZ PRODUCTIONS is a highly detailed 3D generic female model that has an extensive list of morph dials, giving you the ability to model your own custom figures from within Poser itself. Although most of the Higgins brothers' characters start with the manipulation of the Victoria morph dials, at some stage they usually export the head mesh into ZBrush. This program allows them to resculpt the imported head in real time, as though it were made of clay. It can then be exported back as a morph target and applied to the Poser character. In this project, Ian and Dominic Higgins describe how they manipulated the basic figure model of *The Siren* in Poser and ZBrush, and then finished off with a quick makeover and new wardrobe in Photoshop.

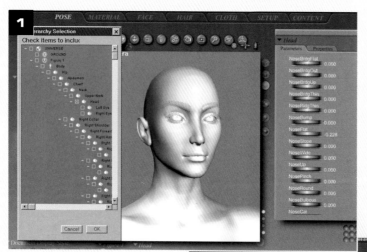

We first imported a head into ZBrush, exporting it from Poser as a Wavefront OBJ file. When you do this, make sure you only select the head from the scene's hierarchy list and choose *As Morph Target (No World Transformation)* from the final dialog box. Importing 3D objects into ZBrush may seem a little strange and convoluted if you're not familiar with the program, but after a little practice, you soon get the hang of it.

With the exception of the *Save* document option, the tools we used to create our custom morph in ZBrush are all located on the menu panels. The panel at the top right of the screen is the *Tool* menu. To import the OBJ, click the star-shaped button: this is the *Polymesh3D* tool. Next, open the *Inventory* menu and select *Import*. When you import your head mesh, you'll notice that it appears in the *Tool* menu, but not in the working window.

Left-click your mouse in the middle of the empty window and, keeping it pressed, drag it slowly downwards. The imported head now appears, getting bigger and bigger, until you stop dragging.

Once the head OBJ is in ZBrush, you need to switch to edit mode. To do this, you select the edit object icon in the *Transform* panel or press T on your keyboard.

ARTIST
IAN AND DOMINIC HIGGINS
TITLE
THE SIREN

SOFTWARE USED
CURIOUS LABS **POSER**
PIXOLOGIC **ZBRUSH**
E-ON **VUE D'ESPRIT**

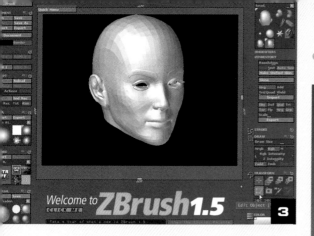

3

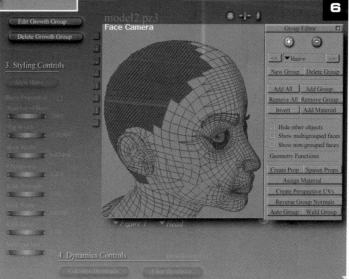

4

ZBrush has a *Symmetry* function that allows you to work on two sides of the head at the same time. It's at the bottom of the *Transform* menu. Select X from the symmetry options and make sure *Mirror* (M) is also selected.

To create our morph, we used the *Move* tool, which is also located in the *Transform* menu. In the *Draw* menu, you'll find the size and pressure settings for this tool. We set the size to about 12 and the Z Intensity to about 3. It's best to keep the settings fairly low as higher settings can cause unpredictable results.

Using the *Move* tool, we began to resculpt the face by gently pushing and pulling various parts of the mesh, rotating the head around constantly as we worked, so that we could view the face from different angles.

Once we were pleased with the head, we named it and exported the mesh as an OBJ. In Poser, we applied the OBJ as a *Morph Target,* by double clicking on our model's head, selecting *Add Morph Target,* and then selecting the OBJ that we had just exported from ZBrush.

We next positioned the model in a suitably dramatic pose using both the *Editing* tools and *Parameter* dials. We've found that some Victoria and Michael Models from Daz Productions tend to fold and 'break' around the joints when positioned in more elaborate poses. But fortunately when you are working in 2D, this isn't a major problem as they can be airbrushed over when exported into a 2D package such as Photoshop.

The lighting was also worked out at this stage. We positioned several *Spotlights* around the figure and used one *Infinite Light* to give general illumination to the scene.

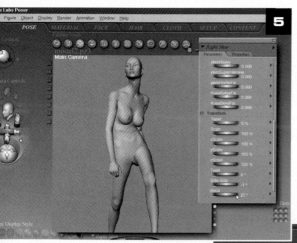

5

6

The next step was to start work on the woman's hair. With Poser 5, you now have the ability to literally grow hair on the surface of your 3D creations. This is all done within the new *Hair Room*. The hairstyle we wanted to create for our character had long flowing locks down the sides and back of the head, with a fringe over the forehead. We created two different *Growth Groups,* one for the sides and back of the head and a second for the top of the head. Using the *Group Editor* tool from the tool bar, we selected the individual vertices of the head to be included in each *Growth Group.*

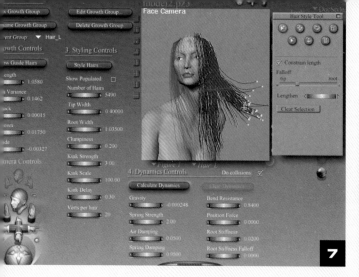

Once we had created our growth groups, we grew the hair guides and applied various parameter settings from the styling options available. Then, using the *Hair Style* tool, we selected various hair strands and sculpted the hair into the exact wind blown style we wanted. This was the trickiest and most time-consuming part of the process and involved us working on the hair from several different angles.

The option of switching to a 'blocked in' preview of the hair proved very useful as it allowed us to see how the hair was shaping.

Before rendering the image, we increased the *Map* size for each of the lights used in our scene. The *Map* setting is located in the light's *Parameter* list. The higher the value here, the better the results.

We rendered the model using Poser 5's new FireFly render engine and exported the image into Photoshop. We then opened the image's alpha channel and made a mask selection of the figure, enabling us to work on the figure without the background.

The next step was to work on the hair. On a new layer, we created a 'block of hair' (see *Creating Hair Textures*, page 102). The 'block of hair' layer was duplicated and the original layer was made invisible and left in case at any time we needed to start the modelling and shaping process from scratch. The duplicated hair layers were then shaped using the *Shear* filter, *Liquify* tool and *Transform* tool [Command+T(or Ctrl+T)]. Once the hair had been shaped it was necessary to work the *Sharpen* tool over certain parts of the hair to redefine detail that had been lost during modelling.

We started the dress by painting in the basic shape. To help recreate the right look for our material it needed to appear more transparent in certain areas, such as on the thighs and abdomen. We created a mask on our layer and using a brush set to about 5% we carefully began to 'fade' down parts of the dress. The *Burn* tool set to about 4% was also used. This helped to create the look of thin material pulled tightly around the upper legs and other areas.

When we were done, we set the layer at about 65% *Opacity*, so that we could see where the folds and creases would fall.

To create realistic material, we painted in the creases and folds on a new layer, using a darker tone for the dress colour. Using the *Smudge* tool, with the pressure set to about 20%, we carefully began to work on their shape. To create our highlights, we duplicated the layer and increased the brightness value to +100. We then displaced the highlight layer and, using the *Smudge* tool worked on shaping it. After experimenting with the strength of this layer, we blended the shadow and highlight layers and worked further on the shaping of the creases and the folds.

We created the floral patterns for the dress from various pieces of clip art. For the hem, we tiled the pattern and then dragged the layer into our figure document. We faded the *Opacity* to about 50% and, with the aid of the *Distort* filters and the *Liquify* tool, we shaped it to fit the hem of the dress. When the modelling was done, we turned the layer *Opacity* back up to 100%. For the pattern down the side, we kept the *Opacity* at 76%. Finally, when all the dress layers had been blended, the finished dress was set to about 90%.

We used Vue d' Esprit to create the stormy sky for the background. Once rendered, we exported the image into Photoshop, where we experimented with various blending modes and adjustment layers before we were finally happy with the sky's colours. Once all the elements were in place, we flattened the image and experimented with additional adjustment layers to help blend it all together.

CREATING HAIR TEXTURES

IF YOUR AIM IS TO CREATE REALISTIC HAIR, then you will need to spend some time studying hair up close. Pay particular attention to the texture and the way light catches strands of hair. Also, make sure you have some kind of reference material, such as a photograph, close at hand as you work. Here Ian and Dominic Higgins outline the techniques they used to create textures to simulate hair for their image *The Heart's Far Cry*.

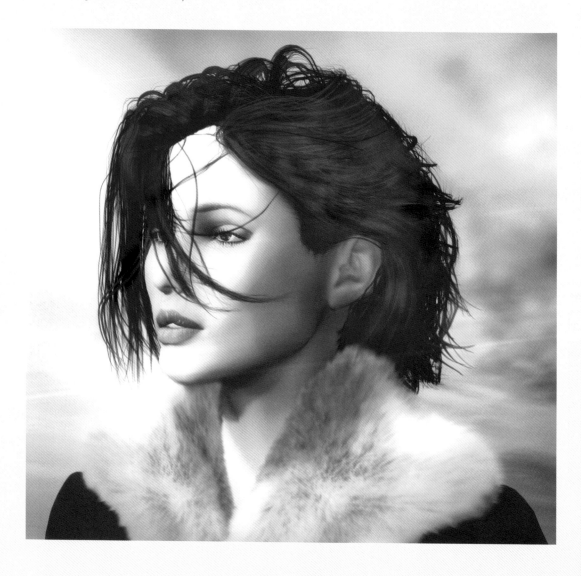

ARTIST
IAN AND DOMINIC HIGGINS
TITLE
THE HEART'S FAR CRY

SOFTWARE USED
ADOBE **PHOTOSHOP**
CURIOUS LABS **POSER**

First, we imported the rendered image of a Poser figure into Photoshop and made a mask selection. This enabled us to separate the figure's head from the background. We then deleted the original layer. Next we created a new layer and made the figure's layer invisible (to make things easier while we worked on the hair).

On the new layer we created a large square with the *Rectangular Marquee* tool. Selecting black as our foreground colour and white as our background, we filled the box with *Clouds* (*Filter>Render>Clouds*).

To create the effect of individual strands, we first added some *Noise* (*Filter>Add Noise*). We set the distribution to *Uniform* and checked the *Monochromatic* option. This applies the filter to only the tonal elements in the image without changing the colours. We set the value of this filter to around 82%.

We then deselected the *Marquee* box and applied some *Motion Blur* to the pattern. We set the blur *Angle* to –90 degrees and the *Distance* to about 54. Too much blur can result in too smooth a texture for hair.

Using the *Free Transform* tool (Ctrl+T or Command+T or right-click on *Mouse>Free Transform*), we stretched and squashed the layer a little. We now had something that was beginning to look like hair.

To help add a little sheen to our hair, we duplicated the hair layer and again applied the *Noise* filter. This time we used a setting of about 32%. A little *Motion Blur* was then applied to the layer. We only used a *Distance* setting of about 4 for this, but you may want to experiment with different settings.

The layer was switched to *Lighten* mode and faded to about 59%, so that only the layer's highlights would be visible. We then applied a mask and carefully painted away parts of the layer to create the illusion of light catching the individual strands of hair.

To create ends to our patch of hair, we chose to use the *Spatter Brush* from the *Brush Style* menu and set the *Spacing* to 999. On a new layer, we applied the brush along the bottom edge of the 'hair'. By using slightly different brush sizes we avoided making the pattern look too repetitive. Gradually we built up the ends of the hair.

5

6

Motion Blur was added to the *Spatter* layer. We used a value of 50%. The layer was then stretched slightly before being *Merged* to the hair layer. Some blending work was needed to finish the effect. We used the *Burn* tool with the range set to *Shadows* (so that only the dark areas and not the highlights would be affected) and painted over any areas where the joins were visible. A little more *Motion Blur* was added to complete the effect.

Now that we were ready to start modelling the hair, we made the figure layer visible once more. However, before we started the modelling process, we duplicated the hair layer and made the original layer invisible. This would prove useful if we needed to start again during the modelling process.

To help us create that sweep to the hair on the sides of the head we used the *Shear* tool (*Filter>Distort>Shear*). You'll find that this process requires some trial and error on your part to get right, so you will need a little patience and persistence.

Using the *Free Transform* tool enabled us to position the patch of hair so that it would flow in the proper direction. To refine the shape of the hair we used the *Liquify* tool (*Filter>Liquify*). First introduced in Photoshop 6, the *Liquify* tool enables you to distort images using an intuitive brush-based interface. Using this tool we were able to literally 'sculpt' the shape in real time.

7

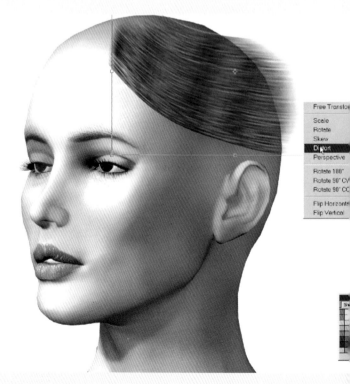

Once we had created our first patch of hair, we duplicated the process to create several more and gradually built up the hairstyle. Each patch of hair was shaped and modified using the *Shear* and *Liquify* tools. The *Brush* tool was used for more detailed painting work, such as fine hair strands.

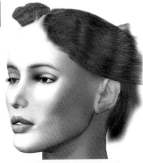

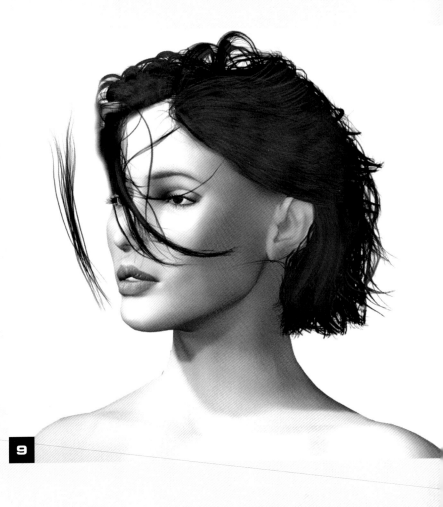

To create those loose strands of hair blowing in front of the face, we simply repeated the above steps then, using a combination of the *Shear, Liquify* and *Smudge* tools, shaped it accordingly. The *Sharpen* tool was used to redefine any detail in the texture that had been lost during the modelling stage.

For fine detail work, we used small brush settings and worked the *Smudge* tool around the edges of the hair. Setting the brush to *Darken* mode enabled us to manipulate just the dark tones of the layer.

To help enhance the feel of movement we blurred some loose strands of hair. We did this by selecting the *Blur* tool and a small brush size. With a low-pressure setting we then applied the brush to the strands.

The next step was to blend the hair layers together. Some shadow was needed under the hair to complete the effect. We created a new layer under the hair layer and carefully painted in the shadow areas. The shadow layer was then faded to about 35% and blurred. Finally all layers on the image were merged and some additional work on colour and lighting was carried out to complete the painting.

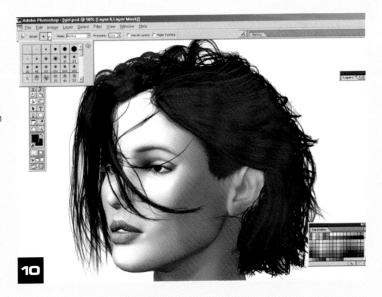

CREATING CLOTHES AND HAIR

WHEN PAINTING CLOTHING AND HAIR, it helps to have references around. Keep a folder of reference material near your computer: pictures from magazines, books and so on. Or take a look at a few books out there that specialize in instructing the artist on how to draw clothing and drapery. Some of the techniques described here by Will Kramer can also be used for painting all kinds of things in Photoshop. Never forget where the light in your scene is coming from – it affects everything.

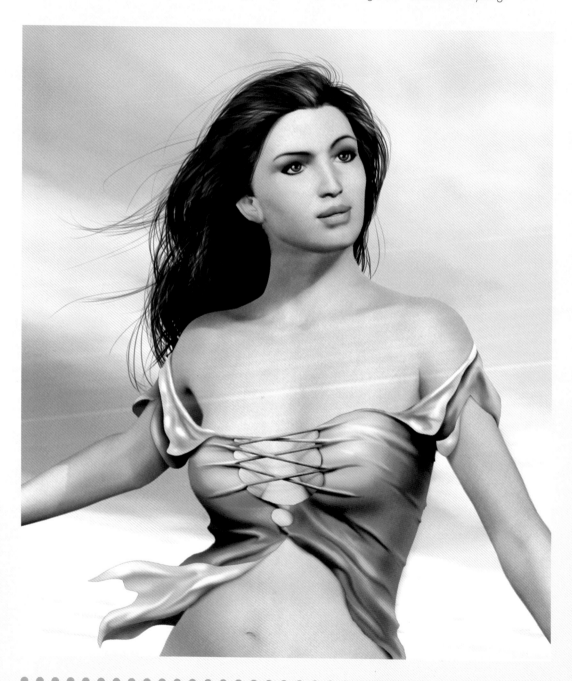

1

I began by setting a basic relaxed pose in Poser, and then exported the figure as a wavefront object (obj). After setting a couple of lights, getting a comfortable sky and texturing the figure, I rendered a full picture and created a mask render in Bryce. I made the picture about 2,500 pixels high. The larger the better — you'll find the later details easier if you begin large.

In Photoshop, I cut and pasted the mask render into a new alpha channel of the main full-colour picture, allowing me to select the figure cleanly and place her on her own layer. Usually a Poser figure has certain inherent oddities in the mesh or texture (various folds, corners, rough areas). I airbrushed these away, made some colour corrections, and painted some more here and there until I was satisfied with the overall skin tone. I also enhanced a few shadows, highlights and wrinkles.

I concentrated next on the clothing. Moving to more of a close-up view, I selected a colour and a small brush, and started painting an outline of the main garment. At this point, it didn't matter what colour I chose, as long as it contrasted fairly well with the background — that is, as long as I could see it.

You need to think about your scene… what is happening? In this scene the wind is blowing, and this governed everything I painted in the woman's clothing, and then later in her hair.

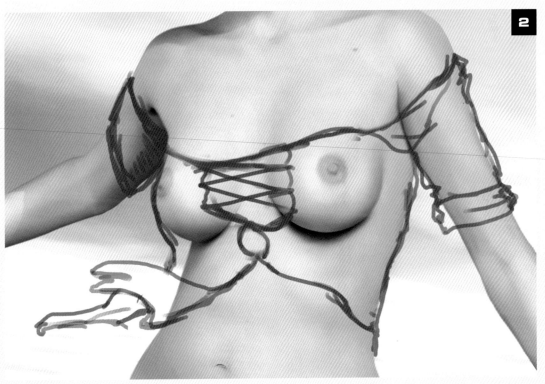

2

ARTIST
WILL KRAMER
TITLE
WIND

SOFTWARE USED
ADOBE **PHOTOSHOP**
CURIOUS LABS **POSER**
COREL **BRYCE**
COREL **PAINTER**

ADDITIONAL HARDWARE
WACOM **INTUOS**
PRESSURE-SENSITIVE
GRAPHICS TABLET

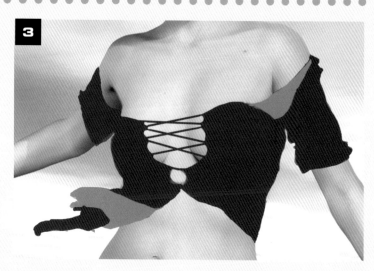

Here is the general outline of her blouse with blocked-in colours, along with some parts that are folded over. I did these in a different colour – not actually the final colour – so I could tell the two sections apart. For the laces, I used the *Pen* tool to create a path zig-zagging back and forth across her chest. After creating the path, I made sure that the last paint brush I had selected was hard-edged and around 5 pixels in size.

On *Brush* options (for the pen tablet), make sure the checkboxes that vary *Opacity* and *Size* with pressure are unchecked. Then go back to your *Path* palette (usually hidden behind your *Layer* palette) and hit the circle at the bottom that will stroke the path with your current paintbrush. You've got your laces.

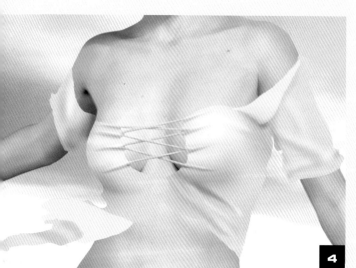

I decided to go with more of a cream colour for the woman's blouse. I duplicated the blouse layer so I could experiment without making any permanent changes. In the *Hue/Saturation* menu I clicked the *Colorize* button, then I played with the sliders until I had a suitable colour.

I next started work on some shadows using the *Burn*, *Dodge*, *Smear* and *Airbrush* tools. Working on the laces, I used the *Burn* tool to darken the bottom edges and the *Dodge* tool to lighten the top edges. I set a small brush to around 20% *Opacity*, making sure I made only small changes at a time.

For some of the creases I set the layer *Opacity* to 85% or so, just enough to see the underlying body. Once I had an idea of where the shadows should go, I took the *Opacity* back to 100%. After getting a few of the folds in, I gently used the *Smear* tool to move the cloth around. Be careful with the *Burn* tool. It's easy to overuse it and find yourself getting farther away from the colours in your clothing. Depend on your airbrush for most of the shading and you'll stay closer to your vision throughout the painting process.

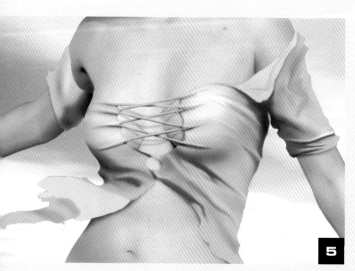

In this step you will notice that the overall colour of the blouse has become darker. There are many ways to achieve this. One method is to duplicate the blouse layer, colourize it, play with the colour balance and then set the blend mode to *Multiply*, *Overlay* or *Soft Light*. In this step there are also a few refinements in the folds and in one of the sleeves. I varied the mode of the layer, sometimes to preserve transparency. But if I'm airbrushing, it certainly helps to make sure I don't paint beyond the edges.

On the woman's skin I airbrushed a few shadows created by the blouse. To do this, I first created a new layer between her body and the blouse. Then using an airbrush set to 5% *Opacity*, I gradually worked shadows in, using a combination of black, a dark skin colour and a very dark blue. This last colour was used for two reasons: the colour blue can be found in all shadows, and the blue sky around the figure will find itself reflected in all kinds of places where you would never think to look. For the shadows created by the laces in her cleavage, I used a smaller airbrush and painted with 4% *Opacity*.

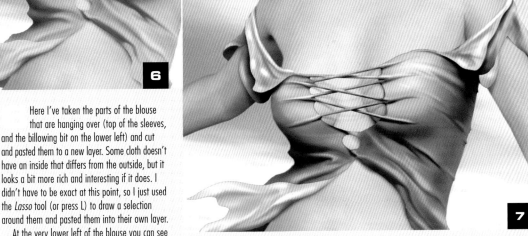

6

Here I've taken the parts of the blouse that are hanging over (top of the sleeves, and the billowing bit on the lower left) and cut and pasted them to a new layer. Some cloth doesn't have an inside that differs from the outside, but it looks a bit more rich and interesting if it does. I didn't have to be exact at this point, so I just used the *Lasso* tool (or press L) to draw a selection around them and pasted them into their own layer.

At the very lower left of the blouse you can see where the cloth goes behind the woman's body. You can paint this area without worrying about painting over her body. Just paint away, and then when you have it done, hold down the Command (or Ctrl key) while clicking on the layer containing the figure, and you'll see a selection based on the body layer. Get your *Eraser* out (or press E) and erase the part of the blouse in front that's supposed to go behind.

7

What you see now is the finished blouse. Having the laying-over parts of the blouse on a separate layer allowed me to do a couple of things. Firstly, I could adjust their colour, making sure they were consistent without changing the main blouse. It also made it easier to airbrush their shadows underneath, on the blouse and skin.

Next I clicked the button on the layer palette to create a mask for the lace shadows layer. Using a large airbrush, I painted in the mask, making the lace shadows in the centre of the woman's chest fainter than those where the blouse is very close to her skin.

The highlight along the left side of her blouse is worth a mention here. If you notice the darker shadow that runs down her side, you'll see that it does not run down the edge of her blouse. In this picture the cloth has a sheen. Near the edge, it reflects a brighter colour brought on by the light in the scene. The blouse cuts into the skin slightly and the skin will react by being pulled in just a bit or bulging out, depending on the garment.

7

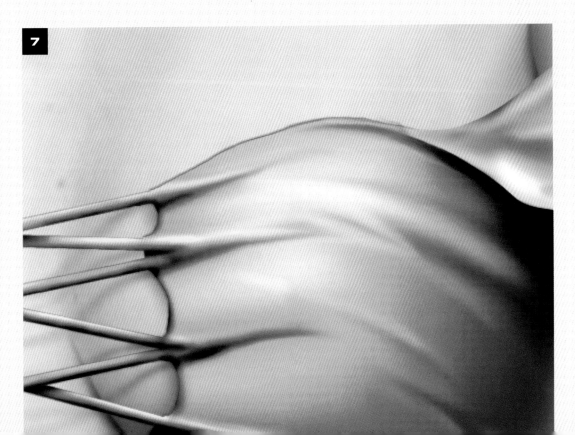

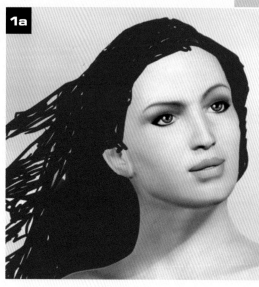

1a

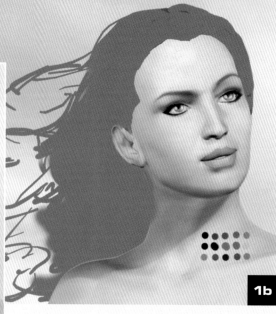

1b

PAINTING THE HAIR

Switching to concentrate on the hair, I created a new layer above the body, selected a smaller paintbrush and began to scribble. Using the pen tablet, I unchecked the box to vary *Opacity* with pressure, to get dark, solid lines. Occasionally, I lowered the *Opacity* of the layer to see the woman's scalp more clearly. Then I would increase the layer *Opacity* and return to painting.

I decided to cover both blonde and brunette hair in this project, and so show the similarities and differences between the ways of approaching each hair type. Looking at the fair-haired figure, you will see a series of coloured dots on her neck. These dots made up my hair palette. I opened up a source file, a photograph of real hair, and sampled a few highlights, mid-tones and shadow colours. I was then able to use these in my picture by holding down the Alt key and turning my brush cursor into an eyedropper, allowing me to select from these colours. Lifting my finger off the Alt key turned the cursor back into the paintbrush.

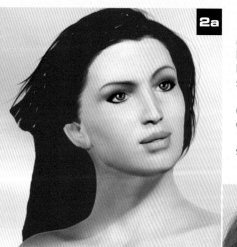

2a

I erased quite a bit of the hair flying towards the left in both pictures. For much of this step on the brunette, I used the *Smear* brush and the *Paintbrush*. I created a few custom brushes that allowed me to smear very small strands away from the solid mass of hair.

To create a custom brush, on a new layer take a very small paint brush and make a series of dots close together. Do this with brush *Opacity* set to 100%. Then go to your filter menu and blur them slightly using either *Blur* or *Gaussian Blur*. Next

make sure the layers behind the brush are invisible, so that all that is behind your small dots is the checkerboard indicating transparency. Select the *Marquee* tool and draw a selection around your tiny dots. Go to the menu bar, and under the *Edit* menu, find the option *Define* brush. Click on it and a window will pop up asking you to name your new brush. After naming you will find your new brush added to your brush palette. Now would be a good time to save your brushes. You wouldn't want to lose all that hard work.

2b

Experiment with creating custom brushes. Different images will require different brushes for the hair, depending on image size.

Now, with your new custom brush, you can check the boxes to vary both *Opacity* and *Size* with pressure. For smearing hair into the sky area or into the woman's forehead, make sure the brush is set to *Darken*. If you don't, you will find yourself dragging a small white outline along with the black hair. When you work the hairline back into her hair on her forehead, set it to *Normal*.

In both pictures, there's been quite a bit of light smearing at first, and then painting with a very fine brush.

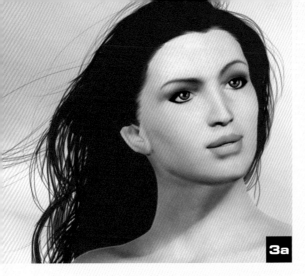

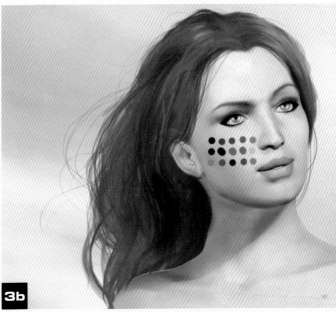

3a

For much of this step, I moved the file into Painter. You can use Photoshop for this step but I've found that I get smoother brushstrokes in Painter. There's an adjustable 'damping' factor at work in Painter that helps to smooth out the stroke. I chose a very small brush (either pencil or ink pen will do), making sure that the brush was not set to pick up paper grain (*Soft Cover* will do). If you choose to remain in Photoshop, take a very small brush, and set it to vary both *Opacity* and *Size* with pressure. I began the work of painting a few strands flying away in the wind, editing my work and leaving probably one good one for every two that got erased.

3b

I was still working with just one basic colour, getting the form or outline of the hair done. Be ready to spend time experimenting. Don't fret if you find yourself erasing a lot of the hair away and starting over. Every new picture is a learning experience.

You may notice that my sampling colours have moved closer to the blonde's hair. Don't hesitate to move the palette wherever you need it.

It's time to catch up with the brunette's hair. I erased some hair on the left, painted it back in – sometimes more than once – and then added more hair on the right. You may notice some hair painted over her neck and shoulder. This is not a problem as in this particular image I planned on having all the hair behind. It would be hard to erase exactly along a line of her body. So in Photoshop I held down the Control key (for a Mac, use Command) while clicking on her body layer. This creates an active selection exactly along the edge of her body. Then just grab your *Eraser* and erase the hair in front. Alternatively, you can hit the Delete key to get rid of it.

4

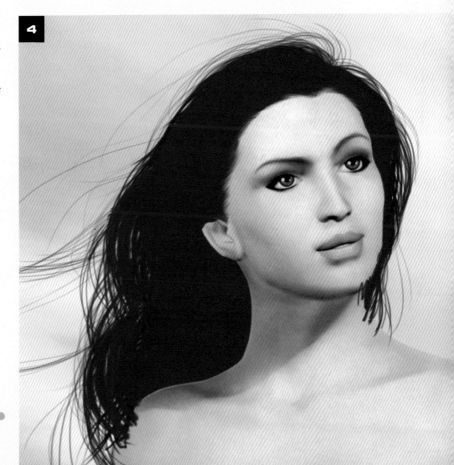

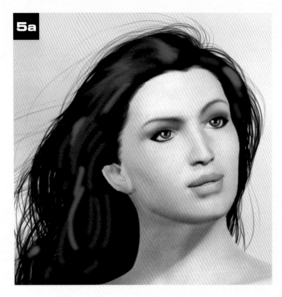

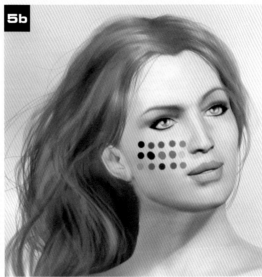

For the next step – all in Photoshop – I clicked the box on the layer palette to preserve transparency. Grabbing my virtual airbrush (press J), I started to paint the other subtle colours present in dark hair. If you are not sure what colours to use, turn to your handy colour palette. If you need one for the brunette, grab a source file from either a reference CD or the Internet (always a good idea, but particularly until you figure things out for yourself).

When I added a few more colours to the dark hair, with transparency preserved, I didn't have to worry about painting outside the confines of the hair. I carried out the same process with the blonde: transparency preserved when I needed it, and turned off when I needed to add more hair outside the defined borders.

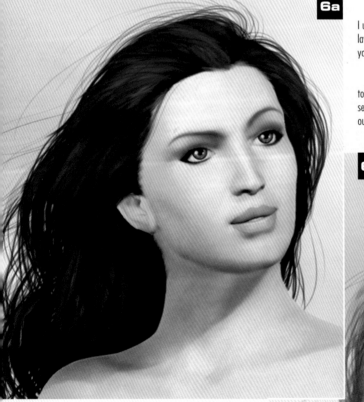

Neither of these pictures seems to show much change from the last step, but there are subtle things going on here. On both figures, I used a few small paintbrushes to paint more variations in the hair. I kept layer transparency preserved, although you don't need to if you're careful or if you want to add more strands to indicate the growing breeze.

I also used the *Smear* tool with my custom brushes on occasion. I set the tool to *Normal* and pulled the hair, gradually adding more form. Sometimes I set the brush to vary size with pressure, sometimes not. Experiment and find out what works best for you.

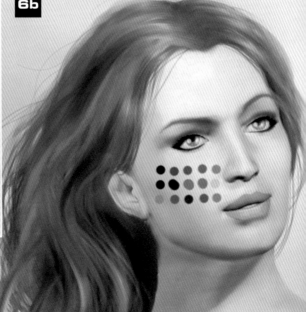

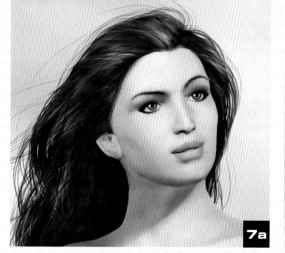

7a

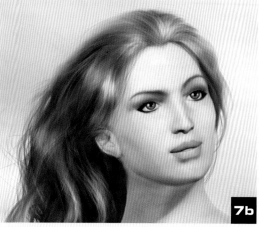

7b

To get to these finished versions of the hair, I began by using the *Dodge* tool on the brunette, set to affect *highlights* in the *Range* menu. I used a larger size at first, followed by small brushes. I also used airbrush, followed by smearing and more painting. After I painted the major highlights, I applied strokes with a 2-pixel size *Dodge* brush to get some very small strands lit up.

If you're unsure as to whether what you're doing is going to work, you can always copy the hair to a duplicate layer and experiment. If it works, keep it. If not, you've always got your older work on a separate layer. To create a duplicate layer, just drag the layer in the layer palette down over the *New Layer* icon at the bottom. Instantly, your new duplicate layer appears above your old one.

The blonde took a bit more work. I wasn't happy with how her hair was near the top. So, on a new layer, I painted new locks of hair that blew more straight back. When I was happy, I hit Ctrl+E (Command+E) to drop and merge that layer with the main hair layer. I used the same tools on her to dodge and paint as I did on the brunette. It may look softer, but that's a good thing.

As I finish up, I always take a look at the overall 'look' of each piece. If needed, I'll adjust the *Brightness*, *Contrast*, *Hue*, *Saturation* or *Color Balance* of the hair. If you compare, you can see the blonde's hair has changed since the beginning. Try a few different things. Try duplicating the layer, colourizing it, and then setting it to *Multiply* and see what happens. Adjust the *Opacity*. Or perhaps set the layer to *Soft light*.

These two samples show in detail how the area around the forehead looks when finished, and gives a better idea of how time spent painting subtle shadows and highlights has paid off.

By constantly switching between different brushes and tools, you can create the effect of soft, clean hair blowing in the breeze.

8a

8b

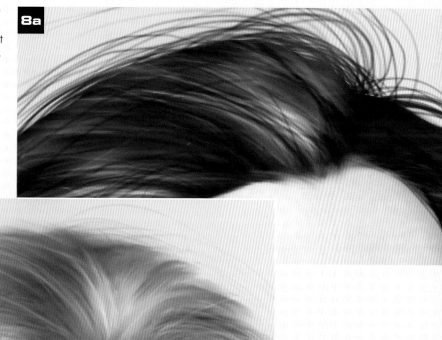

PAINTING AND CLOTHING POSER FIGURES

THE MODEL USED IN *LA DANSE DE LA PETITE MORT* is the Ki character that is based on DAZ's Victoria. This was created by manipulating geometry in a similar manner to that described by Cris Palomino on pages 96–97. Here Palomino demonstrates how manipulated figures can be further customized using rendering and painting effects, as well as the addition of clothing.

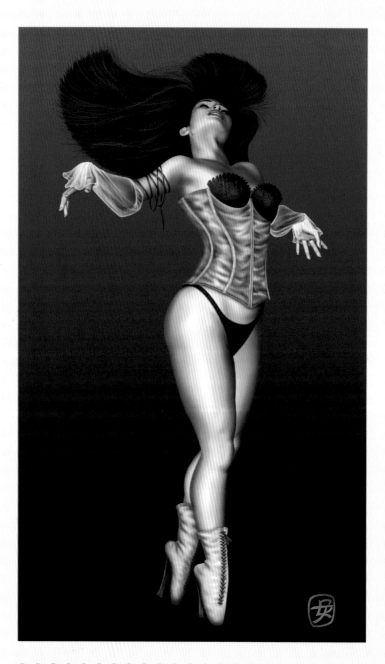

ARTIST
CRIS PALOMINO
TITLE
LE DANSE DE LA PETITE MORT

SOFTWARE USED
ADOBE **PHOTOSHOP**
CURIOUS LABS **POSER**
MAXON **CINEMA 4D**
PROCREATE **PAINTER**
KIERA AND BLACKHEARTED
KI CHARACTER MODEL
AVAILABLE AT RENDEROSITY
MARKETPLACE

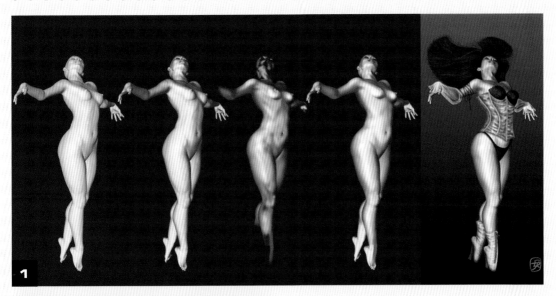

To render the figure for *Petite*, I used a multi-pass method for rendering the illustration in Maxon Cinema 4D, a method more commonly found in video compositing. The multi-pass approach renders a different layer for the various aspects of the piece: *Ambience, Luminance, Radiosity* (you select which ones you want rendered). The layers are visible in Photoshop, as are the modes that Cinema 4D assigns to them (*Multiply, Screen* and so on). You can change those modes and enrich the colour or create special effects. Here you can see stages that show first the original base render and then after I had tweaked the layers. The final stage shows the painting applied to the figure and this layer applied over the tweaked one (the feet were not corrected as I had planned to add boots).

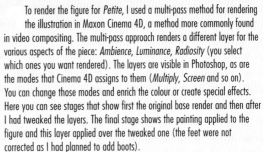

These close-ups show the original render of the arm, the tweaked layers and the final painted version. Many textures are applied with realism in mind, and a number of imperfections are included to make them as photo-realistic as possible. I like to use a painterly post-production approach and simultaneously correct the anomalies in geometry that appear as kinks or breaks when bending the arm, wrist, fingers and other body parts.

To paint the sheer sleeve on the model's arm, I lightly sketched what the sleeve would look like. I then traced this part on the forearm with the *Pen* tool to create a path that I turned into a mask. Using white, with a fairly large airbrush at a low *Opacity*, I painted towards the edges leaving the centre clear.

I went in with smaller brushes to create the wrinkles of the sleeve and used even smaller brushes at a higher *Opacity* to create the hard edges of the wrinkles. On a second layer, I used the same method on the cuff. Both were painted over the arm layer, occasionally turning that layer off to check what the fabric looked like.

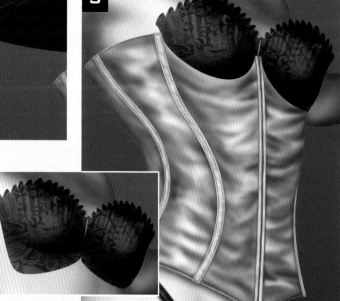

The cups on the corset were created in similar manner to the sleeves using the *Pen* tool. After painting them, a pattern was placed over them and both layers were set to multiply. The corset, previously painted, was placed over those layers to inset the cups.

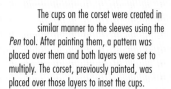

Creating hair is mostly a matter of looking at photographs and seeing how hair grows. I recommend getting hairstyles or hair-colour images from the Internet and then using the *Eyedropper* on them to create a realistic palette. Start with the basic shape of the haircut and block it in with the darkest tone you are using. Hair is normally darker at the roots and is also shadowed by the hanks of hair above it that are closer to light sources. I used Painter's pencils to create this effect – in particular, a 2B pencil with a thick and thin stroke. Hair looks like it has volume when it goes from dark to light and you can also give the strands life by letting some fly loose. Even straight hair will have some flyaway strands. Above all, remember that hair is rarely all one length or one colour. Have fun with it.

6

7

Petite wears a pair of boots based on Victorian fetish boots with a slightly more modern silhouette. I began by sketching them onto the figure. Then I blocked out each boot on a separate layer. Often I build a palette – from which I pick colours with the *Eyedropper* – and put it on another layer off to the side. I can then start to paint in details, such as creases, shadows and highlights, as I work out the look of the kid leather.

8

I repeated the process with the front boot and, on separate layers again, added the lacing. On yet another set of layers, I blocked in the heels for each shoe. Again using colours from a custom palette, I created the look of wooden heels. Mixing colours in the palette using the *Eyedropper*, I added bits of green from the main boot to the shadows in the heel and mixed a bit of the heel's golden tones into the leather of the boot. Finally, I chose to give the laces a bit of brilliance by changing the colour. I added a new layer and set the blend mode to *Color* and painted the laces red. Notice in the main image that for the back boot I've subdued the red slightly.

USING PROPS AND EFFECTS

WHEN CHRISTINE CLAVEL BEGAN CREATING SELENE for her website she had an idea to create a celestial image – an angel or fairy – in the centre of divine illumination. However, as she herself says, ideas can evolve a lot during the creative process. From the original vision of a heavenly coloured Bird of Paradise bedecked with flowers, Selene became a moon goddess in duotone. The artist found the result, *The Rise of Selene*, much more striking than the original, with a distinct lunar feel.

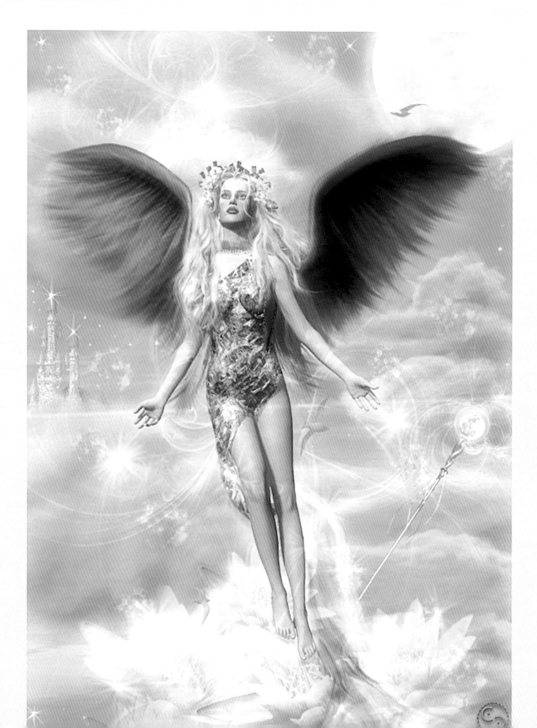

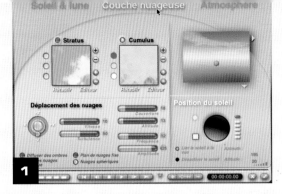

For the heavenly scene I had in mind, I needed some fluffy, candy-floss clouds and a moon. So my first step was Bryce. I decided to place a little castle in the background, as well as some strange flowers, clouds and birds. I started by choosing the image dimensions and then created the sky; a golden one, warm and bright.

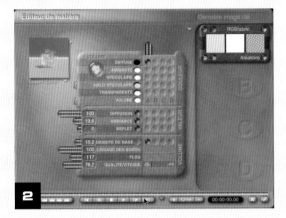

To make the clouds in Bryce, I assembled a great number of giant spheres, and then flattened and placed them very far away from the camera. I then textured them with a Bryce procedural texture. The final look of the clouds in the sky is controlled by the colour, position, size and pattern within the texture controls.

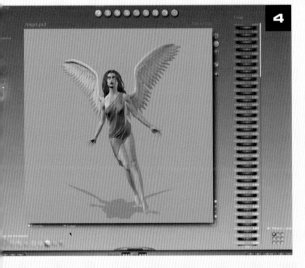

This is the initial background rendered in Bryce. I set to work on the principal character of the angel in Poser 4, using as my basis the model Victoria by DAZ Productions. I remodelled her face (eyes, mouth, eyebrows, nose and the general shape), then her body (working on her waist and breasts and lengthening her legs). I then added the wings and made them dependent on the chest using a parent-child relationship. The wings (child object) are fused with the character (parent object) and follow the body movements when posing the figure.

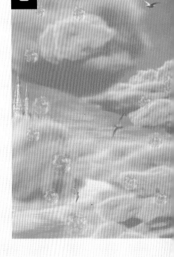

The posing stage needs a delicate touch. I personally prefer to use the slider controls to adjust the parameters rather than using the direct palette controls, as I find them too imprecise. I wanted to create my final render in Bryce, so I didn't worry about lighting in Poser. I dressed my model in a simple wrap and added some long hair. Still in Poser, I exported it in Wavefront (OBJ) format.

ARTIST
CHRISTINE CLAVEL
TITLE
THE RISE OF SELENE

SOFTWARE USED
ADOBE **PHOTOSHOP**
CURIOUS LABS **POSER**
COREL **BRYCE**
COREL **PAINTER**
EOVIA **AMAPI3D**
METACREATIONS **KPT**
FILTERS

ADDITIONAL HARDWARE
WACOM **INTUOS**
PRESSURE-SENSITIVE
GRAPHICS TABLET

5

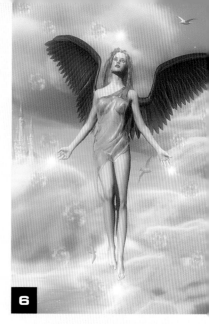

6

The Wavefront format makes it possible to export the objects complete with textures to Bryce. Some adjustments are necessary but most of the information is there. I exported my angel model with its skin texture intact, but the hair, the wings and the tunic were additionally textured in Bryce and then repainted using Photoshop.

Back in Bryce, I imported my character and set up the imported textures. I then relit the background scene to incorporate the imported character. I had only used the Bryce sun to light the scene up till now so I added some radial lights to illuminate the character. I then rendered the image to see the result, as shown here.

Still in Bryce, I decided to change the dress texture from the sheer red material to this green lace, which I created using procedural textures in the Bryce texture lab.

7

8

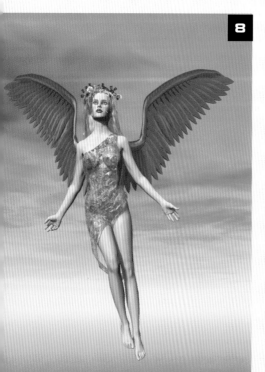

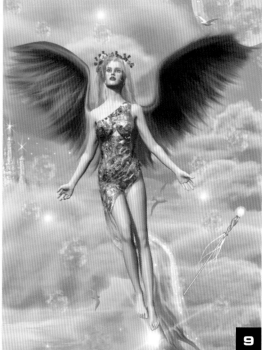

9

Now it was time to render the image. I recommend rendering in Bryce with *Gamma Correction* set to *Off*, as this feature tends to wash out the render. I did two renders: the first was of the whole image and the second a complete render of the background only. I then selected the character alone, chose *Mask Render* from the drop-down menu on the camera palette, and made two masks of the character, with and without wings. I also made a mask of the dress alone, as well as one of the birds. Here you can see the character with her new lace dress composed and rendered with Bryce.

Moving to Photoshop, I opened the main complete render, placing only the background on a new layer and all the masks in the channels palette. This allowed me to create several new layers for my character — the background, the wings, the birds and so on — enabling me to work on them all separately. There were more than 30 layers for the full-colour image at this stage (and 47 in the final duotone version).

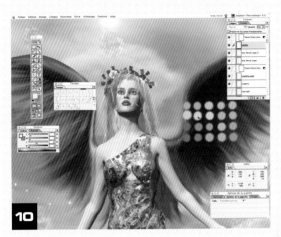

10

I started to paint the hair and wings with some custom brushes I created especially for that purpose. These allowed me to smear very small strands away from the solid mass of 3D hair. It's well worth experimenting with custom brushes – they are easy to create.

After the hair, I started to work on the dress. Thanks to the alpha channel, I could work on it in isolation. I used several layers to colour it and its train (the dress/fantasy wrap is a 3D object but the train is simply a painted addition). I used the various Photoshop layer modes extensively to create the effect I desired for the dress. For Selene's wings, I used the original render colours and the *Smear* tool with my custom brushes. This enabled me to smear very small or large strands away from the solid mass of the rendered wings, depending on the size of the brushes and the image resolution.

11

Working in Amapi3D and Bryce, I modelled a necklace for Selene from my own design. A Bryce render test of the necklace alone is shown here. Back in Photoshop I decided to convert the image to duotone, then continued the postwork on the hair (and on the 3D and 2D flowers in her hair). I did the same for the dress and wings. I also added some pictures – notably some lotus flowers and a real moon picture – to improve on the Bryce version.

12a

I created the rays of light with the KPT filter *Frax Flame* in Photoshop (**a**) and a special *Spark Brush* in Painter (**b**). The fractal flames were rendered on a transparent layer and placed above the image but under the character. The *Spark Brush* is a fantastic tool to use, turning your tablet's pen into a real 'magic wand'. Back in Photoshop, I used the KPT filter *Equalizer* to mix the colours in a surrealistic way, add a slight halo effect to objects, and emphasize the luminous parts of the image.

12b

13

I modelled a scepter in Bryce and Photoshop, and added it to the scene with a little photo of the moon on it. I then changed the colours to a light watery green tone and added some other desaturated colours to make the final image appear more celestial.

ANATOMY OF A PHOTOSHOP IMAGE

SO FAR WE'VE SEEN TECHNIQUES that show how to paint clothes or hair or retouch 3D figures. This project also contains element of these techniques, but will concentrate more on layers in Photoshop, and how they are set up in terms of modes, opacities and so on. Each step will show another layer or two in the order they were set up, from bottom to top. In the process of painting *Liberty 2100*, Will Kramer used a pressure-sensitive graphics tablet fairly extensively, so this is recommended if you want to follow his steps.

The working version of *Liberty 2100* is not that large (1500 x1125 pixels), but with all the layers used, the Photoshop file worked out at around 60 MB. This size of file can really slow down your work rate. That's why, when Kramer worked on the body and clothes, he cropped a duplicate of the picture and worked on those items in a smaller image. When he was done with everything on the woman, he flattened the layers and pasted the image back in the large one with the full background. The work you see here took around 40 to 50 hours from start to finish.

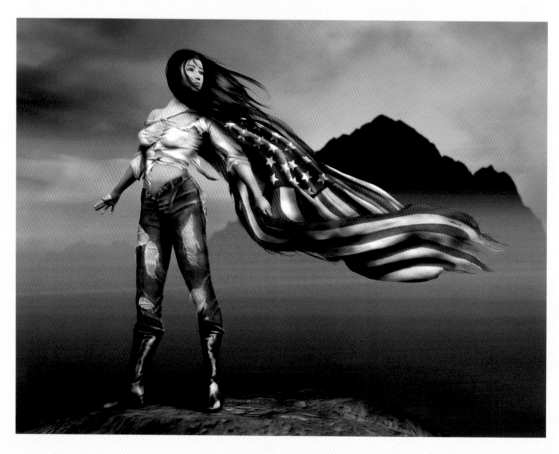

ARTIST
WILL KRAMER
TITLE
LIBERTY 2100

SOFTWARE USED
ADOBE **PHOTOSHOP**
CURIOUS LABS **POSER**

ADDITIONAL HARDWARE
WACOM **INTUOS**
PRESSURE-SENSITIVE
GRAPHICS TABLET

This step involved duplicating the background and setting the layer mode to *Multiply* at 67%. This step might have been done much later, but remember, I'm going from the bottom layers to the top in this image.

What you see here is the basic rendering of a Poser 3 figure in Bryce 3. For the first few steps, however, I'm going to concentrate on the background.

Here I've added two more layers. I added a section of black, masked it, and painted a gradient in the mask in order to give it a gradual fading. I also cropped the rock she's standing on (from the background layer) and pasted it above the fading black.

I've created a new layer, rendered the *Clouds* filter using black and white, and set it to *Multiply* at 32%. I've seen this filter overused in many images on the Web (including some of my own!) but I'm not too worried here; most of them will be invisible by the time I've finished. Recently, I've come to rely more on painting skills rather than risk filter overkill.

5 This is a step involving three more layers: the mountains. I drew them using the *Lasso* tool, and then filled the resulting selection with black. Depending on where I want the mountains, I'll resize them or adjust the *Opacity* to give the feeling of distance on the ones on the left side of the image. For blurring, you can either draw them with a feathered *Lasso* or *Blur* them afterwards.

6

In the centre part of the image, on a new layer, I created a gradient of a light to dark orange. Using a feathered rectangular *Marquee* tool, I deleted very thin areas to give the banding effect. I then duplicated the layer and set its mode to *Multiply* at 64%.

7 Before I began to paint the clothes, I did quite a bit of airbrushing on the figure, fixing seams in the rendered mesh and adding a few more curves to the figure. Then I worked on her boots (three layers), the boot shadow and her jeans (four layers, including the jeans, the whiter threads and shadows). You can also see shadows on her body for her shirt and flag (painted behind those items afterwards; remember, we are going from bottom to top in the image layers). The flag was created using around eight layers, the bottom three of which you can see here. There is also a very low *Opacity* layer of dirt that I've painted on her. All of what you see added, like most of the picture (outside the original render), was painted by hand using Photoshop's standard brushes and a few of my own custom brushes.

Three more layers are added here: the woman's shirt, dirt on the shirt and the shadow across her chest from the flag. Creating the shirt took four layers on its own, and looks strangely familiar to one that I've covered in another project (see *Creating Clothes and Hair* on page 106). Again, all the clothing was completed in a cropped version of the full picture so that I could work with a smaller file size and speed up the computer. If you're challenged by the amount of RAM you have available this is a great way to get a large image done. Sooner or later, however, you're going to have to merge the parts of your image together, bite the bullet and take coffee breaks while your computer takes five to ten minutes to save the file.

8

9

Here's the rest of the flag, along with a couple of low-*Opacity* layers of dirt. One of the layers was set to *Multiply* and the other to *Overlay*. After painting the dirt, I duplicated the layers and changed the modes and *Opacity* until I got the look I wanted. To paint the stars on the flag, I created a single custom brush then painted stars where I needed them, rotating as necessary and erasing where the folds in the cloth dictated a disappearing star. It helped to have a reference photo to judge the placement and size of the stars.

10

The layers for the hair were applied to a separate, cropped image copy, then pasted into the final version – the hair and its shadow took three layers. One final layer, the one on the very top, was a *Levels* adjustment layer. I used that to add contrast and bring up the brightness.

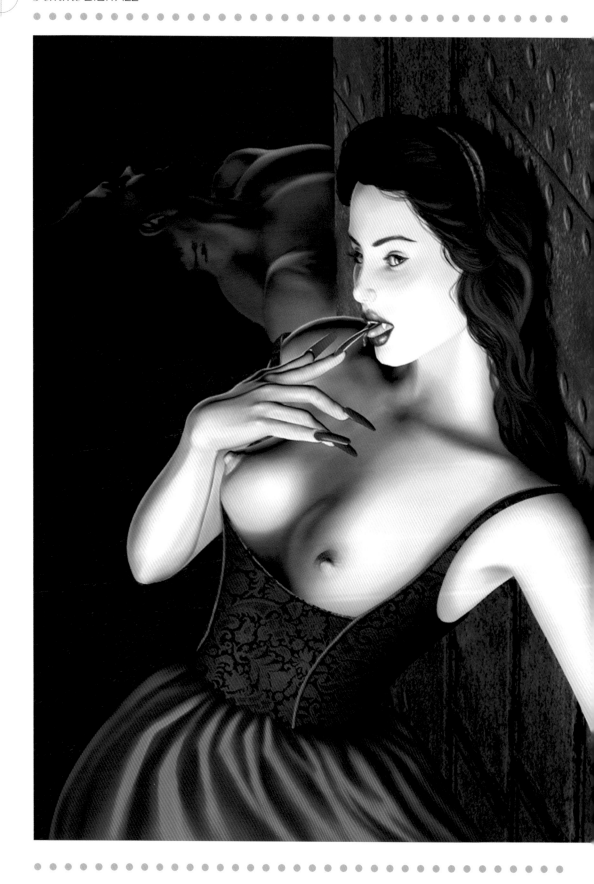

BRINGING IT ALL IN

ONCE YOU HAVE ALL YOUR COMPONENTS IN PLACE, IT'S TIME TO PUT THEM TOGETHER TO CREATE A FINAL PIECE OF ARTWORK. BUT WHAT IF THE CLOTHES ON YOUR RENDERED SUPERMODEL JUST DON'T FIT PROPERLY OR THE SCENE STILL LACKS THAT CERTAIN REALISTIC TOUCH? WELL, HELP IS AT HAND AGAIN AS OUR PROFESSIONAL ARTISTS EXPLAIN HOW BEST TO INTEGRATE YOUR POSER MODEL INTO PHOTOGRAPHS, DEMONSTRATE POST-PRODUCTION TECHNIQUES IN ADOBE PHOTOSHOP AND VUE D'ESPRIT, AND SHOW IN STEP-BY-STEP MODE HOW TO COMPOSE DISPARATE SCENE ELEMENTS IN BRYCE. IN NO TIME AT ALL YOU'LL BE USING THESE TIPS TO SET A PROFESSIONAL SEAL ON YOUR OWN FINISHED ARTWORK.

ARTIST
CHRIS PALOMINO
TITLE
LADY KILLER

INTEGRATING POSER FIGURES IN THE REAL WORLD

AFTER ALL YOUR WORK IN POSER creating your perfect woman, you may be daunted at the prospect of creating an environment to place her in. Have you ever thought, then, of rendering a Poser figure in a real photo? Or creating a digital painting using a photo reference with a Poser figure? In this project, you'll see how Will Kramer created *Waterfall* using his own models and other people's photographs.

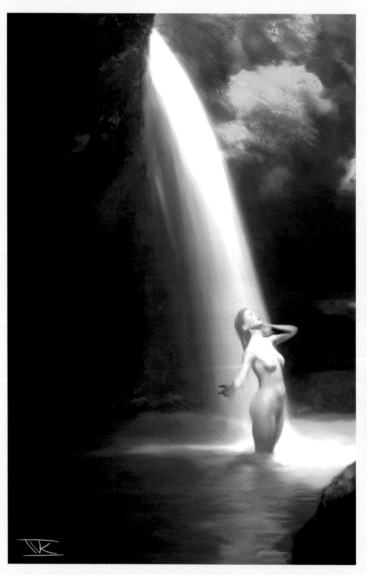

ARTIST
WILL KRAMER
TITLE
WATERFALL

SOFTWARE USED
ADOBE **PHOTOSHOP**
CURIOUS LABS **POSER**
COREL **PAINTER**

I found my picture of a waterfall for the scene in a CD collection of royalty-free photographs. The original was small, around 700 pixels high, but I wasn't worried at this point as I knew I was going to use Painter and Photoshop extensively.

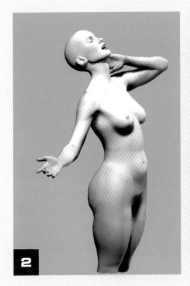

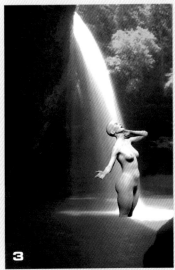

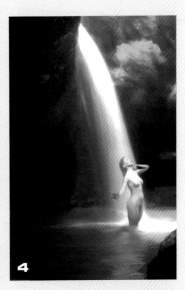

The figure was rendered in Poser, created using the waterfall picture as a background with two lights to simulate the lighting in the original picture. I was careful to get the colour right — skin colour in Poser has so much to do with lights. I chose a high-contrast background. This makes a cleaner selection when cutting the figure out using the alpha channel that Poser creates whenever you export as a .psd file.

I set up the main camera with the figure in the place I wanted in the waterfall and used the pose camera for fine tuning. Then I did a larger render, exported a .psd file and opened up Photoshop.

Now working in Photoshop, you can see a composite of the waterfall picture and the Poser figure. I enlarged the waterfall picture to 1500 pixels high. There was, of course, some pixellation, but this would be remedied later in Painter. I opened both pictures, then cut the figure out of the Poser render and placed her into the waterfall picture on a separate layer. At this point she's much too large, but I'll fix that by scaling the figure down.

Still in Photoshop, I painted her hair and fixed a couple of Poser figure 'artefacts' in the mesh (elbows, tummy and so on). I also painted some splashing water and cut and pasted part of the waterfall over her in a separate layer. Painting in a layer mask, I toyed with the *Opacity* until it looked somewhat close to the effect I desired. I painted over the pool of water on a separate layer (set to *Colorize*), and then adjusted the *Hue* until I was happy with the greenish colour. I then added the ripple to the water in the foreground, saved a flattened copy and opened up the picture in Painter.

Working in Painter, I first cloned the Photoshop image. Next, using a large square chalk (because it's fast), I roughed in the entire image using clone colours. After this I used a couple of different oil brushes, set at high and then low *Saturation* to get the brush strokes where I wanted them. After the major cloning work was done, I unchecked the *Clone-Color* box and colour-picked my way around.

I used a custom brush (in this case, a kind of oil brush I came up with that manages to pick up paper grain) to brush in textures on the rock and trees behind. I used the same brush to colour-pick and paint the water pool, mostly using a very low *Saturation* at low *Opacity* to gradually work the strokes in. If I ever got too far away from my initial idea, I recloned a section and started again.

I could have done a bit of colour-correction in Painter, but I always use Photoshop. Nothing beats it for adjusting overall colour values. So in Photoshop, I created two adjustment layers: one for *Levels* to increase the contrast, and one for *Hue/Saturation*, which I used to bump up the *Saturation* and change the overall *Hue* just a bit. Playing with the layer *Opacity* sliders, I went back and adjusted a few things until I was happy with the result.

Tip: Use those adjustment layers. Paint in them and don't forget they are masks. By using the *Airbrush* you can remove parts of the mask you don't want to show. I use them quite often, painting in them or using gradient fills to help draw the viewer's eyes to the parts of the picture I want them to see (or away from the parts I don't want them to notice). One more layer for the signature and it's done!

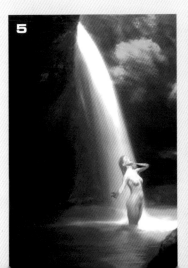

POST-PRODUCTION TECHNIQUES IN PHOTOSHOP

ONCE YOU HAVE YOUR FULLY RENDERED FEMALE MODEL, you'll be ready to add atmosphere and realism. For this project, Byron Taylor wanted to take his angelic warrior, created entirely in Poser and Photoshop (with props supplied by third-party vendors), one stage further. Here he shows how to add shadow and lighting effects using a combination of layers, masks and filters. The result is the *Avenging Angel*.

Although the background was rendered in Poser, the techniques used here will work when placing your 'femme digitale' into any setting.

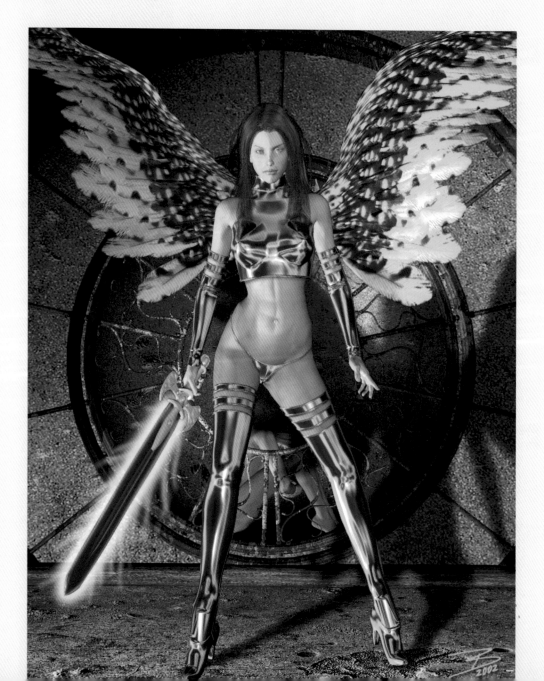

1a

1b

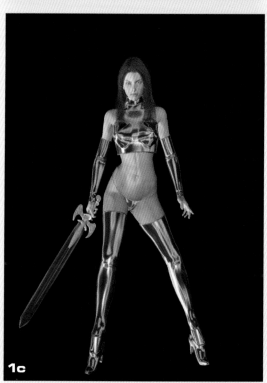

1c

Be sure to make the background of your render similar to the background you want in the finished piece. This way, your selections can blend with each other more easily. In this case, I was able to render over the actual background I wanted to use. You can always drop an image into the background of Poser to achieve similar effects.

If you render as a .tif file, Poser will supply you with a mask, which makes selecting your figure very easy. This is a much larger file than rendering as a .jpg file, but it's well worth it for the time and trouble the mask saves you. I did four renders of this figure to get all the elements I wanted. The first render (a) was done mostly for the background, although it's a pretty good render by itself. I also rendered the angel by herself (b), by herself with no wings (c), and by herself with no props, clothes or hair (d). I almost always start with this process, as it gives you a lot more parts and options later.

1d

ARTIST
BYRON TAYLOR
TITLE
AVENGING ANGEL

SOFTWARE USED
ADOBE **PHOTOSHOP**
CURIOUS LABS **POSER**

In Photoshop, the full render was used as the base file for the new image. I removed the backgrounds of all the other renders using the supplied alpha channels. (To do this hold down the Ctrl (or Command) Key and click on a layer of the *Channels* palette to make a selection of it, then press Ctrl+J (or Command+J) to make a new layer of the selection). I then duplicated all the other renders to the base file (go to *Layer>Duplicate Layer* and select the base file to do this), saved the base file as a psd file, hid those layers and did some work on the bottom layer. First, I darkened the layer overall using the *Levels* command. Then, using a stone texture, I added a floor by dropping it in as a new layer and using *Free Transform* to give it perspective. You can do this by holding down the Ctrl (or Command), Alt and Shift keys while dragging the corner boxes. Next, I created a new layer and setting it to *Multiply*, created a black to white gradient that darkened the top of the background more than the rest. I then adjusted the *Opacity* of the layer to achieve the effect I was looking for.

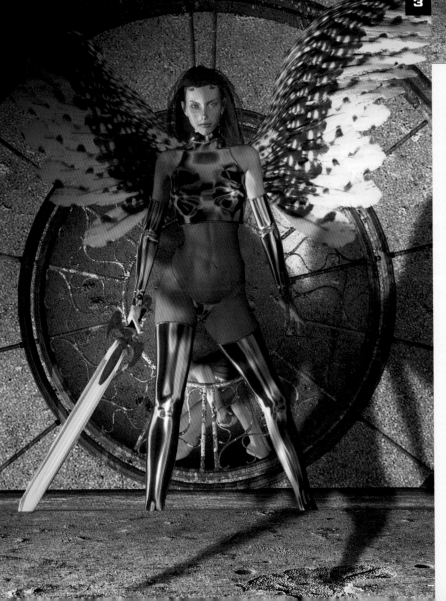

Using a selection made from the full Angel, I created a shadow. I *Free Transformed* using the Ctrl (or Command) key while dragging the top anchor box to shear the image, and used *Gaussian Blur* in a *Multiply* layer to fit the scene.

Note: Merging layers is a matter of style and preference. I sometimes have 20 or 30 layers in a working Photoshop file. I'm reluctant to use the *Merge Layers* command for any part of the image until I'm absolutely certain that it is finished. I still retain layered Photoshop files of finished pieces (often keeping as many as ten layers), just in case I want to go back in later and tweak something.

I next used the nude render to create the new strips in the boots and gloves. First, I deleted everything I wouldn't need for this process. Then, using the *Pen* tool, I created smooth curves and made these into selections. I used them to remove areas of the leg, exposing the layer with the boots and gloves underneath. I then selected the ridges at the top of the boots and gloves and duplicated them to complete the newly created strips.

The main thing I wanted in this image was much more dramatic lighting than I had in the original render. I wanted to create stronger blue lighting, preferably emanating from the sword. To achieve this, I looked at the RGB channels to see which would give me the desired effect. I experimented with duplicating channels, blurring them, changing *Levels* on the new channels and creating layers from them until I developed a channel based on the highlights of the Angel.

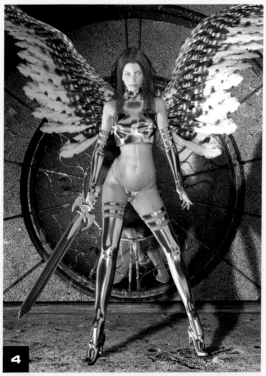

4

5

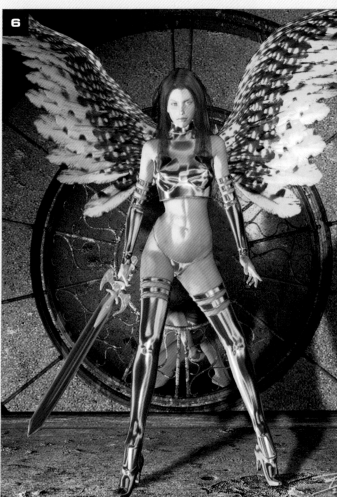

6

I next created a new layer, filling the selection from the channel based on the highlights of the Angel with a light blue, and setting the layer to *Overlay* so that the image below would be coloured but not obscured. I added a glow to the sword by making a selection of the weapon and used *Stroke* (*Edit>Stroke*) to paint it with white and a light blue, with the layers usually set at *Lighten* or *Screen* (there were several new layers involved here). Finally, I used the *Smudge* tool to give it a flaming look.

POSTWORK WITH PHOTOSHOP

AN ESSENTIAL TOOL IN ANY DIGITAL ARTIST'S TOOLKIT is a good image-processing program. This can save you many hours of rerendering on any 3D graphics application. Adobe Photoshop has a collection of invaluable features, which provide artists with the ability to flex their creative muscles and apply them onto the digital canvas. There are other comparative products on the market and so you do not need to have Adobe Photoshop to accomplish what Michael Loh describes here. The same concepts apply for any image-processing program you choose to use.

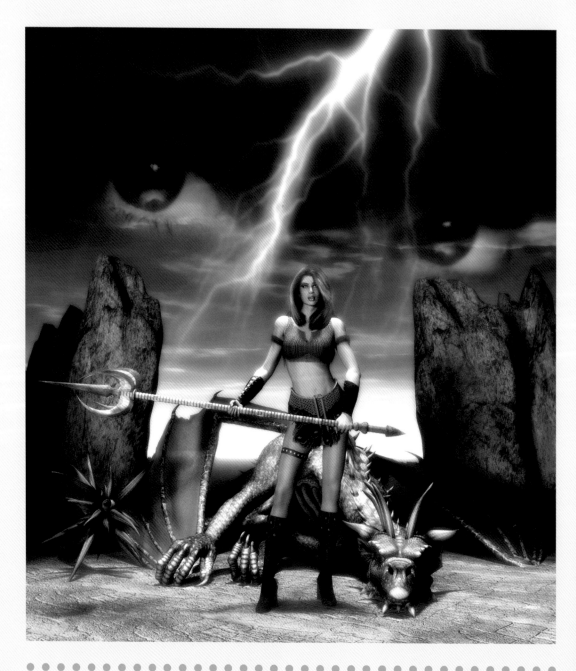

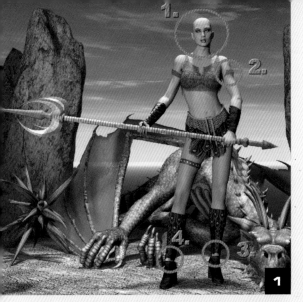

I created a picture of a statuesque, feminine Amazon who stands triumphant in front of her kill: the last dragon of its species. The Amazon and dragon are the characters Victoria 2 and Millennium Dragon from DAZ Productions. These characters were manipulated and textured in Poser 5 and imported into Vue d'Esprit 4.1. Within Vue, the sky and lighting settings were established to give a dark, stormy environment and the scene was then rendered. The final render had the following dimensions: 4500 x 3755 x 300 dpi. The picture showed some artifacts, which would require remanipulation in Poser and a rerender in Vue D'Esprit. I did not want to take this route, as it would have added several more hours to the production cycle and I could achieve the same same effect more quickly with Photoshop. On top of fixing these artefacts, I also wanted to add hair and spice up the background.

1

2

The hair was done in several steps and using several layers in Photoshop. I started out with a broad soft brush and painted an outline of the hair. I then used a *Smudge* hard brush of about 5 pixels with mode set to *Darken* and *Strength* of 62%, to drag out some hair strands from the base of the hair.

On another layer, using a lighter colour and a soft brush of about 13 pixels with full *Opacity*, I painted in the outlines of hair groups as shown.

% (Hair Outline, RGB)

3

ARTIST
MICHAEL LOH
TITLE
LAST DRAGON

SOFTWARE USED
ADOBE **PHOTOSHOP**
CURIOUS LABS **POSER**
EON SOFTWARE
VUE D'ESPRIT

Using a hard brush with a *Size* of 1 pixel and a lighter colour with full *Opacity*, I painted in the single strands of hair, making sure to follow the flow and shape of the head and hair outline. I varied the brush size to obtain paint in different strand widths.

The next step was to create some highlights on the hair. The scene has two spotlights, one on top and another to the bottom right of the Amazon. On a new layer, using a light orange colour, a broad paintbrush with 50% *Strength* and 50% *Flow*, I painted in the highlights at the top and front of the hair as shown.

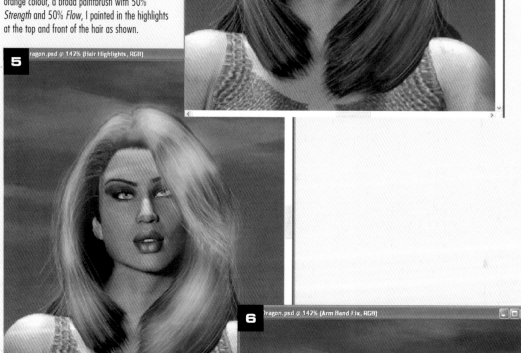

I then changed the layer's blend mode to *Overlay* and applied more highlights. With the spotlights shining down and to the left of the face, the hair would create shadows around the face. To remedy this I used a very dark brown soft paintbrush with *Strength* setting of 23% and *Flow* of 53%, and lightly drew in the shadows around the face on a new layer to produce the result seen here.

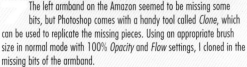

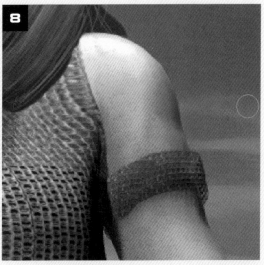

7 The left armband on the Amazon seemed to be missing some bits, but Photoshop comes with a handy tool called *Clone*, which can be used to replicate the missing pieces. Using an appropriate brush size in normal mode with 100% *Opacity* and *Flow* settings, I cloned in the missing bits of the armband.

8 The cloned armband looked a bit flat, so using the *Paintbrush* tool in *Normal* mode with an *Opacity* setting of 38% and a *Flow* of 36%, and a brush size about one-third of the width of the armband, I painted in the shadows along the bottom. I did the same for the right armband.

9 The next item to fix was the boots. There seemed to be a gap in the boot material between the joint of the shin and foot of both legs. Photoshop 7.0 comes with a tool called the *Healing Brush*. This tool is very handy for correcting old photos, skin blemishes on photos — and for mending boots! Using the *Healing Brush* with an appropriate sized brush and *Normal* mode, I painted over the exposed skin and closed the gaps.

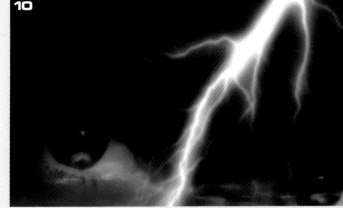

10 The postworked picture looked fine thus far. However, the background was a little empty and I thought of adding a large pair of eyes and lightning to symbolize the anger of the gods on finding out that their magnificent creation, the dragon, had been killed. I scanned in a pair of eyes from a magazine and pasted it onto a new layer. I then added a mask to this layer and painted out the areas of the face around the eyes that I did not require. I then selected *Overlay* mode for this layer. For the lightning, using the *Color Picker* tool, I picked up a light blue colour from the background and painted the lightning glow with varying soft brush sizes with *Opacity* of about 50% and *Flow* of 100%. Then using a white colour brush with a higher opacity, I painted in the lightning flashes to complete the picture.

COMPOSITING A PICTURE USING POSER AND BRYCE

BOTH BRYCE BY COREL AND POSER BY CURIOUS LABS are great applications, but they have limitations when used alone. Poser 4 doesn't have much available memory under Windows 98 to render complex scenes while Bryce has an incredible (if slow) renderer, but isn't set up to texture Poser figures easily. So to make *Come Up for a Bite Sometime*, Lynn Perkins rendered the figure in Poser, then added a Bryce background and some Bryce props. The rest was handpainted using a Wacom tablet and composited in Photoshop.

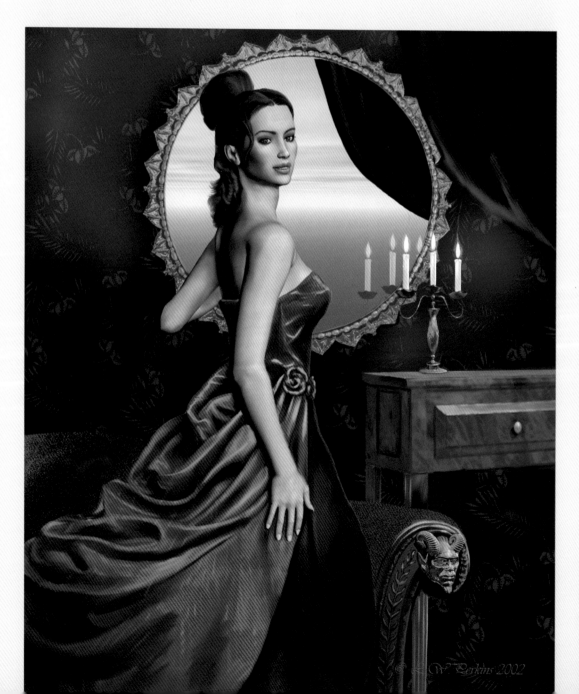

1

I set up the pose in Poser, applying the textures and adjusting the lights. For this figure I used a commercial texture called 'Margot' (available from 'Dalinise' at Marketplace on Renderosity.com). The base figure and hair models are from DAZ Productions.

After making some adjustments on the shape of the face and the expression, I rendered the figure at 1440 x 1440 pixels, a size that was large enough to work with, without crashing my renderer. (If I had needed a larger file for print, I would have set up the pose in Poser and then exported the figure as a Wavefront OBJ file to Bryce, since Bryce can render directly to a folder in the hard drive.) The rendered Poser figure still needed work so I cleaned up broken geometry using the *Airbrush* and *Smudge* tools in Photoshop, added the little fangs and smudged and brushed the hair. Then I saved the file.

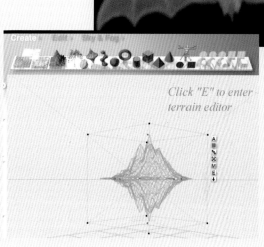

Click "E" to enter terrain editor

To build the bat mirror, I drew a crude bat in greyscale mode in Photoshop, with dimensions of 500 by 500 pixels. I saved it as 'bathgt.jpg' (hgt is my own shorthand for 'heightfield'). In Bryce I created a symmetrical lattice (by clicking on the icon at the top of the dialog box), then accessed the *Terrain Editor* for terrains and lattices by clicking on the e on the sidebar.

ARTIST
L.W. PERKINS
TITLE
COME UP FOR A BITE SOMETIME

SOFTWARE USED
ADOBE **PHOTOSHOP**
CURIOUS LABS **POSER**
COREL **BRYCE**
IRFAN SKILJAN **IRFANVIEW**

ADDITIONAL HARDWARE
WACOM **INTUOS**
PRESSURE-SENSITIVE GRAPHICS TABLET

I selected *New* in the *Editing Tools* palette to create a blank lattice for the bat. I moved to the *Picture* menu, clicked *Load* to open the browser and selected my bat file (**2**). I then clicked *Apply* to create the bat-shaped lattice. Moving to the *Elevation* menu, I clicked once on the *Smoothing* button and then exited the palette.

Rotate and duplicate bats around origin handle

Back in the workspace, I opened the *Attributes* panel by clicking on the A. After checking *Show Origin Handle*, I closed the panel, then put my mouse on the green dot (the 'origin handle') in the centre. I dragged this down to an arbitrary point that would form the centre of my mirror. I clicked on the *M* for materials, applied a gold metal material, and then started duplicating (*Edit>Duplicate*) the bat, rotating it along the edge of the circle. (If you're better at maths than I am, you can work out exactly how many bats will fit and the necessary degrees of rotation and use the *Multi-Replicate* feature accessible from the *Edit* menu.) I just eyeballed it.

Once the bats were arranged and a reflecting circle plane was put behind them, I compared the lighting to the Poser figure and checked the Bryce document setup (*File>Document Setup*). Always check your document resolution before rendering: in this case it needed to render at least 1440 pixels across to match the Poser figure. After rendering the bats, I rendered the couch (by 3dStrike from the Free Stuff area at Renderosity.com), the hall table (by Tony Lynch, also from Renderosity's Free Stuff), and candelabra (by 'tac' from the 3dCafe.com). I saved them all in the same folder as Margot and the bat mirror. Always save the Bryce .br5 file as well as the image, in case you need to rerender it larger or at a different angle!

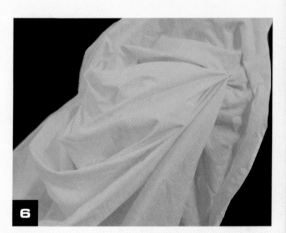

6

In Photoshop, I created a new 2000 x 2000 pixel document. The wallpaper went in first (a scan of some pyjamas!) on a new layer, then the bat mirror. More details were added to the mirror by hand. Then I copied and pasted the couch and the hall table. I had to use the *Transform* function from the *Edit* menu to fit the hall table properly in its space. I copied and pasted Margot and added another layer above her for the painted clothes. I then started working from a reference picture – a digital photo of some draped cloth.

I painted in the dress, starting with a dark red base and adding lighter reds. The cloth photo was applied as a reference layer and then deleted. Any mistakes are easily erased on the separate layer. Once it looked right, I duplicated and flattened the image, saving in Photoshop format in case I wanted to change elements later. I also reopened the file in a free picture viewer called IrfanView to get a look at the whole picture, to spot any places I missed in the small working window of Photoshop.

7

SPECIAL PROJECTS

THERE ARE MANY FIELDS IN WHICH YOU CAN APPLY YOUR SKILLS IN DIGITAL CHARACTER CREATION. CREATING FIGURES FOR ANIMATION IS BUT ONE STEP FURTHER FROM MODELLING AND RENDERING, WHILE THE USE OF FEMALE CHARACTERS IN COMPUTER GAMES HAS BEEN FASHIONABLE FOR SOME TIME AND SHOWS NO SIGNS OF BECOMING LESS POPULAR. IN THIS SECTION WE HAVE A MIX OF GENRES. OPPOSITE WE FEATURE *KARMA*, A FIGURE CREATED IN MAYA FOR THE 3D ADULT COMIC STRIP *AMAZON SOUL*. SHE IS A MODEL MADE UP OF 20,000 POLYGONS WITH 2048 X 2048 PIXEL RESOLUTION TEXTURES.

ARTIST
RENE MOREL
TITLE
KARMA

ILLUSTRATION FOR ADVERTISING

WHEN WORKING AS A FREELANCE ILLUSTRATOR, you often have to produce initial drafts of artwork fairly quickly to win commissions. It's a fine balance that has to be reached between meeting the client's needs and not overworking so much that the return on your valuable time is whittled down to nothing. In this example of a logo for a Belgian advertiser, the commercial illustrator Jean Yves Leclerq reveals his techniques. Thanks to Hot Belgium for giving authorization to publish details of this project.

ARTIST
JEAN YVES LECLERQ
TITLE
HOT BELGIUM

SOFTWARE USED
ADOBE **PHOTOSHOP**

ADDITIONAL HARDWARE
WACOM **INTUOS**
PRESSURE-SENSITIVE
GRAPHICS TABLET

1

I always start with a classical pencil sketch — the best graphic tablet is not as good as a pencil for freehand drawing. I usually have a picture as reference for my realistic pinups, but in this instance the sketch was done without a model. Over an afternoon I created three different faces and a few postures before being satisfied. I then traced my 'rough' sketches onto a new sheet of paper to work on the details. Often, I scan parts of the drawing and adjust proportions or work on details on the screen. The priority here is to quickly obtain an image that is good enough to be accepted by the client.

With the drawing accepted, I scanned images into Photoshop for the inking stage. Image size was 15$\frac{1}{2}$ inches (40 cm) long at 300 dpi. A nice way to ink is to put a white fill layer on top of the sketch, adjust its *Opacity* to make it semi-transparent, then ink on a third layer on top. I used a paintbrush with a depth of 7 pixels for the outlines and 3 for the details. *Opacity* was set to 100%, *Size* was set at *Stylus*.

2

3

To work on different areas of the image, it's best to separate them. I used *Channels* to create masks for the different body parts. Three were created for the skin: one for the entire skin, a second for parts covered by the stockings and a third for the laces. This enabled me to paint the skin tones and then the transparent stockings over the top. When all the masks were completed, I filled all the remaining parts (such as the hair and the corset) with a basic colour set at 100% *Opacity*.

4

I then airbrushed some areas of the body darker and others clearer to give volume. I set the airbrush to very light (8–10%), size to *Off*, and pressure to *Stylus*. All the drawing now had volume, with a general lighting that I visualized as coming from the upper left of the scene. To improve the overall look, I added a blue ambient light coming from the right and a purple light coming from the text frame, reflecting mainly on the legs (purple and blue are the colours of 'Hot Belgium' — the client).

I filled the background with black and copied, pasted and resized the girl's eyes to fill the text frame. I then darkened it slightly using the lightness slider from the *Hue/Saturation* dialog box.

The 'HOT' element is type on a simple text layer, with a *Pillow Emboss* effect applied. I changed the shadow colour to blue to be in tune with the lighting of the scene. I repeated this process for the 'Belgium' element. To finish, a white outer glow was applied to the girl layer and a similar one applied to the 'HOT' text frame. The client received the files in .psd format with the image not flattened, thus allowing their designer to manipulate it for different uses. At the client's request, the logo was also provided in vertical format.

5

DESIGNING JEN FOR PRIMAL

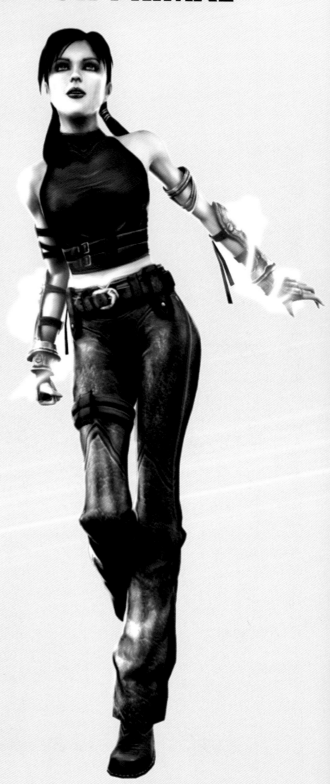

THE SONY CAMBRIDGE STUDIO has a reputation for creating visually stunning third-person action-adventure console games, the most famous of which is the *Medievil* series for PlayStation. For *Primal*, the studio's first title on PlayStation2, the team chose for the first time to make its main character female. According to Mark Gibbons, Lead Artist on *Primal*, the nature of the game and the development of its story drove the choice of character. Here Gibbons uses the example of Jen, the heroine and main focus of the game, to reveal the design process behind building a major female game character. This is followed by a tutorial project on using Maya and Photoshop to build the actual character of Jen.

ARTIST
SCEE CAMBRIDGE
TITLE
PRIMAL

SOFTWARE USED
ALIAS|WAVEFRONT **MAYA**
ADOBE **PHOTOSHOP**

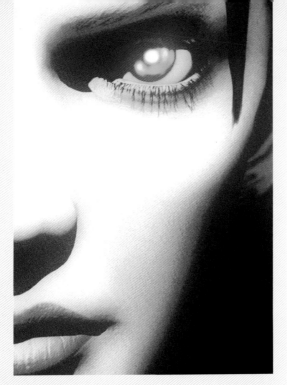

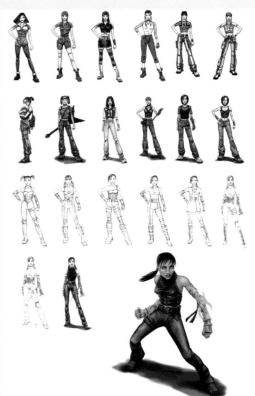

Here's just a small selection of the hundred or more concept sketches produced of Jen. The earliest designs are on the top row, working down towards the final design. Some of the ideas considered (and shown here) included a bookish Librarian Jen; a Rock Chick Jen, complete with Flying V guitar and Biker Mechanic Jen in snakeskin chaps and complete with monkey wrench! Some of these actually appeared in the game before Gibbons and his team decided on a darker, alternative image. The first concepts for this final style appear as the black-and-white images in the third row.

Primal represents a significant step forward for the creative team at Sony Cambridge. The technical capabilities of PlayStation2 have meant that for the first time we've had the freedom and resources to design a lead character with a depth and resolution that extends far beyond the limits of polygons and pixels. Jen is a three-dimensional character in every sense of the word.

Primal is an adventure that takes a character from our modern world and transports her to a place of dark, demonic fantasy, violence and intrigue. It was important that as the game began, the player felt helpless and vulnerable; only by battling through the world would they gain the strength and experience to survive the ordeal. The team thought that making the character female would help to emphasize the danger she initially finds herself in. It also made the subsequent transformations that she undergoes significantly more dramatic.

INITIAL DESIGNS

The most difficult and protracted part of the initial design process was deciding on Jen's look. We'd established that she was a cool, sassy 20-year-old

from a big, unnamed American city, with all the associated attitude and street cred, but whatever we dressed her in had to look like convincing attire in both the real world and the demon worlds of Oblivion. This was not as straightforward as you might think. At first we tried dressing her in a range of contemporary fashions, including everything from miniskirts and tank tops to combat trousers and fishnet shirts. Although she looked cute, she looked totally out of place once seen running through a demon-haunted forest in the falling snow. Back to the drawing board...

It took an additional one hundred or so design sketches to arrive at the final look for Jen. The opening movie for the game takes place in a nightclub where Jen is watching her musician boyfriend perform onstage. The club has an industrial/goth/alternative look to it and the music

TRIBAL MARKINGS

Jen's tattoo serves many functions. It works as part of her underground style, but also serves as an energy meter within the game. The tattoo symbol is so distinctive that it has grown to become a major part of the game's advertising.

(supplied by LA rockers 16Volt) suggested a tough underground vibe. We felt that the culture and fashion styles associated with this scene might provide Jen with a dress sense and outlook that would resolve all the problems her previous images were presenting.

We dressed her in battered leather jeans, steel-toed boots and a shiny halter-neck strapped vest – a combination that gave Jen a tough yet sexy and individual style. We also gave her dark, heavy eye make-up and tied her hair up in bunches. As much as it might have been interesting to have her hair loose and free-flowing, it would have raised a number of technical issues. Bunches meant that we could still give her hair a convincing dynamic movement, yet avoid any significant problems.

DIGITAL INK

Another element incorporated into her look at this time was her tattoo. Jen sports a large circular tribal tattoo between her bare shoulders. Since the player spends much of the time watching Jen from behind, this bold symbol on her sexy bare back is an interesting, pretty thing to look at. It also reinforces her edgy, alternative style. The notion of a tattoo stemmed from a desire to minimize the on-screen clutter of energy bars and health meters usually associated with this genre of video game.

Through the course of *Primal*, Jen discovers the shocking secrets of her mysterious past. She learns that she shares a demonic heritage with the races of Oblivion and as the game progresses, she acquires the ability to transform herself into four distinctly different demon Aspects. The tattoo is linked with the demon energy Jen requires to power these Aspects. When in demon form, the tattoo glows with an

associated colour. The brighter the glow, the more energy Jen has in that particular Aspect. Energy is depleted when Jen receives damage or uses any of the special abilities that each form gives her. The tattoo symbol itself has developed into a significant icon for *Primal*. It appears architecturally in the environments and as an immediately identifiable symbol of the game.

INHUMAN CHARACTERISTICS

Defining Jen's demonic Aspects took some time. We needed to create four alternative versions of Jen that, while monstrous, still retained a degree of feminine charm. Tricky!

Jen acquires the Ferai Aspect first. The Ferai are a brutal, bestial demon tribe – horned and muscular warriors with patterned, fur-covered skins. Jen needed to transform into a human-Ferai hybrid that was scary yet still sexy. We created a morph target so Jen would shift smoothly from her delicate human self into her powerful fanged and horned first alter ego. The transformation worked on a sliding scale so that at 0% she was entirely human and at 100% she was

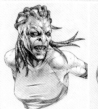
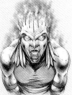
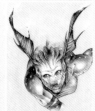

JEN – ASPECT CONCEPTS

These illustrations were generated once Jen's human appearance had been decided upon. You can see that a degree of consistency is maintained by retaining the hair bunches (whether tentacles or fins) in all four Aspects. Holding on to a degree of femininity was possibly the hardest task here and in fact some of the final in-game versions of the different demon forms are rather less monstrous than they appear in these sketches.

completely hybrid. This proved to be a fortuitous piece of design since we realized, only once all four Aspects had been created, that 100% hybrid was just too much! She lost so much of her femininity that she was no longer physically attractive to look at – an undesirable quality in a video-game heroine. In the final game we only used a 70% transformation as the full demon Aspect.

We were determined to maintain a certain consistency across all of Jen's different guises. Her clothing remains essentially the same throughout, although we do change the texture of her vest to better complement the different Aspects. Harking back to a point made earlier about her outfit: the tougher alternative fashion we had now decided on worked perfectly with all her demon forms.

Jen also retains her hair bunches in all the Aspects, although they shift in appearance to better reflect the different demonic natures. In her sinister, vampiric Wraith Aspect, her hair morphs into writhing tentacles. In her aquatic Undine form her bunches lengthen into fishlike fins and in her final Djinn Aspect, where her skin transforms into shining, living metal, her hair becomes golden knife blades.

WEAPONS AND CLOTHING

Despite her initial vulnerability, Jen evolves into a deadly combat opponent once she acquires the first of her four demonic Aspects. We built her fighting prowess around the focusing of the energy associated with each form and channelled that energy through the devices Jen wears, strapped to her forearms, called vambraces.

Each Aspect was to have different weapons and combat styles but we needed to avoid weighing the poor girl down with heavy physical objects like swords or axes. So we hit upon the idea of the vambrace providing a useful 'shaping' ability. Aspect-specific energy could be channelled through the vambrace and formed into a variety of energy weapons, each with their own attacks, blocks, combos and, ultimately, finishing moves.

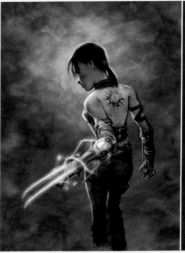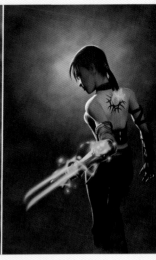

FROM SKETCH TO RENDER
For these two images the in-game model of Jen was posed and rendered with appropriate lighting. The sketch image was then printed out and worked over with pencil, paint and ballpoint pen. It was then scanned back into the PC and a number of Photoshop filters were applied to increase the rough, sketchy feel of the piece.

The weapons themselves reflect the nature of the different Aspects. The Ferai weapons are scything claws of green energy and Jen's combat moves are fast, close-range, frenzied attacks. By contrast, when in Wraith Aspect, she is armed with a Lightning Whip and Main Gauche (a short, shielded stabbing blade) and her moves have a certain sadistic flourish to reflect the Wraith's sinister nature.

Early in the game, before Jen acquires her first Aspect, she is given a long knife to defend herself with by one of *Primal's* more benevolent characters and this becomes her fallback weapon should her demon energy reserves become depleted.

The final rendered version took a lot more effort. Because this image was created using our in-game model, time had to be spent overpainting with Photoshop. Hard polygon edges were painted out, small imperfections in the textures were disguised and additional detail was added to her fringe and bunches.

The glowing energy claw was created in Photoshop from building up and refining a series of blurred layers. The background is a number of *Difference Cloud* layers overlaid on a gradient that creates a soft halo around Jen's head.

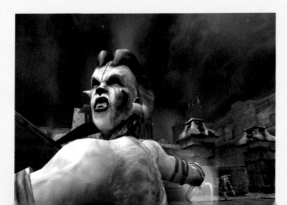

THE HORNED ONE
Here we can see the final render of Jen as the Ferai Aspect alter ego.

CREATING CHARACTERS FOR COMPUTER GAMES

REATING JEN, THE LEAD CHARACTER IN THE SONY PLAYSTATION 2 GAME PRIMAL, was an ever-evolving process for Sony Computer Entertainment Europe (SCEE) and Lead Artist Mark Gibbons. Her design changed many times and became more detailed as the game design changed overall. Every detail of Jen was under minute scrutiny all the time and needed to be flexible enough to adapt to different game proposals and the changing dynamics of the gameplay. Coupled with the fact that Jen could also morph into four different demon forms, the challenge to make her sexy, tough and as individual as possible was not an easy task.

Early construction of Jen in Maya required some background knowledge of what SCEE needed to achieve. First, Mark Gibbons had to look at concept artwork and consider the details of the character, how she would animate, the expressions and facial poses she would need, and where to put dynamic joints for her hair and so on. When working with game characters, texture space and polygon count are also important, as they need to be efficient to keep the game running fast. Texture space needs to be planned ahead and laid out roughly, so making thumbnail sketches helps.

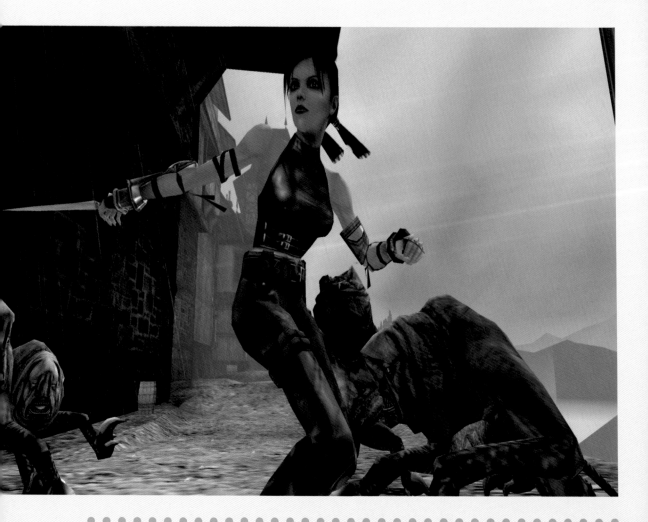

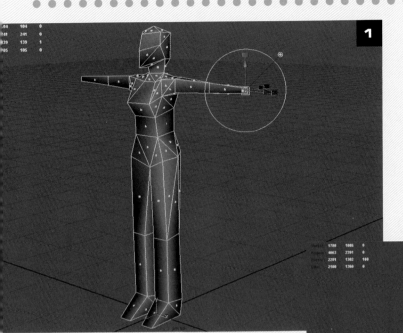

1

2

The first step in modelling Jen was to extrude simple box shapes into torso, arms, legs and head shapes, and then subdivide faces and manipulate vertices to create the basic outline and proportions according to the concept artwork. She could now be viewed as a three-dimensional figure and this brought the first of the changes: adapting the proportions. The main changes in Jen were to the length of her legs, the height of her hips, the size of her breasts and the width of her shoulders.

Making a figure out of boxes and subdividing faces is a good method for making higher-resolution models because the base mesh can be kept simple, enabling quicker changes. A simple *Subdivide* tool, or *Smooth* tool for more detail, can be used to view the final result. The base pose of Jen has her arms outstretched to the sides in order to make weighting the model to a skeleton easier. Most human/biped characters are symmetrical and so only one half of the base mesh needs to be made. Details can be added on once the two halves are welded together. This also helps with texturing as only one half is worked on. Asymmetric textures are applied after the two halves are welded together. Jen has more detail around joints that will bend, such as shoulders, elbows and knees — this helps to prevent the mesh from deforming too much.

The next stage was to prepare the model for texturing. This meant visually breaking up the model into different parts, finding obvious seams where differing textures could be placed together so that the joins were less obvious. I used Jen's red top as a starting point, using the seam to break up the top and skin textures. The belt was also a natural seam to break up the pants and the top textures. I selected all the faces associated with the top that would be mapped and then applied a cylindrical map.

Another way to map this shape and perhaps obtain more texture space is to apply different planar maps from front, side and back, and weld the UV maps together. I tried to lay out the UV maps by hand afterwards to maximize texture space and slightly increase resolution, which is important when working on a game character with limited texture space.

ARTIST
SCEE CAMBRIDGE
TITLE
JEN

SOFTWARE USED
ADOBE **PHOTOSHOP**
ALIAS|WAVEFRONT **MAYA**

The UV map in this example was cut and pasted as a layer into Photoshop. It was used as a guide to how to arrange the texture, where to lay out blocks of colour and where details would go. Most 3D software packages have plug-in functions that allow exporting of this map as a picture, but even a simple *Print Screen* function on the keyboard (Command+Shift+3 on the Mac) and paste into Photoshop will do this. Make sure you have enough contrast between the lines and background to make it clear.

Texturing begins by researching appropriate pictures to use as reference material, either to give a realistic look or to adapt and form the basis for a texture. I try to find pictures that give me a similar colour or texture to the one I'm trying to create and use these to build up layers in Photoshop, playing with the different layer types — *Normal, Soft light, Luminance* and so on — to create a new base. To produce this example I scanned in a well-worn leather texture and placed it on Jen's jeans base colour, and softened the edges to make them look more worn around the area of the thighs.

I work on a larger resolution than I need for the game and then size it down when I'm finished; this gives me greater detail in the final result. I make great use of masks to preserve the original layers and use bevel and emboss techniques to add depth. Finally I add layers of shadow and highlights to enhance the image, until the final result is more like an illustration than a photograph. It's very important to keep testing the texture back in Maya on the model, as you must always visualize it in three dimensions. It is also useful to see the two halves of the character together, even if separate.

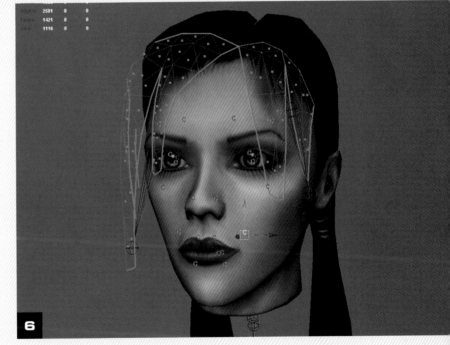

Once all of the textures are complete, the two halves of the character are welded together. On Jen, details such as vambraces, fringe and dagger were added. Next the skeleton was added, and the mesh was weighted to it. Maya has the option to fine-tune the weighting by painting the weights directly onto the mesh. To add more weight on the mesh to a specific joint, simply add more white. Flooding the appropriate joints with the *Smooth* function can be used for smoothing between joints. Jen has extra joints for all her dynamics: the fringe, the bunches at the back, the tassels from the vambraces and one to control the movement of her breasts.

The final stage in Jen's construction was to add her facial setup. This was done using a system of clusters (groups of vertices) with which we can manipulate different parts of the face and eventually create facial poses or speech. In this example, the left side of the mouth is the group of vertices selected to create a cluster.

In Maya it is possible to weight the vertices differently in a cluster, so as to soften the edges, simply by using the paint cluster weights on *Smooth*

and hitting *Flood* a few times. Once all the clusters are working, you need to group them all together and link them to the head joint. Select all the clusters and make a character set in the *Trax Editor*. With all the clusters' positions set to zero, make a base pose and then start making all the different facial expressions and speech poses. Jen has 16 expressions, including angry, concentrated and confused, and more combat-oriented expressions such as dazed and feeling pain.

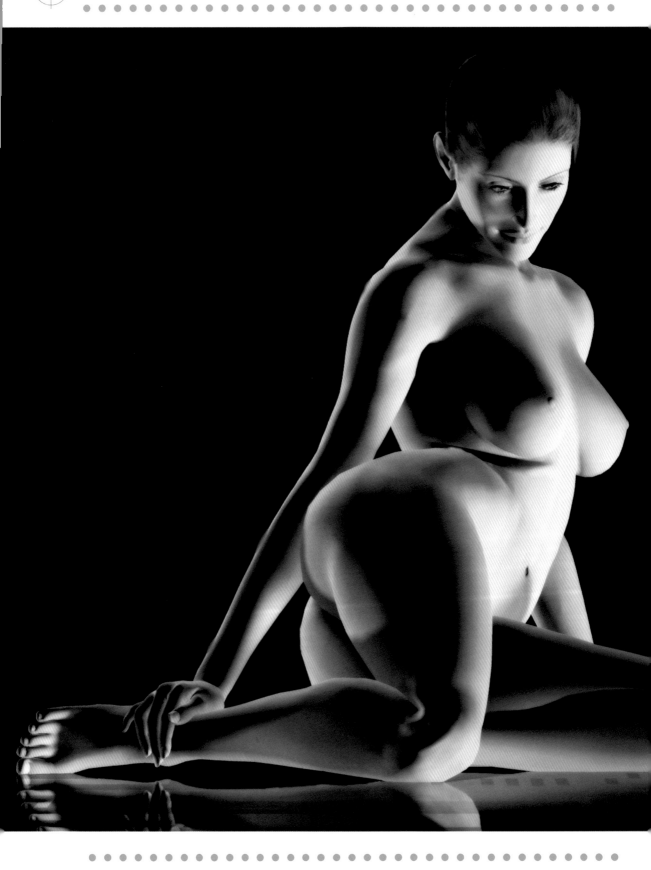

GALLERY

THE TECHNIQUES SHOWN IN THE PRECEDING CHAPTERS ALL HAVE ONE AIM: TO CREATE THE BEST AND MOST REALISTIC DIGITAL ARTWORK. WHAT FOLLOWS IS A SHOWCASE OF SOME OF THE BEST IMAGES CREATED BY ARTISTS IN THIS BOOK, AS WELL AS MATERIAL FROM OTHER LEADING PRACTITIONERS OF THE GENRE. TAKEN ON THEIR OWN, THEY CAN BE USED AS INSPIRATION FOR YOUR OWN WORK, BUT IF YOU WANT TO FIND OUT MORE ABOUT THE ARTISTS AND SEE MORE OF THEIR IMAGES, YOU WILL FIND NAMES AND WEB ADDRESSES IN THE SOURCES AND INFORMATION SECTION (PAGE 216).

Ellie Morin©02

ARTIST
ELLIE MORIN
TITLE
REFLECTIONS

GALLERY

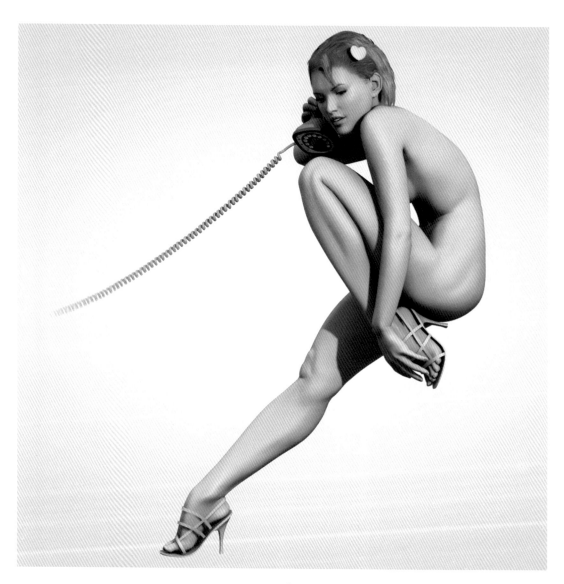

ARTIST
STEVEN STALHBERG
TITLE
PHONE GIRL ABOVE
STOOL OPPOSITE

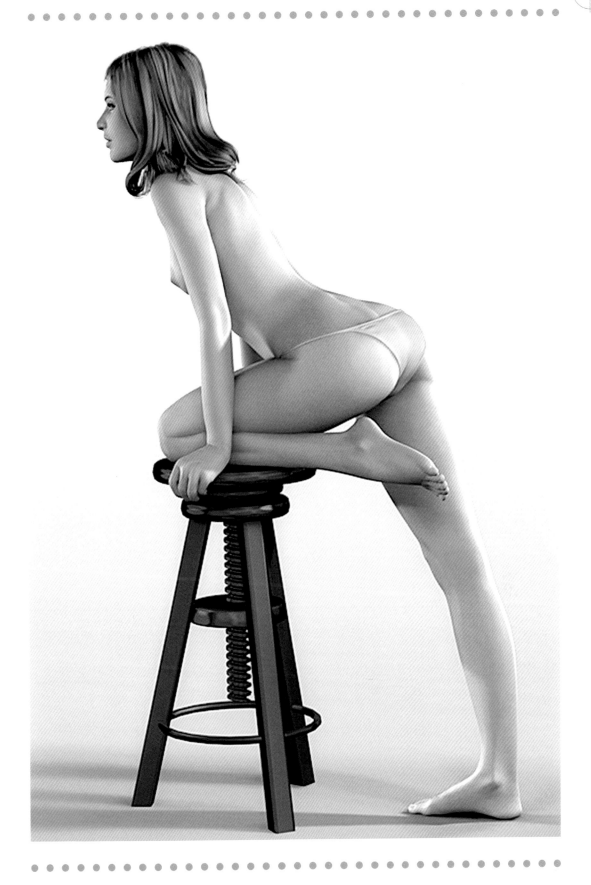

GALLERY

ARTIST
FRANCOIS RIMASSON
TITLE
SARAH

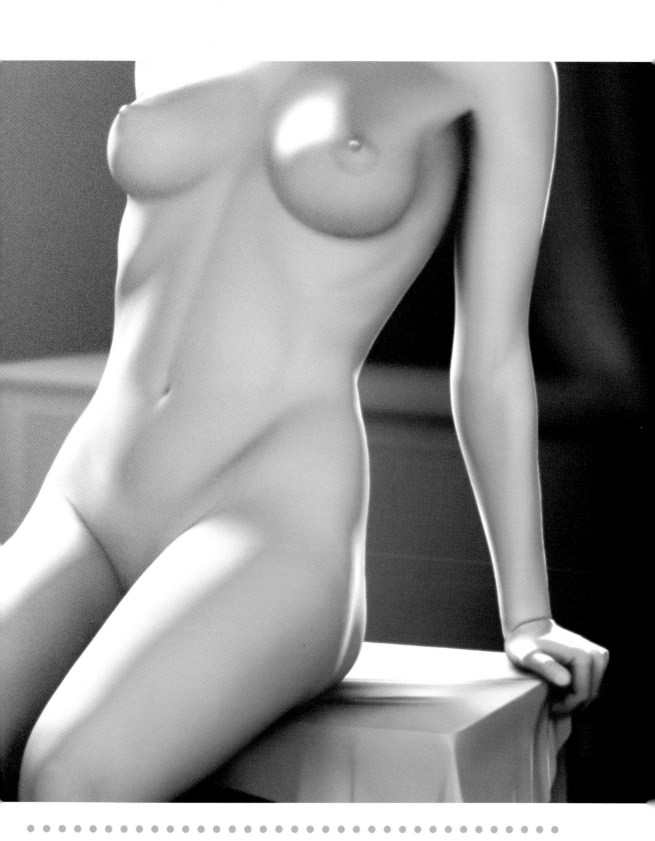

GALLERY

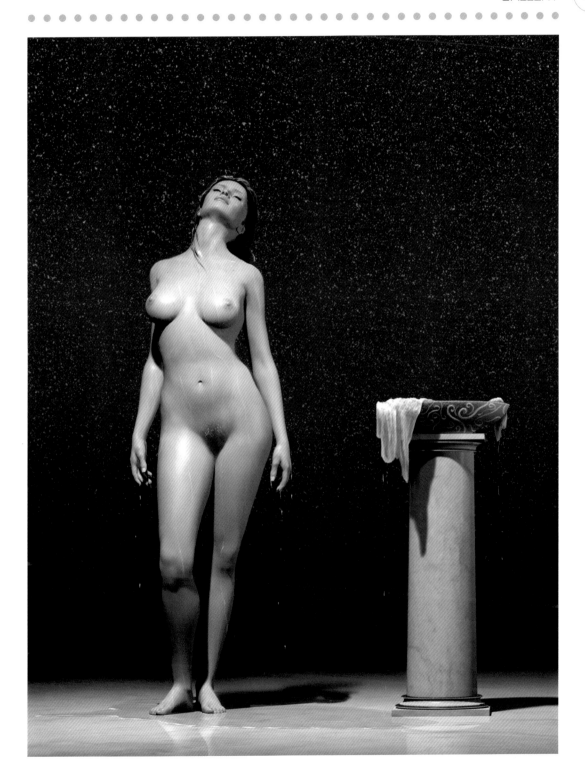

ARTIST
FRANCOIS RIMASSON
TITLE
EBONY LEFT

ARTIST
WILL KRAMER
TITLE
WASHCLOTH ABOVE

GALLERY

ARTIST
MUNGO PARK
TITLE
SHOWER LEFT
JAPANESE FANS ABOVE

OPPOSITE
THE ROOM TOP LEFT
STRANGE FRUIT BOTTOM LEFT
BEHIND THE BLINDS FAR RIGHT

GALLERY

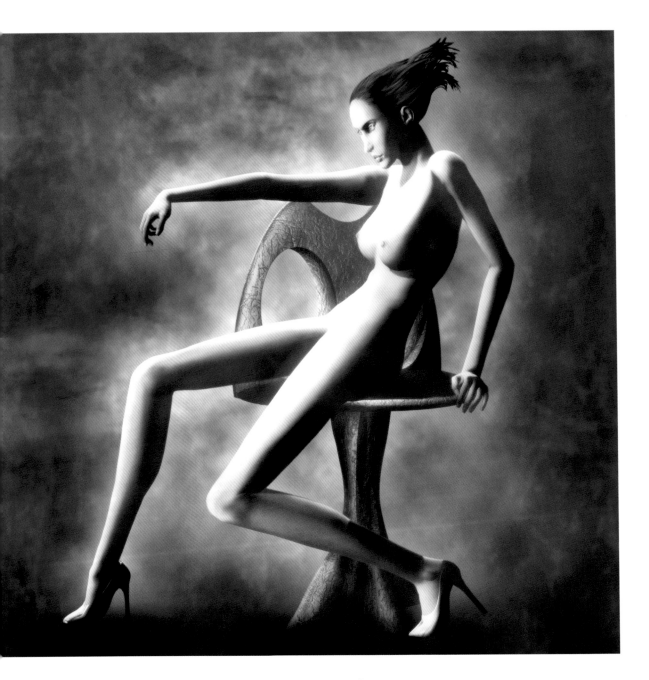

ARTIST
IAN & DOMINIC HIGGINS
TITLE
PORTRAIT OF A NUDE ABOVE
NATURAL SELECTION OPPOSITE

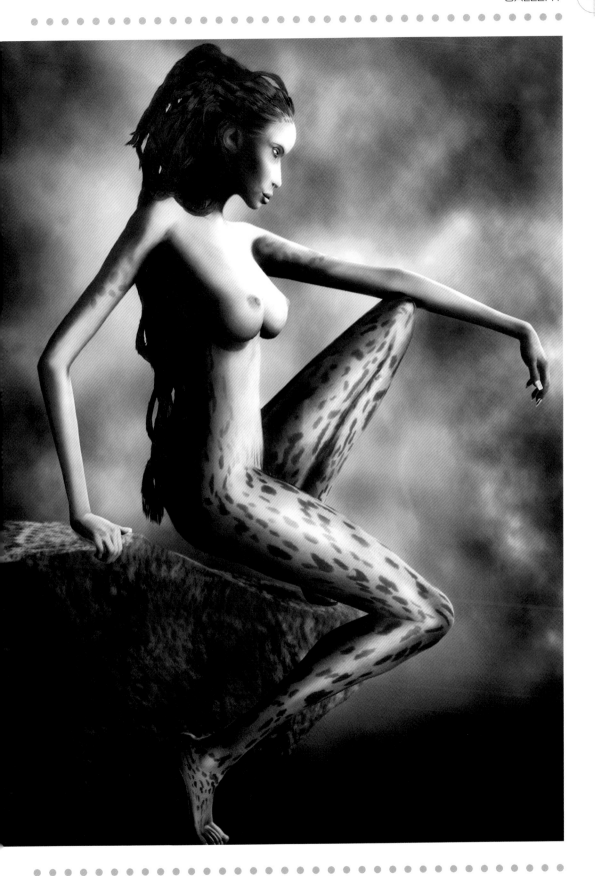

GALLERY

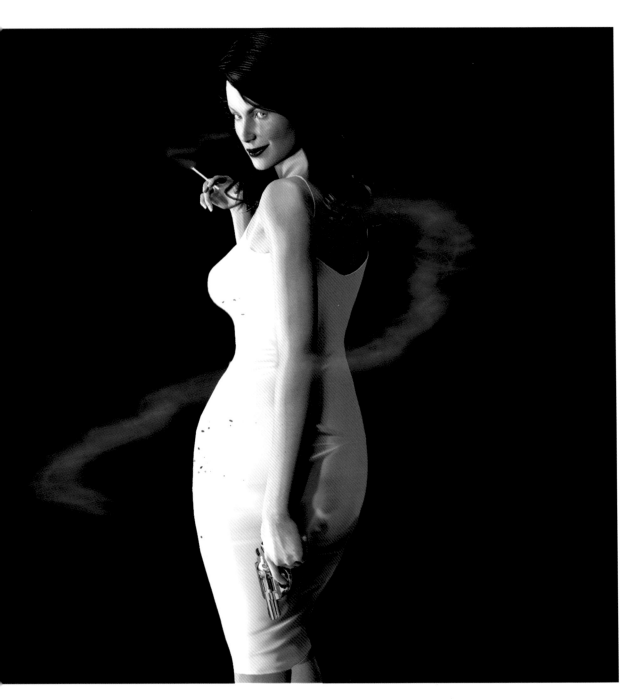

ARTIST
DANIEL SCOTT GABRIEL MURRAY
TITLE
HANDYWORK

ARTIST
KRISTEN PERRY
TITLE
GEISHA

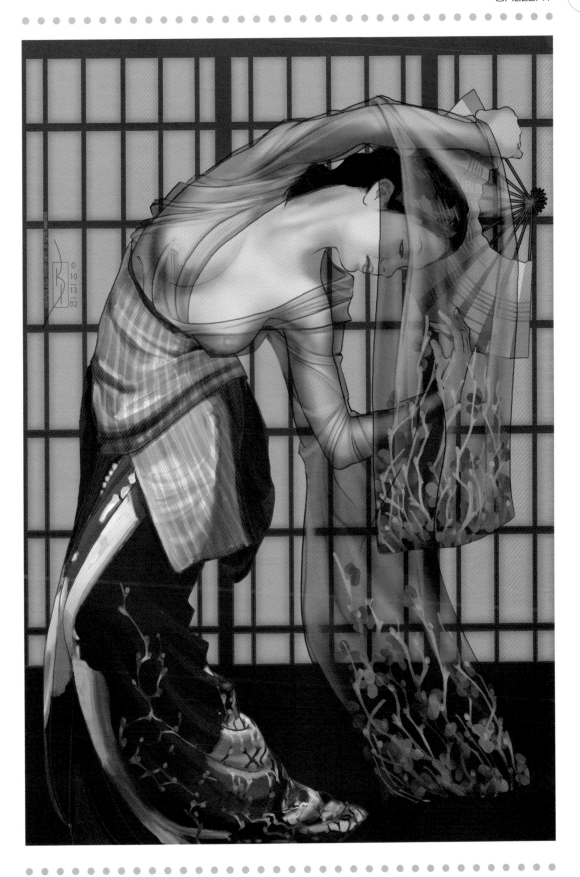

GALLERY

ARTIST
ANATOLIY MEYMUHIN
TITLE
LAST NIGHT ABOVE
BATHING OPPOSITE

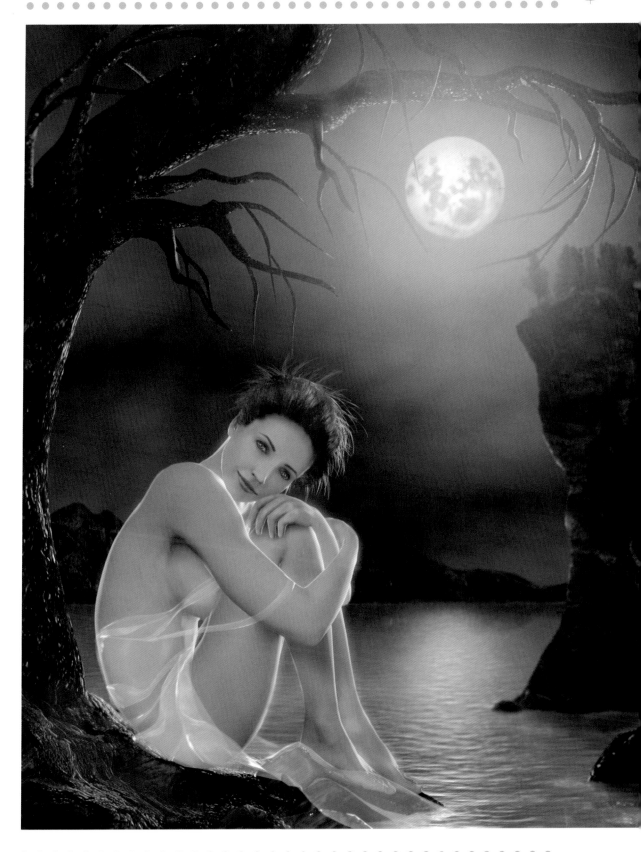

GALLERY

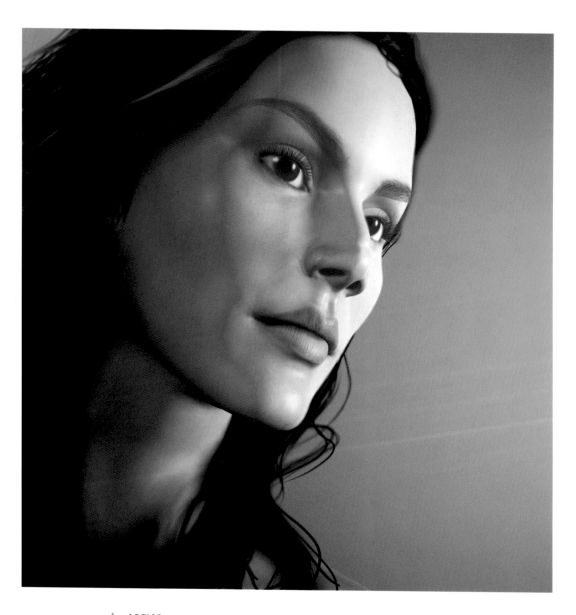

ARTIST
DANIEL SCOTT GABRIEL MURRAY
TITLE
PORTRAIT

ARTIST
ELLIE MORIN
TITLE
IN THE MOMENT

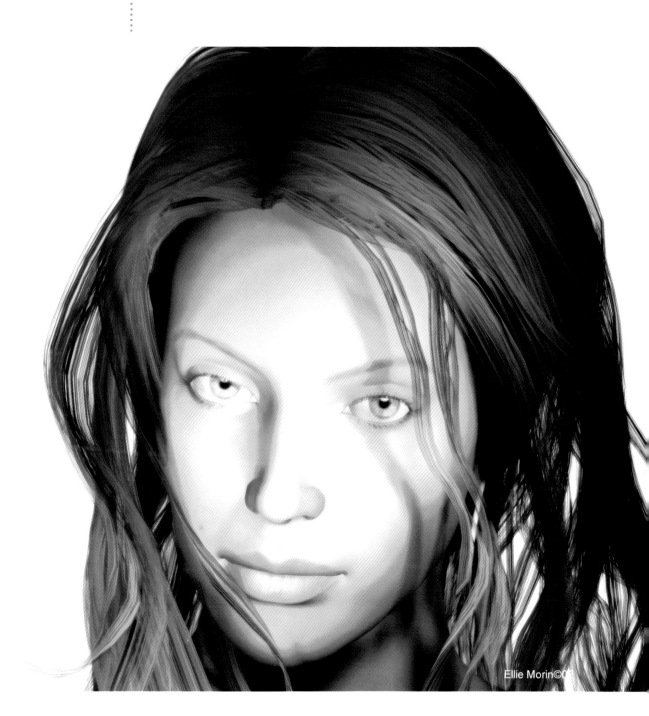

Ellie Morin©0?

GALLERY

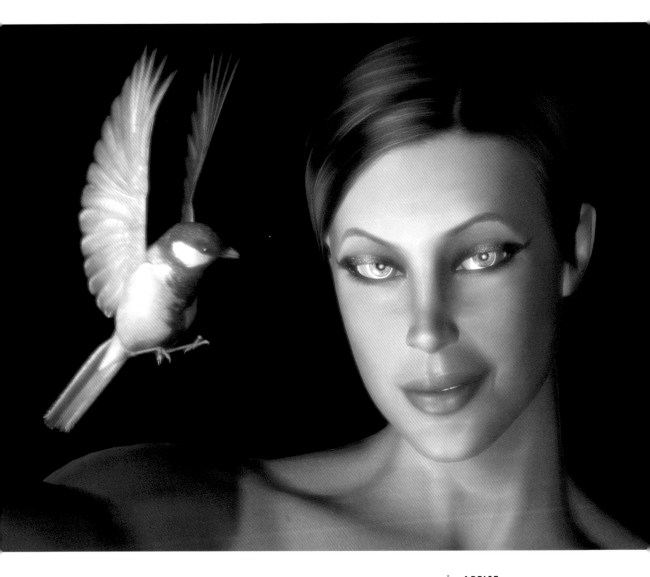

ARTIST
MICHAEL LOH
TITLE
ANGELIQUE

ARTIST
ALCEU BAPTISTÃO
TITLE
KAYA

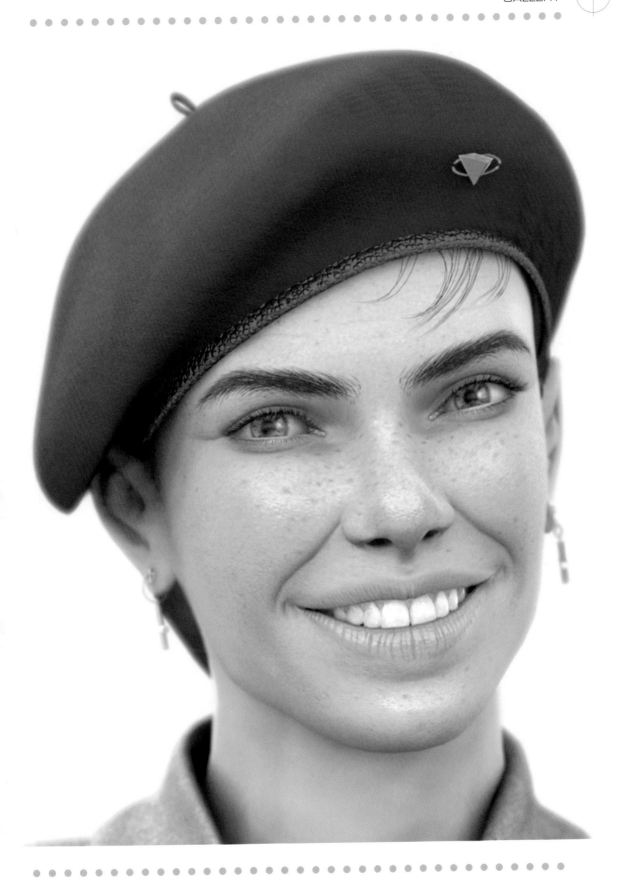

GALLERY

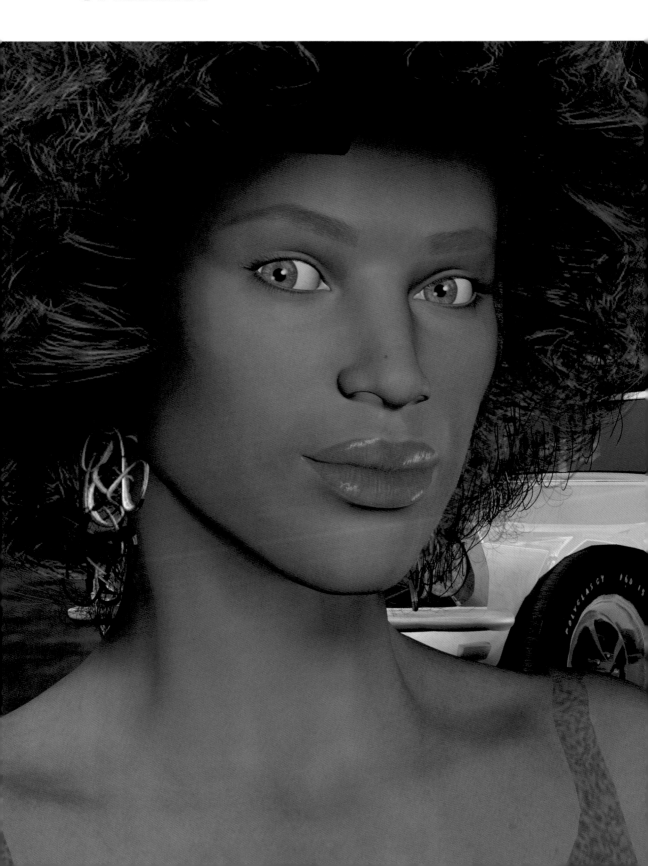

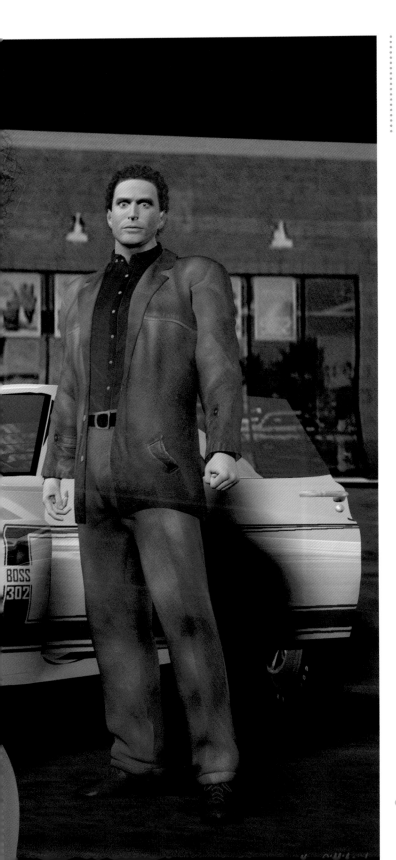

ARTIST
KEN GILLILAND
TITLE
WAITING

GALLERY

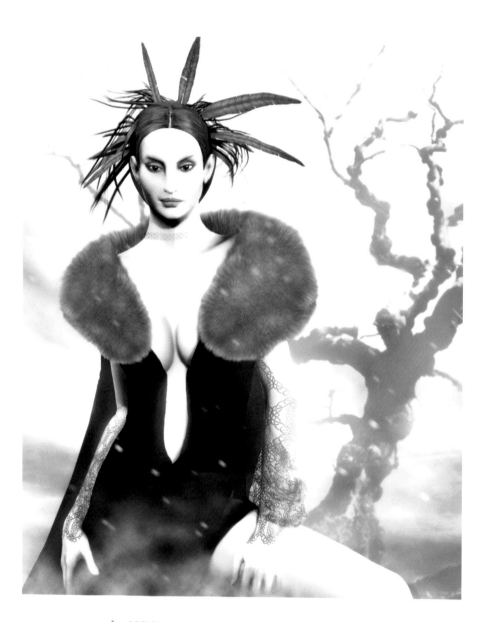

ARTIST
IAN & DOMINIC HIGGINS
TITLE
THE MORRIGAN ABOVE
LIAN OPPOSITE

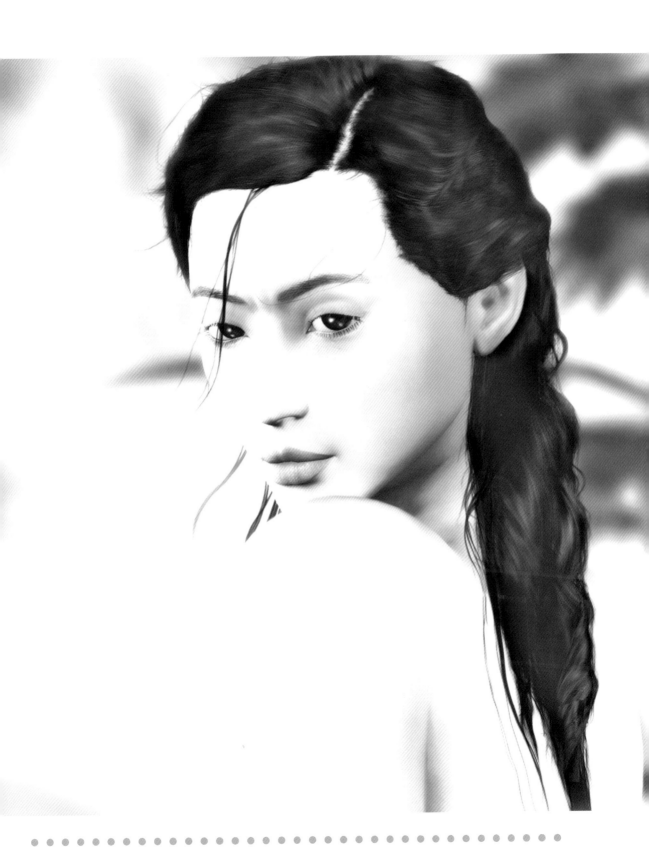

GALLERY

ARTIST
DANIEL SCOTT GABRIEL MURRAY
TITLE
GHOST ABOVE
DEADLY C DOLL OPPOSITE

GALLERY

ARTIST
MARCO VERNAGLIONE
TITLE
LISA PETERS ABOVE
DISTANT WORLDS OPPOSITE

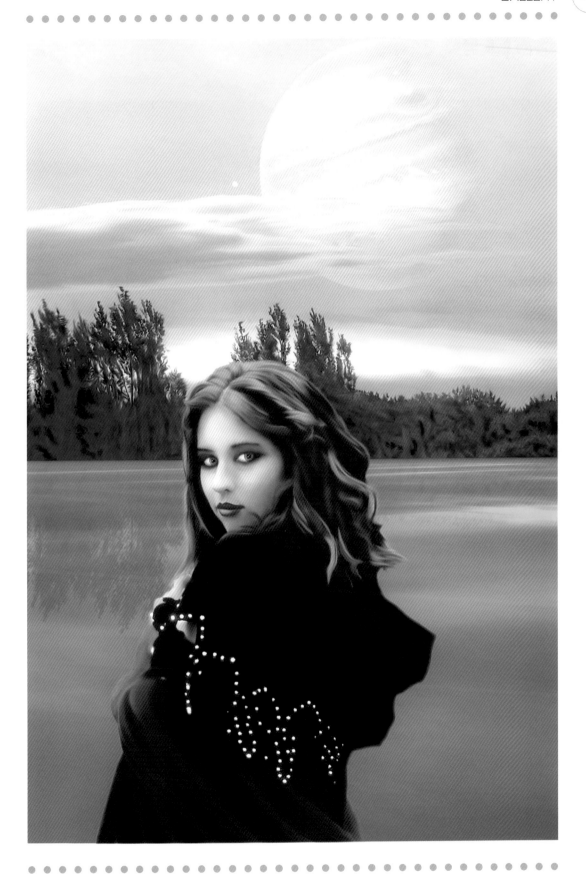

GALLERY

ARTIST
STEVEN STALHBERG
TITLE
TALENT STUDIO

ARTIST
ROBERTO CAMPUS
TITLE
WATERFALL

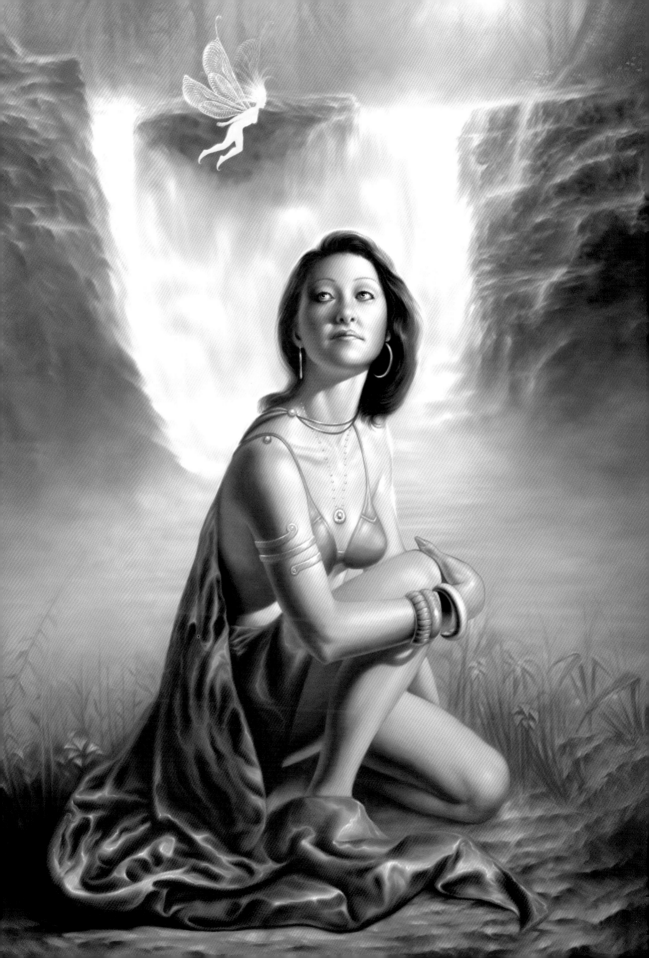

GALLERY

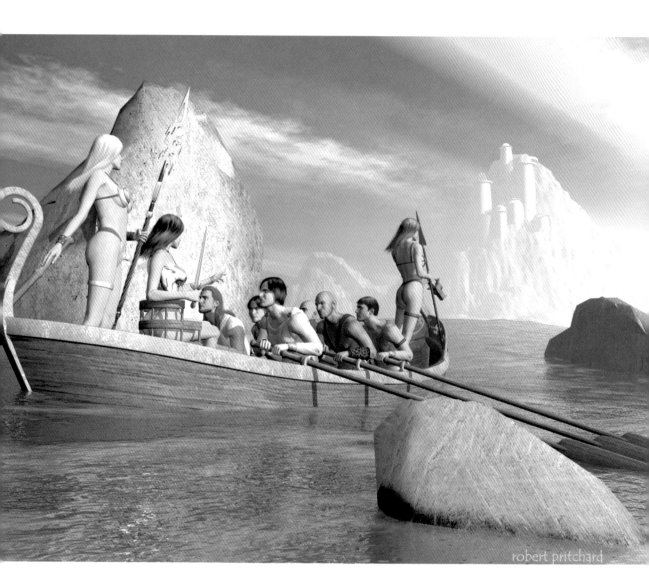

ARTIST
ROBERT PRITCHARD
TITLE
AMAZONIAN CRUISE

ARTIST
WILL KRAMER
TITLE
STANDING

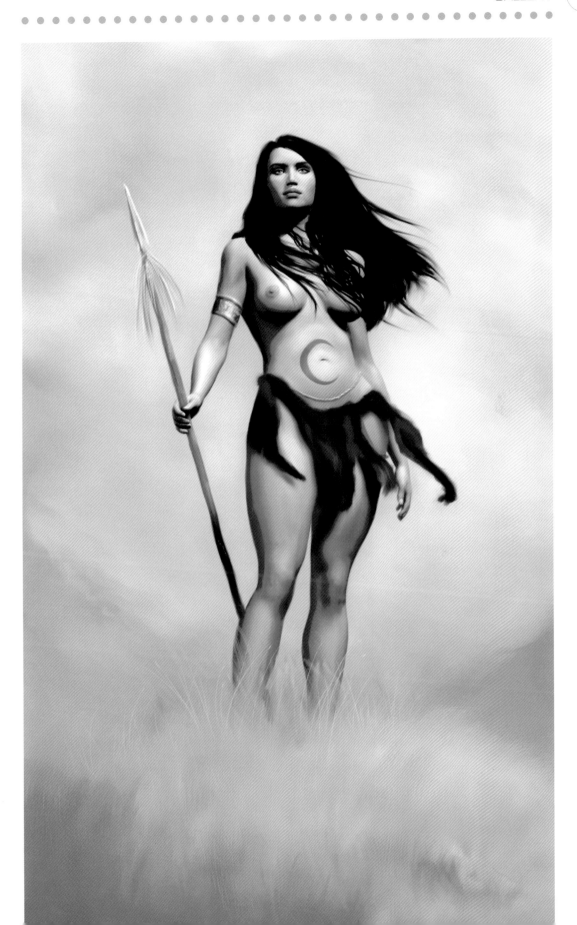

GALLERY

ARTIST
MICHAEL LOH
TITLE
DRAGON AND HUNTRESS

GALLERY

ARTIST
KRISTEN PERRY
TITLE
CATCH

ARTIST
ADAM MORTON
TITLE
MISS DEMEANOUR

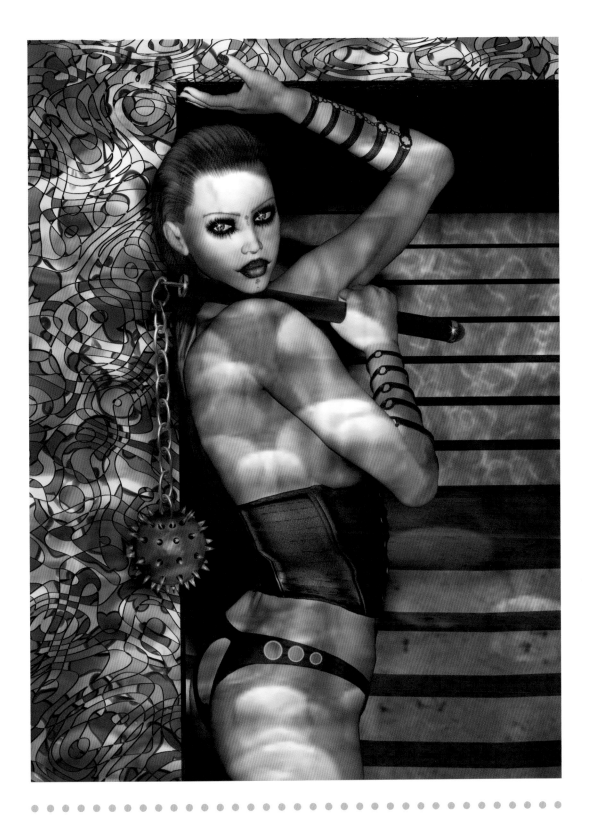

GALLERY

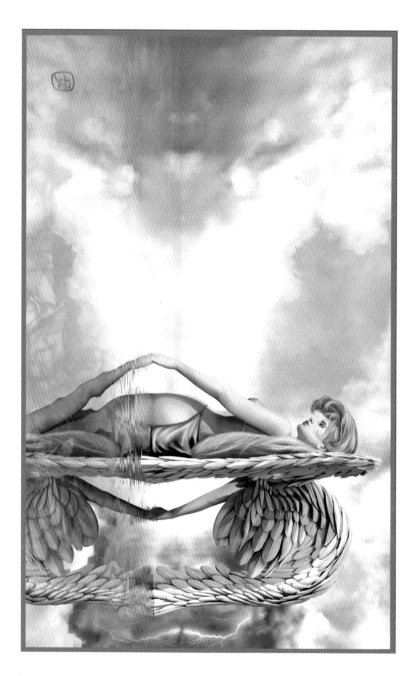

ARTIST
CRIS PALOMINO
TITLE
AT REST ABOVE
BEATIFIC MALIFICENCE OPPOSITE

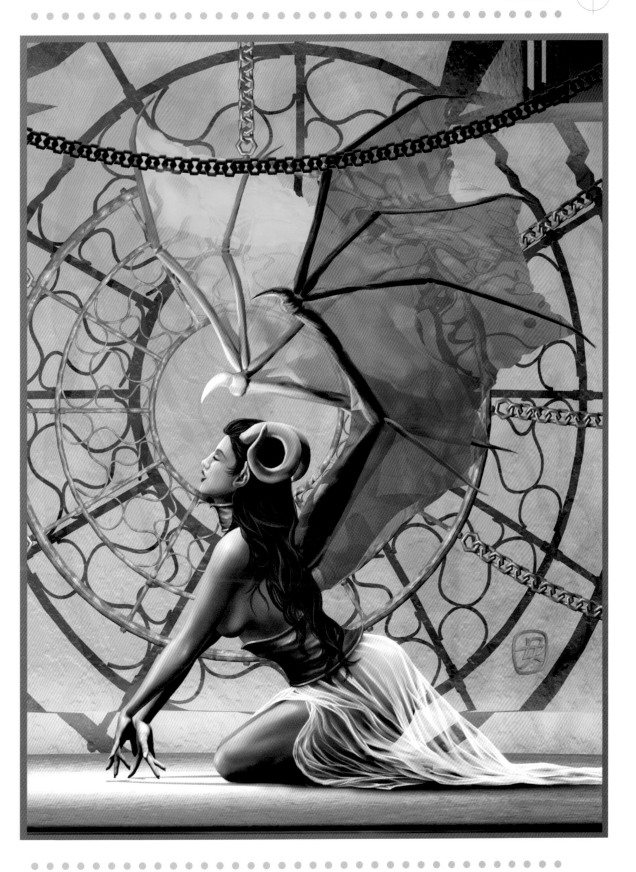

GALLERY

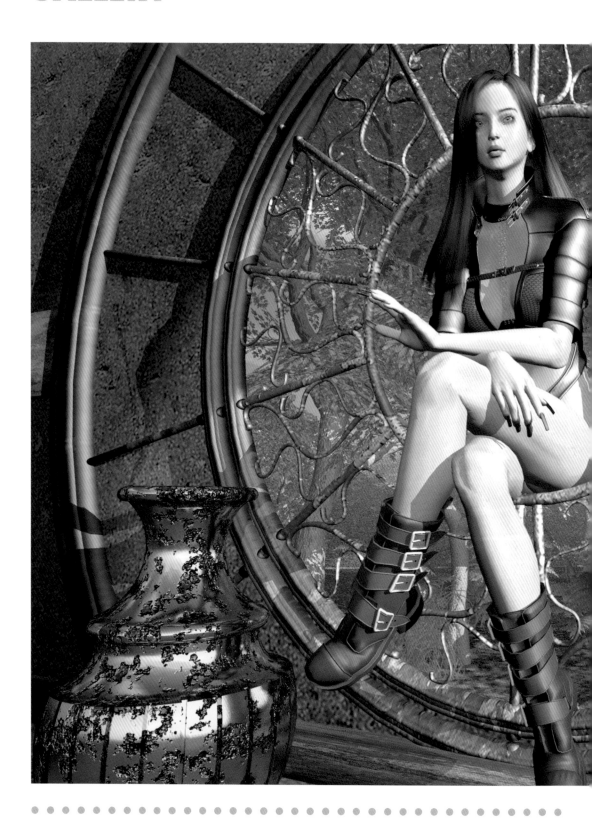

robert pritchard

ARTIST
ROBERT PRITCHARD
TITLE
BEAUTY

GALLERY

ARTIST
ADAM MORTON
TITLE
CYBERANGEL

ARTIST
RALPH MANIS
TITLE
BUTTERFLY LADY

GALLERY

ARTIST
DANIEL SCOTT GABRIEL MURRAY
TITLE
INFIDELS

ARTIST
RENE MOREL
TITLE
KARMA

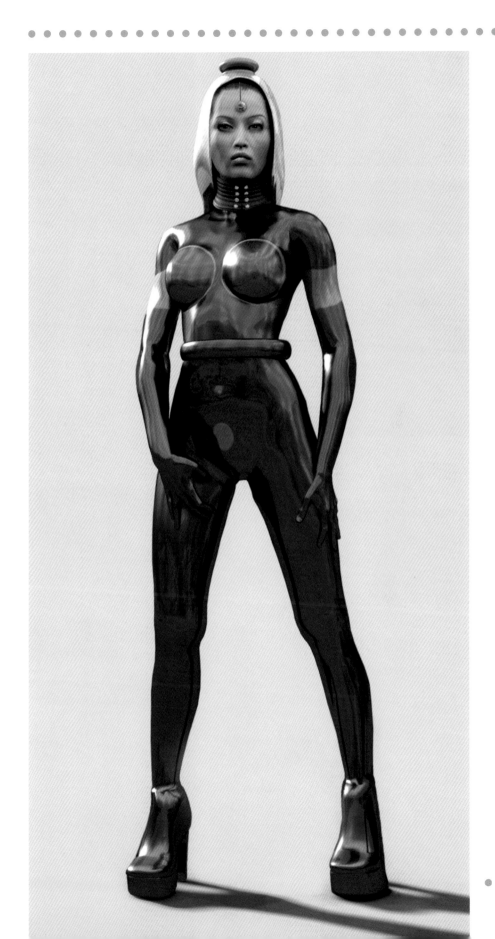

GALLERY

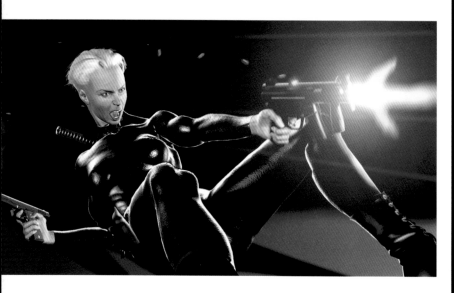

ARTIST
DANIEL SCOTT GABRIEL MURRAY
TITLE
IT'S HIT THE FAN ABOVE
THE RIDE OPPOSITE

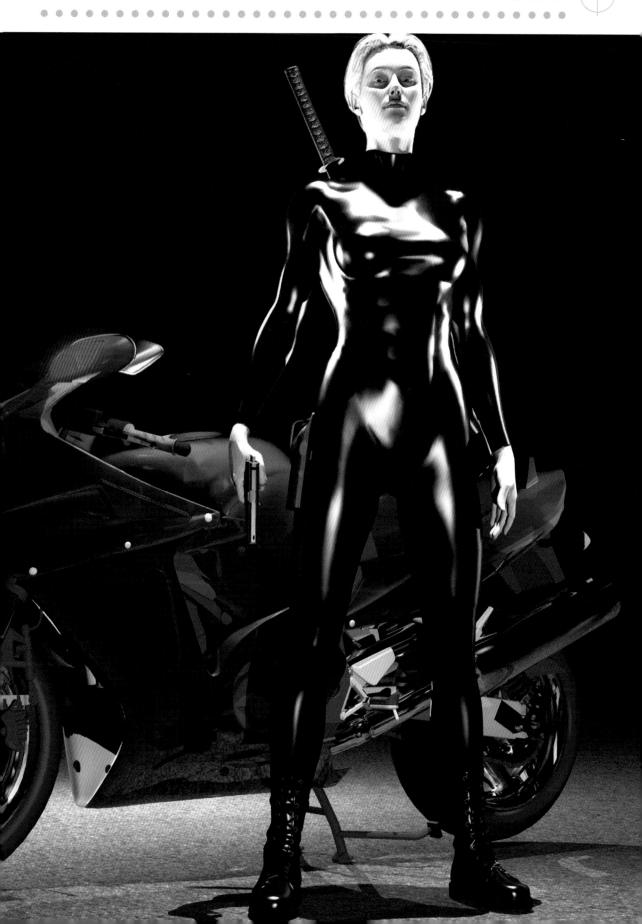

GALLERY

ARTIST
RALPH MANIS
TITLE
LOVE GUN

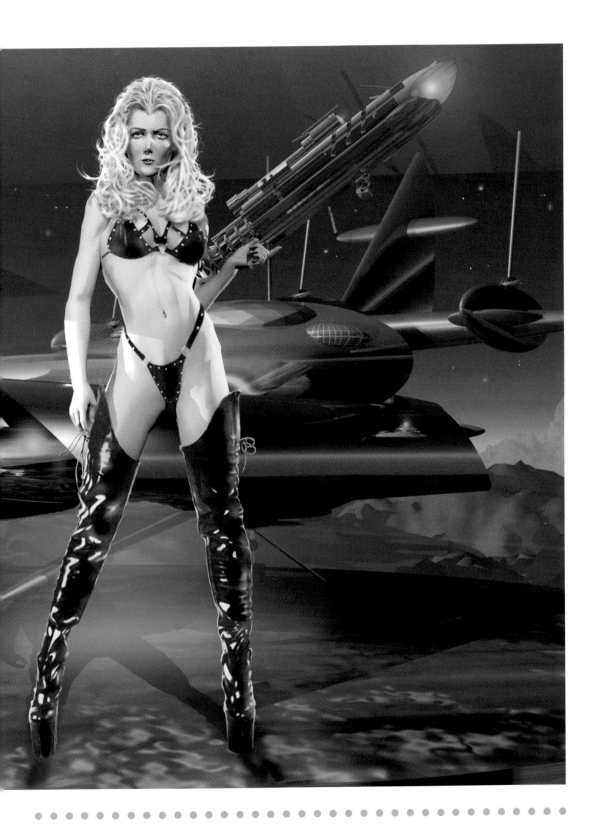

GALLERY

ARTIST
JEANETTE THOMPSON
TITLE
SWAY OPPOSITE
DEFIANT BELOW

Jeanette 2002

GALLERY

ARTIST
DAVID HO
TITLE
FILE SHREDDER BELOW
CONTEMPLATION RIGHT

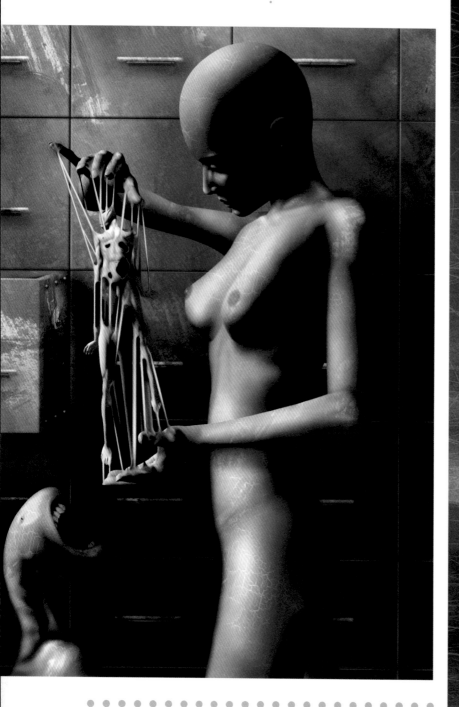

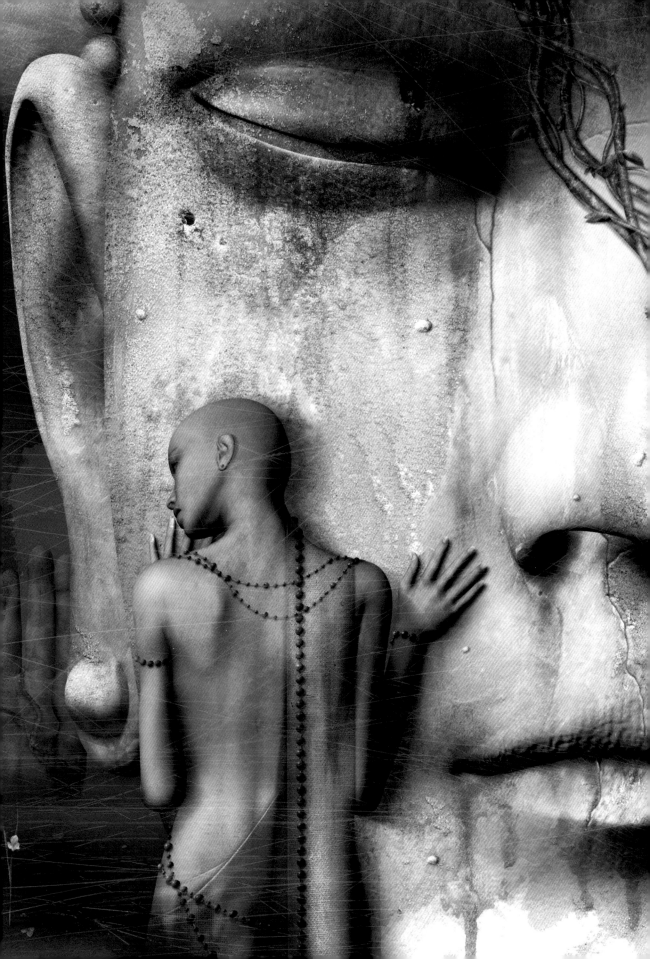

ARTIST
ADAM MORTON
TITLE
WINDOW

REFERENCE

HARDWARE

YOU MAY BE AN ESTABLISHED ARTIST trying your hand at digital art. You may be a complete beginner, new to both the world of art and computers. If either of these apply, this section is for you.

Computers are everywhere and it's unlikely that you've gone through life without encountering them in some form. The question here is what is best to use to create digital art? Well, for a start, you'll need to look at the platforms available. This basically means buying into the use of an operating system (OS), of which several are available. The most common are Windows, from Microsoft, which runs on the PC platform, and the Mac OS, developed by Apple for its Macintosh computers. Another is Linux, an operating system that runs on just about anything and is gaining popularity in the 3D and design world. Windows is by far the most popular platform available, but this does not mean

it's the best for graphics applications. Indeed, many would argue that Apple has the upper hand here. However, most of the software vendors write for the OS with the most users, on grounds of financial survival if nothing else.

Recently, at the time of writing, both Microsoft and Apple have completely revamped their main offerings, setting out a roadmap that their systems will follow for at least the next five years, so it's safe to describe some of the key points of each with reference to the topics contained in this book.

OPERATING SYSTEMS

There are several versions of the Windows operating system, but many of the 3D applications were for a long time only to be found on the higher-end Windows NT or Windows 2000. This changed eighteen months ago with the launch of Windows XP, which combined the power of NT with the usability of the consumer-based Windows 98, and brought powerful graphics software to the hands of many more customers. Both the Home and Professional editions can run multiple applications simultaneously with great system response and impressive stability.

What's more, Windows XP is fully compliant with the latest graphics hardware. Built into XP is Direct X, a collection of Application Programming Interfaces (APIs) that basically enhance the computer's ability to 'talk to' or control multimedia hardware and applications. This allows the developers of the most popular 3D graphics applications to offer far more advanced authoring tools and has the additional effect of helping you create more realistic artwork.

Apple's Mac OS X operating system has also been designed to provide stability, power and ease of use. It has a protected memory system and advanced multitasking capabilities, which leads to fewer system crashes, as well as support for multiprocessor systems. Apple has integrated the OpenGL 'graphics library' into its latest system, which adds compatibility with a greater range of high-powered graphics hardware, especially for 3D use.

Apple Power Macintosh G4. With Apple and most PC manufacturers offering multiprocessor models, the digital artist can have almost supercomputer power on the desktop.

Unfortunately, the advances in graphics software mean that such fast machines are a necessity for digital artists at the cutting edge. *Image courtesy of Apple Computer, Inc.*

OpenGL provides standardized control for such things as lighting, rendering, texturing and other operations, making it very easy for developers to produce high-quality 3D applications.

OpenGL is also the key to Apple's Quartz Extreme, an innovative technology that takes advantage of the faster and more powerful processors in today's video cards and boosts graphics power for applications. With such an advanced graphics engine under the hood, Mac OS X has been successful in attracting complex image-creation tools across from other platforms, notably, for readers of this book, Maya from Alias|Wavefront and Vue d'Esprit from Eon Software.

COMPUTERS

Advances in computer processor power, larger storage capacity, streamlined data transmission and superfast system architecture have all contributed to producing workhorses of startling power on the desktop. Apple has its own proprietary range of computers, designed to work with the Mac OS. It has equipped the Power Macintosh line with multiple processors, large hard drives (60 GB is now an entry level size among machines used for digital content creation), top-of-the-range video cards (also called graphics cards or accelerators), enhanced networking and large amounts of memory (RAM) to run applications.

Microsoft does not make desktop computers, but there are scores of Windows-compatible PCs on the market, and the choice for the graphics enthusiast comes down to how highly specified the individual makes are. IBM, for example, the creator of the original PC, is only one of several vendors who offer a dedicated content creation workstation, as part of its IntelliStation line. These graphics workstations are typically designed in conjunction with software manufacturers to give the best graphics performance through a select combination of processors, graphics cards and memory configuration.

Of course, you don't have to go that far. Any PC will run Windows (although a fast Pentium 4 or Athlon XP system would be the sensible minimum for the sort of work in this book). The main thing to remember is to stock up on memory to run applications (256 MB of RAM should be considered the absolute minimum for 3D work, especially on XP), buy a machine with the most powerful processor you can afford and get yourself a good graphics card.

PIXELS AND RESOLUTION

Digital images, when displayed on the monitor screen, are composed of tiny dots called pixels (from 'picture element') which contain an individual colour value and intensity or brightness.

The resolution of the video image refers to the number of pixels that can be displayed on screen. This is commonly presented by a pair of numbers, such as 1024 x 768, respectively defining the number of pixels that can be displayed horizontally and vertically on the screen. The higher the resolution is, then the more pixels can be displayed, though this depends on both the monitor and graphics card being used. The pixel resolution of a digital image is usually described as pixels-per-inch or ppi, and as such refers to the density and hence the quality of the image. To provide a real-world example, a 3000 x 2400 pixel RGB image on screen could be reproduced on paper as a 10-inch x 8-inch picture at 300ppi. The file size (in megabytes) would be 18 MB.

GRAPHICS

Graphics cards provide the drawing power behind imaging and illustration applications, and the technology used to create them has advanced enormously in recent years. It is now common for graphics accelerator cards to carry 64 MB of their own video RAM and to be loaded with number-crunching algorithms that have the sole purpose of calculating geometrical equations and pixel values, thus removing the strain on the machine's main processor.

Several names are prominent in this field, including Nvidia, ATI, Elsa and 3Dlabs. The one thing to look out for, especially for 3D work, is that the card supports the OpenGL standard. Good cards are not cheap, though, so this is largely an option for serious 3D artists. Many workstations do, however, ship with decent graphics accelerators as part of the package, thanks to the popularity of high-quality computer games. As long as the card supports a resolution of 1280 x1024 pixels, it will be adequate for most applications.

MONITORS

A good monitor is essential for any graphics work as this is the canvas for the digital artist. Get the biggest and best you can afford because you'll be spending a lot of time looking at the thing. The lowest specification should be a multiscan 17-inch screen, but 3D work is best carried out on monitors with larger screen sizes. As a starting point, go for a monitor that supports millions of colours at a resolution of 832 x 624, which you can scale up to higher resolutions when the work requires it. Remember that the larger the monitor and more resolutions and colours you require, the more

Wacom Intuos tablet. Wacom produces a range of graphics tablets that enable digital artists to use a pressure-sensitive pen to 'draw' on the screen. This level of hands-on control cannot be replicated using a mouse.
Image courtesy of Wacom Technology Co.

demands are made on the Video RAM of your system, so make sure you have a graphics card that can handle your demands. Traditionally, bulky CRT monitors have been used for colour-sensitive applications, but today's artist has the choice of a wide range of much slimmer LCD or TFT monitors that are fast catching up in price and colour fidelity.

Here's a tip: if the thought of a huge monitor dwarfing your workspace frightens you, consider buying two smaller displays, possibly of different sizes (and price). Use one as your canvas and the other for all the palettes and controls that litter modern graphics applications. Many graphics cards are available today that can handle a dual monitor display, so consider it as an option. It also provides a backup for when the main monitor develops a fault.

EXTRA STORAGE

Hard disks (or drives) are the storage devices within computers that store the operating system and the applications. They also provide storage for your digital creations and their intermediate stages. An essential routine for any artist should be backing up the data on their system. There is nothing worse than working on a piece for many hours (or days) only to have the computer crash or develop a fault which means that the data on the hard disk is irretrievable or damaged. Therefore regular saves and transferring of data to an external drive are essential. For backing up and archiving work, which can also free up valuable space on your internal drive, many computers today come with CD-RW drives, which write and rewrite data onto CD media. The media

is relatively inexpensive for us and has become the present day equivalent of floppy disks. Another type of device used for this purpose is removable storage such as Zip disks, optical media, or tape cartridges. All bring the benefits of a rewritable storage system for protecting your work.

Another method of storage is to acquire extra hard disks. These are usually self-contained devices, but drives which you add internally to your computer are also widely available. External drive sizes can typically be anything from about 40 GB to 250 GB at the time of writing and are commonly connected through high-speed FireWire™ or USB cable interfaces. It's worth investing in an external drive for storage and also to provide a 'scratch disk' or temporary storage for graphics applications such as Adobe Photoshop.

INPUT DEVICES

The humble mouse is often the paintbrush of the digital artist. Not just a pointing-and-clicking device, the mouse comes in a variety of forms, though a three-button mouse, often equipped with a thumbwheel, is a standard accessory for any serious 3D work. However, many artists prefer to use a pressure-sensitive drawing tablet with accompanying wireless pen and three-button mouse. Such tablets are highly useful, with those by Wacom being the market leader. Many applications, such as Corel Painter, Adobe Photoshop and Alias|Wavefront Maya, take advantage of the tablet's ability to measure pressure and react accordingly, increasing the flow of paint to a brush head or varying the thickness of a line in response to the amount of pressure of the pen on the tablet.

The pen, which Wacom suggests can also reduce the risk of repetitive strain injury and other computer-related injuries, is also tilt-sensitive. Some pens carry a replaceable black ink cartridge, which allows hand-written input to be visible to the user both on paper documents and in digital format on the computer screen. The digital information from the pen can be transmitted through paper up to 0.4 in (10 mm) thick on the tablet surface and is thus ideal for tracing, illustrating original artwork and inputting hand-written text. Drawing pad sizes vary from A4 down to A6, with some artists claiming the smaller size is better for painting and drawing, as the pen does not need to move around so much. They are also less expensive.

Canon EOS 1DS. Digital cameras are an increasingly common way of capturing digital reference material, both for 2D artwork and 3D textures. *Image courtesy of Canon (UK) Ltd.*

Wacom has now gone one stage further than the tablet, in a move that some artists may find more appealing than a traditional computer setup. The Wacom Cintiq range is the latest example of a new device that combines a touch-sensitive display with tablet and pen technology. The specially coated LCD display is glare-free and offers a microstructure that produces a small amount of friction when touched by the pen. Artists say painting and drawing on the LCD display is almost like using pen on paper.

IMAGE INPUT

For bringing in external imagery to a piece of work, whether to form the basis of a picture or add a component, there are two main hardware options to consider: scanners and digital cameras.

Scanners, whether for flat images or transparencies, have plummeted in price compared with a few years ago and technical performance has increased considerably. They are ideal for bringing in natural objects and photographs as texture maps or the basis of a scene, and many flatbed scanners double up to provide a way of scanning in transparencies.

Dedicated slide scanners are also available, and the prices have dropped enough to bring them within the reach of the mainstream. The same can't be said for the far more expensive drum scanners, used largely in professional printing and publishing. For the digital artist, however, flatbeds are very often used to import rough pencil sketches of a scene before the digital process begins, providing both a base and guide for the artist to work from. Prices vary but if you are looking to include scanners in your digital workflow, it's best to avoid the cheapest. Manufacturers' claims for scanners are often overblown and deliberately confusing. So ask for a test scan and check the detail in the image yourself before buying.

The other way of getting base images into the computer is through the use of a digital camera. Like scanners, the digital camera market has been boosted by new technology and lower prices as these devices become more popular. There are many vendors in this market and many reasonably priced models are of excellent quality. Again it comes down to personal preference. Things to look out for are ease of use, lens quality, image capture resolution, battery life and storage capabilities. Few of today's cameras rely on built-in storage, and most use one of several memory card-based removable storage options. The better the image resolution, the larger the file size of the picture, so it's well worth investing in an extra 64 MB or larger memory card.

This resolution depends on the quality of the image sensor chip that takes the place of the film – commonly a CCD. Typically, digital cameras are described by the effective number of pixels the chip can output, for example, the Epson PhotoPC 3100z, with a chip that can handle 3.14 million pixels, is referred to as a 3.14-megapixel camera.

Most digital cameras are point-and-shoot models. However, some traditional camera manufacturers, such as Canon and Nikon, have produced expensive digital models that replicate the SLR standard, right down to interchangeable lenses, exposure modes and other professional features.

Epson GT30000. A high-quality scanner is another vital tool for the digital artist, enabling them to use anything from photographs to textured materials as an element in their 2D painting or 3D modelling. *Image courtesy of Epson UK Ltd.*

PRESENTATION

DIGITAL ART CAN BE OUTPUT IN several ways including printing, video and uploading to websites, but what's the best way to prepare your artwork for exhibiting? This depends on what medium you are outputting it to. If your work is purely for screen-based, Web or multimedia display, then looking good on a monitor is the only criterion your image needs to fulfill. However you may want to produce prints for checking and exhibiting images in the physical world.

COLOUR AND RESOLUTION
Digital colour, much like traditional printing methods, is made up of colour channels – RGB (red, green and blue) being the standard for on-screen work and CMYK (cyan, magenta, yellow and black) a four-colour process commonly used for printing. Thus if you want to transfer your images within the digital domain, to a Web page say, you do not need to change the colour mode. If, however, you want to print, you have to change the mode to CMYK and you can do this easily in software like Adobe Photoshop. A key point to remember is that all devices have a different colour 'gamut' – basically the range of colours that the monitor or printer can handle. CMYK has a smaller gamut than RGB, so your vibrant colours may not be reproduced as faithfully in the printing process as they are on the monitor. Colour-matching software is available, however, usually built into operating systems and image-editing applications or included in printer and scanner software. Colour management – that is, having the image from your scanner, monitor and printer all with the same colour values – is an exact science, so if you are concerned about faithful colour

reproduction, seek professional help or purchase commercial software dedicated to the purpose.

Printer resolution is measured in dots-per-inch (dpi) – a higher dpi means a smaller printer dot and thus a sharper image. There are two things to remember here: first, dots per inch and the pixels per inch designation used by scanners and monitors are not quite the same (due to the processes involved), and second, you can adjust the dpi of a printer in the same way that you can set the resolution of an on-screen image.

PRINTERS
Types of printer available for ordinary use are laser, bubble, or inkjet, dye-sublimation, solid ink, thermal and dot matrix (though the latter is useless for artwork), and the quality of the printing varies widely. For fine art prints of your work it would be wise to enlist the services of a professional printing bureau, which typically will provide high-quality prints using a CMYK process such as the Scitex Iris system. Considering its quality and relative cheapness, the latest desktop colour inkjet technology is probably the best avenue to explore for your own proofing and even some exhibition output. A wide variety of paper stock exists to present your masterpiece in almost any way you desire (or can afford).

There are a wide variety of options for the digital artist. Leaders in the field are Epson, Canon, HP and Lexmark, and these companies offer a variety of printers, including 'photo' inkjets that recently have been able to produce near-photographic quality prints that are almost indistinguishable from the real thing. The 'light fastness' of the media – that is, the protection from fading that the ink and paper provide – has also been improved, so much so that you can buy media guaranteed to keep your artwork pristine and sharp for around 75 years. Inkjets work by spraying quick-dry pigment ink onto the paper in four, six, or even seven colours. The spray nozzles use a variety of technology to transfer the ink to the paper, depending on the manufacturer. Some heat the ink to create a bubble until it bursts, with the ink driven onto the paper by the pressure created, while the Epson method uses a piezo-electric cell to force the ink through the nozzle by mechanical pressure. All,

IMAGE TYPE
There are two main types of image format used in 2D digital art – bitmaps and vectors. The former is resolution-dependent, so if you have a 72-ppi image that you scale up to 300-ppi, your image will become degraded. This process uses a method called interpolation where the computer fills in the gaps between pixels with its own approximated versions, with not always the best results. Vector illustrations are resolution-independent, as they are merely a set of instructions to the processor on how to draw the object. This means they will always be reproduced at the highest resolution the output device can handle.

however, use a collection of coloured-ink droplets to represent one image pixel – the alignment and shape of the dots are crucial factors in the sharpness of the dot and thus the overall print.

OUTPUT THROUGH MOTION GRAPHICS

Another method of output is through video, animation or other motion graphics. This is largely reserved for the output from 3D modelling and 2D animation applications – Alias|Wavefront Maya is a good example. In Maya the image-file name consists of three parts: the base name for the animation sequence, the frame number from the scene's timeline and the file format. An image from a 3D application can be rendered with the RGB colour channel as normal, but can also carry an alpha channel (or mask channel), which is used by other applications that require opacity and coverage information, such as other animation or compositing software. The image file can also include a depth channel, which records the distance from the 'camera' to the objects in the scene (the 'Z-depth').

As well as outputting to bitmapped formats, 3D modelling packages can output to proprietary formats such as 3DS, common file formats like OBJ or movie files like uncompressed Apple QuickTime and Microsoft's AVI, enabling artists to import their work into other applications. Maya and other similar high-

IMAGE FILE FORMATS

File formats for image output usually depend on the use they will be put to. Some formats denote a compressed file, basically one that uses algorithms to create a smaller file size. Here are the most commonly used file formats in image editing:

JPG This is the compressed format from the Joint Photographic Experts Group and is by far the most popular image format in general use for photographs and other continuous tone images. The jpg format is preferable for exporting pictures with less detail as the compression scheme is 'lossy' (i.e. it loses picture information) and can lead to image degradation. If you are outputting to this format, perhaps for Web export, only save as a JPG at the very end, to avoid compressing the data more than once. The JPG format supports CMYK, RGB and greyscale colour modes, but does not support alpha channels. JPEG2000 is an updated version of the format that uses wavelet compression to store images in smaller file sizes, yet with more detail than previously. It now features alpha channels and transparency, has a lossless compression mode and can support up to 16-bit RGB images.

TIF The Tagged Image File Format uses a lossless compression scheme and is thus very popular, but the resulting file sizes are larger than jpg. Service bureaus usually ask that you save your images in this format.

BMP This is the Windows bitmap file format, which can contain 2 (black and white), 16, 256 or 16.7 million colours. Most BMP images are uncompressed but it's possible to save 16 and 256 colour images in a compressed format (known as RLE). BMP is less used now than in the past.

GIF The CompuServe Graphics Interchange Format is a compressed format capable of handling up to 256 colours, which has been very popular for online output. It is usually best for type or vector illustrations.

PNG The Portable Network Graphics format is used for lossless compression and for display of images on the Web. PNG supports 24-bit images and produces background transparency without jagged edges as well as supporting RGB, indexed-colour, greyscale and bitmap-mode images without alpha channels. PNG preserves transparency in greyscale and RGB images.

EPS Encapsulated postscript files are generally used by vector graphics applications such as Adobe Illustrator and Macromedia Freehand.

PSD The default format for Adobe Photoshop, PSD supports all Photoshop features including layers.

TGA The Targa format was developed by Truevision for its graphics cards, but is still used by 3D and image-processing applications. It can support up to 32-bit RGB images.

Inkjet printers are highly affordable and therefore commonplace on the desktops of artists everywhere. The latest photo-quality models, such as the Epson printer shown here, can print artwork up to A3 at a resolution and clarity comparable to what can be obtained with traditional photographic processing. This type of printer is also ideal for proofing and presentation purposes. *Image courtesy of Epson UK Ltd.*

Online galleries, like Renderosity, are the main avenue for exposure for the majority of today's digital artists. As well as providing a showcase for artwork, Renderosity – and the many other sites like it – also play host to user forums, software downloads and online stores. See page 216 for addresses of the most prominent online communities.

end products can also output 16-bit animation formats for use in film work.

For 2D illustration, some software also exists to convert a number of your image files into a 'slideshow' for presentation on a TV screen via DVD or VideoCD, or as a dynamic portfolio on CD-ROM.

USING THE INTERNET

Of course, the latest way of getting your work noticed is via the Internet. You can get access through an Internet Service Provider by using a modem or high-speed broadband connection. Artists upload their work to personal websites for pleasure or commercial reasons, or they submit work to an online gallery. Many sites exist for this purpose and you'll find some of the best listed in the section on *Sources of Software and Further Information* (page 216). As far as digital artists are concerned, the Web also acts like a huge library, learning

establishment and online shop: essential for downloading software updates, learning techniques, buying 3D components and generally keeping up to date with the wider artistic community.

Preparing your work for the Web requires an understanding of the process of optimization as well as compression. The file sizes have to be small, because images take a lot longer to download from a Web page than plain text, and not everyone that visits your site will have a fast broadband connection. Several file formats exist, such as JPEG, GIF and PNG, that can be adjusted in applications like Adobe Photoshop to give the best Web images. Depending on the file format, you can specify image quality and compression, background transparency or matting, the numbers of colours displayed and the downloading method. The 'Save for Web' feature in Photoshop does all the hard work for you, providing a preview selection of images employing different optimization methods for you to choose from, then generates the HTML code for displaying the image in a Web browser.

For formats other than these, such as those for vector images like SVG and Macromedia Flash, your browser audience will need a plug-in to view your images.

3D on the Web is another avenue open to artists. For a long time this was confined to output like industrial design, architectural walkthroughs and models of commercial products such as cell phones. Now, though, there are Web exporters for many of the major 3D packages, and Discreet has even brought out a powerful application dedicated to Web 3D. Named Plasma, it can load (but not save) the MAX and 3DS file formats, making it useful for export from the main Discreet 3ds max application or as a standalone Web 3D authoring tool. Discreet's software exports to both Macromedia Flash and Shockwave file formats, allowing even skinned 3D characters (including deformations and weighted vertices) to populate your websites. All this export functionality from the main 3D vendors has seen a corresponding move by experienced 3D professionals to the Web, bringing character-modelling skills from the animation and games worlds to a browser-based audience.

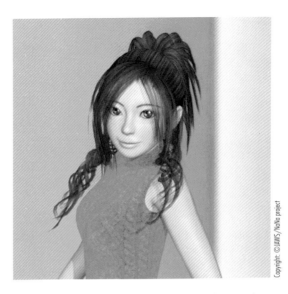

NaNa is a Web and TV sensation in Japan, with her own site, galleries and online shop. Created by Tokyo-based digital model agency Japan Audio Visual Workshop, she is an example of the Japanese style of female character. NaNa and her colleague NeNe are not just cartoon-like 2D animé girls, however. They are created using 3D tools such as *Shade*, and show how computer-generated characters can become reusable 'products' in their own right. More images and details of the NaNa project can be found at www.nana-fan.com

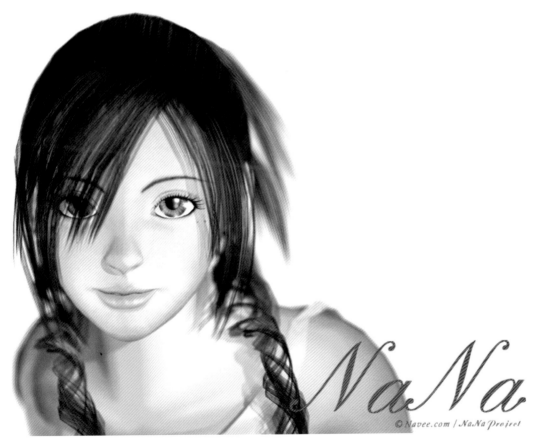

©Navee.com / NaNa Project

SOURCES OF SOFTWARE AND FURTHER INFORMATION

SOFTWARE USED IN FEMME DIGITALE

CONTENT CREATION APPLICATIONS

Animatek World Builder
Digital Element
http://www.digi-element.com/

MojoWorld Generator
Pandromedia
http://www.pandromeda.com/

Natural Scene Designer
Natural Graphics
http://naturalgfx.com

Terragen
Planetside Software
http://www.planetside.co.uk/terragen/

Vue d'Esprit
Eon Software
http://www.e-onsoftware.com

World Construction Set
3DNature
http://www.3DNature.com/

CorelDraw, Corel Photo-Paint
Corel
http://www.corel.com

Photoshop
Adobe
http://www.adobe.com

Painter, KPT Effects
Procreate
http://www.procreate.com

Poser
Curious Labs
http://www.curiouslabs.com

Cararra Studio
Eovia
http://www.eovia.com

Cinema 4D
Maxon
http://www.maxon.net

Lightwave 3D
NewTek
http://www.newtek.com

Maya
Alias|Wavefront
http://www.aliaswavefront.com

3ds max
Discreet
http://www.discreet.com

Deep Paint 3D and Texture Weapons
Right Hemisphere
http://www.righthemispher.com

ZBrush
Pixologic
http://www.zbrush.com

The GNU Image-Manipulation Program
GIMP
http://www.gimp.org/

PEOPLE, PLUG-INS AND PROPS

DAZ figures
DAZ Productions
http://www.daz3d.com/

Eye Candy
Alien Skin Software
http://www.alienskin.com

Cinematte
Digital Dominion
http://members.aol.com/dgdominion

Glitterato, Lunar Cell, Solar Cell, BladePro and SuperBladePro
Flaming Pear
http://www.flamingpear.com

Defocus Dei
Blackfeet
http://www.blackfeet.com

Druid
Sisyphus Software
http://www.sisyphus.com

Shag-Fur and Shag-Hair
Leapfrog
http://www.leapfrog.co.uk

Zygote
http://zygote.com

dacort
http://www.dacort.com

Renderosity
http://www.renderosity.com

ADDITIONAL SOFTWARE

There are many other high-quality painting and modelling software applications, so here is just a sampling to whet your appetite.

BodyPaint 3D
Maxon software (www.maxon.com)
Painting tool that enables you paint and draw directly onto 3D objects in realtime. It also helps you create detailed textures.

Expression
Creature House (www.creaturehouse.com)
Vector-based paint package that also offers fractal bitmap effects. It features natural media effects, live transparency, blending modes, object warping and variable brush stroke width and opacity. It supports Photoshop filters and file export and also supports the use of a pressure-sensitive graphics tablet.

Nendo
Izware (www.izware.com)
Quick and easy 3D modelling and painting tool. Streamlined for speed, it has a 'floater' free interface and context-sensitive menus for reduced clutter on the desktop, and allows users to model in a 'digital clay' environment, based on traditional sculpting methods. Its interactive 3D painting tools include brush options such as size, opacity and softness.

Paintshop Pro
JASC (www.jasc.com)
Highly popular and affordable image editor on the Windows platform. Features extensible brush architecture called *Picture Tubes* similar to the *Image Hose* in Corel PhotoPaint and Photoshop, as well as layers, a visual browser, general photo-editing tools and special effects.

Photoshop Elements
Adobe (www.adobe.com)
Cut down version of Photoshop featuring most of the parent applications tools while *Levels*, *Hue*, *Saturation*, *Invert*, *Brightness* and *Contrast* are all included as adjustment layers.

Rhino
Robert McNeel & Associates (www.rhino3d.com)
Windows-only modelling tool that creates, edits, analyzes and translates NURBS curves, surfaces and solids. Rhino also supports polygon meshes and there are no limits on complexity, degree or size.

Softimage XSI
Softimage (www.softimage.com)
Advanced high-end 3D modelling, rendering and animation package featuring excellent polygon and NURBS modelling tools. It also features fully integrated subdivision surfaces, interactive rendering and global illumination. Mental Image's mental ray 3.0, integrated into XSI, provides superior ray tracing and the package also features the *Render Tree*, a graphical *Shader* network, advanced texturing tools and a *Hair/Fur* simulation system. Softimage also produces Softimage 3D for modelling and animation.

trueSpace
Caligari (www.caligari.com)
3D modelling and rendering tool that offers advanced capabilities such as hybrid radiosity rendering and a direct manipulation user interface. trueSpace provides real-time feedback on all operations and offers real-time display of bump maps, multi-textures, procedural textures and environment mapping, as well as hardware-accelerated lighting and geometry transforms.

Universe
Electric Image (www.electricimage.com)
Cross-platform modeler and rendering software with easy-to-use interface enabling users to work with solid objects, NURBS or UBER-NURBS (subdivision surfaces) in the same environment. A high-quality photo-realistic ray-tracing and scanline rendering system, called Camera, is seamlessly integrated within the Universe package.

OPERATING SYSTEM SUPPLIERS

Linux
Linux Online
http://www.linux.org/

Mac OS
Apple Computer
http://www.apple.com

Windows
Microsoft
http://www.microsoft.com

ONLINE SOURCES OF INTEREST AND FURTHER INFORMATION

Online galleries and communities

CreativeCow forums
http://www.creativecow.net/
Extensive community of moderated forums for professional digital artists.

Elfwood
www.elfwood.com
Huge not-for-profit site. Home to the online galleries of over 1,500 artists. Mainly fantasy themes.

Digitalart.org
http://digitalart.org/
Gallery of over 4,000 works of computer-generated art.

DeviantArt
http://www.deviantart.com
With an emphasis on 'digital works as pieces of art rather than desktop eye candy', this is a central location for graphical artists to display their creations for feedback and exposure.

Highend 3D
http://www.highend3d.com/
Industry news, events, software updates, galleries and communities.

Renderosity
http://www.renderosity.com/
Community, forums, extensive gallery listing and online store for the digital artist.

Renderotica
http://www.renderotica.com/
Gallery site for adult CG graphics.

3D Artists
http://raph.com/3dartists/artgallery/
Gallery site with large number of artists.

Sites for discussion and information about 3D software and related issues

3D Links http://www.3dlinks.com/
3D Cafe http://www.3dcafe.com
3D Total http://www.3dtotal.com/

GLOSSARY

16-BIT COLOUR
A facility in image-editing applications that allows you to work on images in 16-bit-per channel mode, rather than eight, resulting in finer control over colour, but larger file sizes. An RGB image would total 48 bits (16 x 3) and a CMYK image 64 bits (16 x 4).

24-BIT COLOUR
The allocation of 24 bits of memory to each pixel, giving a screen display of 16.7 million colours (a row of 24 bits can be written in 16.7 million different combinations of 1s and 0s). Twenty-four bits are required for CMYK separations (eight bits for each).

ADDITIVE COLOURS
Describes the light-based primary colours of red (R), green (G) and blue (B), which, when added together, create white. RGB is used to form every colour for display monitors and image reproduction.

ALPHA CHANNEL
Pixel channel used to store data such as mask or transparency information. Appears as a separate greyscale channel, which accompanies any image file and determines which parts of the final image are affected.

ANCHOR
Adjustable points, such as curve or corner points, added when changes of direction are introduced into a path.

BITMAP
A 'map' describing the location and binary state (on or off) of 'bits', which defines a complete collection of pixels or dots that comprise an image. Unlike vector graphics, bitmapped images are not mathematically defined.

BLEND(ING)
A merging of two or more colours, forming a gradual transition from one to the other. The quality of the blend is limited by the number of shades of a single colour that can be reproduced without banding.

BLEND MODE
The method used by an image-editing application to control the interaction between a layer and the layer below it. As different blend modes allow complex interactions of light, tone and colour, blend modes can be used to create a range of interesting effects.

BMP
Windows file format for bitmapped or pixel-based images.

BUMP MAP
Surface material that adds 'bump' or depth detail to the surface of a model without actually affecting its geometry.

BURN
A technique which has transferred from photography to many 2D image-editing applications. When applied, it darkens up parts of an image.

CAST
When the colour balance of an image (often a scan or digital photo) is wrong; for example, if the image appears too blue or red.

CHROMA
The intensity, or purity, of a colour; thus its degree of saturation.

CLIPPING
Limiting an image or piece of art to within the bounds of a particular area.

CMYK (Cyan, Magenta, Yellow, Key)
Four-colour printing process based on the subtractive colour model. The letter K stands for the black 'key plate'. In theory, cyan, magenta and yellow, form black when combined, but in the printing process this is difficult to achieve and expensive, hence the additional use of black ink.

COLOUR GAMUT/COLOUR SPACE

The full range of colours achievable by any single device in the reproduction chain. While the colour spectrum contains many millions of colours, not all of them are achievable by all devices, such as a four-colour commercial press.

COLOUR PICKER

A colour model displayed on a computer monitor, which may be specific to either an application or to your operating system.

COLOUR TEMPERATURE

The temperature – measured in degrees Kelvin – to which a black object would have to be heated to produce a specific colour of light.

CONTROL VERTICES (CVS)

Handles that pull a curve into a more fluid, organic shape. CVs do not lie on the curve itself, but 'float' above the surface.

CURVES

Adjustment parameter in image-editing applications that allows precise control of the entire tonal range of an image.

DENSITY RANGE

The maximum range of tones of an image, measured as the difference between the darkest and the lightest of the tones.

DODGE

A technique originating in photography. When applied, it lightens up parts of an image. The dodge tool is found in many 2D image-editing applications.

ENGINE

A complex set of processes and routines used by an application to perform a particular function. Examples would include 2D or 3D graphics rendering, or organic modelling in a 3D application.

EXTRUSION

The method of creating a 3D object from a 2D path.

HIERARCHY

Tree structure listing objects in a scene or materials on a object, in order to display the logical relationships between them.

JPEG (JPG)

A standard graphics file format used primarily for photographic images, which uses a form of lossy compression to keep file sizes low. Named after the Joint Photographic Expert Group, which defined the format.

LAYERS

Used in many software applications, layers allow you to work on one element of an image without disturbing the others.

LEVELS

Adjustment parameter in image-editing applications that allows the user to correct the tonal range and colour balance of an image by adjusting intensity levels of the image's shadows, midtones and highlights.

LOFT(ING)

A 3D modelling method where a surface is applied to a series of profile curves that define a frame.

LOSSLESS COMPRESSION

Methods of file compression in which little or no data is lost.

LOSSY COMPRESSION

File compression where data is irretrievably lost. JPEG is a lossy format.

METABALLS

Used in 3D modelling, these are spheres that blend into each other.

MODELLING

In 3D, the creation of virtual 3D objects in a virtual 3D space using polygon or NURBS-based geometry.

GLOSSARY

NURBS
Non-Uniform Rational B-Splines. A technique that is used to interactively model 3D curves and surfaces, creating realistic, rounded shapes.

OBJ
A standard file format created by Wavefront to describe 3D objects. OBJ files can be used within many 3D packages, making it a useful format for cross-application projects, particularly those including work with Curious Labs Poser.

OMNI LIGHT
Illumination source that points light in all directions.

PARENT
An object that is linked to another (known as a 'child') in a modelling hierarchy. When the parent moves, the child object moves with it.

PERSPECTIVE
A technique of rendering 3D objects on a 2D plane, by giving the impression of an object's relative position, size and shape as seen from a particular point of view.

PIXEL
A contraction of 'picture element'. The smallest component of any digitally generated image, such as a single dot of light on a computer screen. In its simplest form, one pixel corresponds to a single bit: 0=off (white); 1=on (black). In colour or greyscale images, one pixel may correspond to up to 24 bits.

PIXELLATION
A visual effect where a digital image appears blocky as the pixels that make it up become visible.

PLUG-IN
A small, specialized application that plugs in to a host application in order to provide extra features or functions. In a 2D graphics application, such as Adobe Photoshop, a plug-in might create an impressive special effect. In a 3D application, such as 3D Studio Max, a plug-in might handle complex hair or skin modelling, or act as a specialized rendering engine.

POLYGON
A number of connected points that together create a shape or face. Polygonal meshes are created from joining the faces together. These form the basic geometric shapes that make up a model.

PRIMITIVES
Simple geometrical objects in 3D applications such as spheres, cubes and cylinders, which are combined together or deformed to create more complex shapes.

PSD
Image format for files created using Adobe Photoshop.

RASTERIZE
To electronically convert a vector graphics image into a bitmapped image.

RAY TRACING
A rendering procedure that sends out hypothetical rays of light originating from the objects in a scene in order to determine the appearance of each pixel in the final image.

REFLECTION MAP
A surface material that determines what is reflected in an object's surface.

RENDER/RENDERING
The application of textures and lighting, which together transform a collection of objects into a realistic scene. All the data in the 3D scene – the location and nature of all light sources, locations and shape of all geometry, and also the location and orientation of the camera through which that scene is viewed – are collected to create a fully realized 2D image.

REVOLVE (TOOL)
This creates a surface from a profile curve that revolves around a defined axis.

RGB (Red, Green, Blue)
The colours of the additive colour model, used on monitors and in Web graphics.

SHADERS

Shaders determine the appearance of an object. These are layers of attributes that make up how the surface of the model reacts to light, colour, reflectivity, appearance and so on.

SMOOTHING

In drawing and 3D programs, the refinement of paths or polygons to create smooth curves or surfaces.

SPECULAR

The 'highlight value' of a shiny object, defining which parts reflect light and with what intensity.

SPOTLIGHT

Illumination in one specific direction, along a cone-shaped path.

SUBDIVISION SURFACES

Geometric surface type used for modelling organic objects. Usually built from a refined polygonal mesh.

TEXTURE MAP

A 2D image (such as a JPG image) used as a shader. Texture maps are applied to the surface of a 3D object in order to give it extra detail, such as scratches and patterns. They can be created inside the 3D application using procedural methods or imported as 2D bitmapped images (file textures) from a digital photo.

TIFF or TIF

Tagged Image File Format. A standard and popular graphics format used for scanned, high-resolution bitmapped images and colour separations. The format also supports LZW compression: a lossless file compression technique.

TRANSLATION

Manipulation of the position of an object.

TRANSPARENCY MAP

Surface material that determines what is reflected in a transparent object's surface.

UV COORDINATES

The vertex coordinates of a model that define the surface parameters of an object and therefore let artists accurately place parts of an image onto the correct place. (See texture map).

UV MAPPING

A way to texture map a 3D polygonal model using the UV coordinates.

VECTOR GRAPHICS

Images made up of mathematically defined shapes, or complex paths built out of mathematically defined curves. As a result, they can be resized or displayed at any resolution without loss of quality, but lack the tonal subtlety of bitmaps.

VERTEX

A control point on a path in a 3D object. Often shortened to 'vert'.

VRML

Virtual Reality Modelling Language. An HTML-type programming language designed to create 3D scenes (virtual worlds).

WIREFRAME

A three-dimensional object viewed as a mesh with no 'surface' or texture applied to it (the object has yet to be rendered).

INDEX

ACKNOWLEDGEMENTS

The publisher would like thank the following artists for all their contributions to this title.

Greg Baldwin
underpaint@sbcglobal.net
www.bagaple.com

Alceu Baptistão
alceu@vetorzero.com.br
www.vetorzero.com/kaya

Roberto Campus
bob@robertocampus.com
www.robertocampus.com

Christine Clavel
christine.clavel@free.fr
http://christine.clavel.free.fr/

Les Garner
lgarner@sixus1.com
www.sixus1.com

Mark Gibbons
Mark_Gibbons@scee.net
www.primalgame.com

Ken Gilliland
empken@empken.com
www.empken.com

Damon Godley
damon@o2.co.uk

Ian & Dominic Higgins
eon7@talk21.com
www.livingposer.com

David Ho
ho@davidho.com
www.davidho.com

Shannon Howell
webmaster@shannonhowell.com
www.shannonhowell.com

Phillip James
jayjames@digitalart.org
www.portfolio.com/jayjames

Will Kramer
will@earthcurves.com
www.earthcurves.com

Michael Loh
mwkloh@e-maginaryarts.com
www.renderosity.com/homepage.
ez?Who=mwkloh

Ralph Manis
mach1@infinitee-designs.com
www.Infinitee-Designs.com

Anatoliy Meymuhin
aem3d@mail.ru
www.anatoliy.epilogue.net

Rene Morel
morelr@sympatico.ca
www.amazonsoul.com

Ellie Morin
artofspirit@aol.com
www.artofspirit.org

Adam Morton
alchera@alcheraonline.com
www.alcheraonline.com

Richard Murrin
richard@richardmurrin.co.uk
www.richardmurrin.co.uk

Daniel Scott Gabriel Murray
kahuna@alpc.com
www.alpc.com

Cris Palomino
elektralusion@elektralusion.com
www.elektralusion.com

Mungo Park
mungo.park@aon.at
www.renderosity.com/homepage.
ez?Who=MungoPark

Lynn Perkins
lwperkins@snip.net
www.lwperkins.com

Kristen Perry
merekat@merekatcreations.com
www.merekatcreations.com

Robert Pritchard
budda21@bellsouth.net
www.renderosity.com/homepage.
ez?Who=Robert0921

Francois Rimasson
rimasson.francois@wanadoo.fr
http://perso.wanadoo.fr/
rimasson/index.html

Stephen Stahlberg
stahlber@yahoo.com
www.optidigit.com/stevens

Byron Taylor
byron@byrontaylor.com
www.byrontaylor.com

Jeanette Thompson
moxiegraphix@com.cast.net
www.moxiegraphix.com

Masaru Ueda
uedadai@a1.mbn.or.jp
www.nana-fan.com/

Marco Vernaglione
cyberartist@gmx.de
www.thepowerofbeauty.com

Michael Yazijian
yazstudios@hotmail.com
www.yazstudios.com